9-4-04

8-11-07(41)
9-27-12(48
4.21.16(5)
3-20-17(58)

♡ W9-AXG-636

Henri Cartier-Bresson

PHOTOPORTRAITS

Henri Cartier-Bresson

PHOTOPORTRAITS

Preface by André Pieyre de Mandiargues

With 255 illustrations in duotone

Thames and Hudson

Translated from the French
Henri Cartier-Bresson: Photoportraits
by Paula Clifford

Translation © 1985 Thames and Hudson Ltd, London

© 1985 Henri Cartier-Bresson and Editions Gallimard

First published in the USA in 1985 by Thames and Hudson Inc.,
500 Fifth Avenue, New York, New York 10110

Library of Congress Catalog Card Number: 85-51213

Printed and bound in Switzerland

The first picture – the first shot – in this large and fascinating volume of Henri Cartier-Bresson's photographic portraits is much more than merely strange. I know nothing about the main figure in that picture beyond a time, 1967, and a place, Israel; but I know enough to be captivated by something unfamiliar, yet inescapable, which is none other than that indefinable element of the fantastic which I have pursued all my life but seldom achieved. A young man, naked except for a tatty pair of shorts or underpants and sandals, is holding up with both hands an ancient-looking garment – a shirt or jacket – as if to hide the face of a little girl who might be his sister or his victim. This is exactly the stance of a torero in the bullring who holds out a muleta to the bull he is going to kill; and the expression of grim excitement on the boy's face evokes the beast itself. With its precise positioning of hands and feet, the pictorial composition is no less structured than the work of a great painter, Goya perhaps; and the story that it illustrates I would be tempted to attribute to Kafka. Yet it is a photograph by Cartier-Bresson that so stirs my imagination; and the gesture of the young man wielding a garment reminds me next, after the torero, of the artist's own antics with a cape in his darkroom when he was covering and uncovering his first camera.

Although the origins of photography are not very far removed from the year of writing, 1985, they seem inseparable from the occult experimentation of the astrologers and the alchemists. It was Jerome Cardan who, in the sixteenth century, first placed a glass lens

over the opening in the *camera obscura*, a device already known to Roger Bacon in the thirteenth. Only a little more than a century and a half ago, by using mercury vapour, silver iodide, a hot solution of sea salt and then a plate of polished silvered copper, Nicéphore Niepce, closely followed by L.J.M. Daguerre, made the essential breakthrough: fixing in a stable manner, on the plane of projection, the image captured in the outside world by a ray of light from the sun. With a considerable display of initiative Daguerre at once set to work with the outcome of his method, which he called the daguer-rotype, to reproduce the features of famous men; thus we are fortunate enough to possess early true likenesses of some of our best-loved poets, Gérard de Nerval in particular. Then, in similar vein, having perfected a technique in which, most notably, the length of pose had become a little less interminable, Nadar began around 1854 to create his *Panthéon Nadar*, which is precious to us for the same reason. What is perhaps most notable is that photography owed its existence and early development above all to the portrait.

Whenever I see Henri Cartier-Bresson today, I am always reminded of 1930, 1931 and the years that followed, when, in the course of car journeys all over Europe, and strolls in Paris, I witnessed the emergence of the greatest photographer of modern times through a spontaneous activity which, rather like a game at first, forced itself on the young painter as poetry may force itself on other young people. Not with any thought of making a profitable career out of it: in fact, *petits-bourgeois* that we were, barely out of

adolescence and trying with difficulty to get away from the rules of polite society, the words 'career' and even 'craft' merely turned our stomachs – as our families, with some disquiet, were beginning to realize.

Time passed. Thanks to photography, there rapidly crystallized in Henri Cartier-Bresson, born under Leo, the ardent, impulsive, energetic man of genius that he was to become. As a prisoner of war in Germany, he escaped at his third attempt and played a part in the underground movement helping prisoners and escapees. Then in 1944 he joined the professional photographers who were recording the liberation of Paris. Next he went to the United States, where he had made a name for himself before 1939, and there supervised a so-called 'posthumous' exhibition, which The Museum of Modern Art in New York had arranged under the mistaken impression that he had died in the war. This exhibition was accompanied by a monograph, the first important publication to be devoted to him.

Henri Cartier-Bresson had found his vocation; and I should like to stress that the word 'vocation' – with, surely, its overtones of a calling and of imperious fate – has more meaning, weight and dignity than 'career' and 'craft', which I have already rejected. He is a photographer. A photographer who is different because he is always original as well as passionate in everything he does. When in 1952 his first big album of photographs was published by Verve, with a cover by Matisse, he chose for it the excessively modest title 'Pictures on the Run' (*Images à la sauvette*). Except for the prisoner-of-war camps,

Henri Cartier-Bresson, to my knowledge, has never run away from anywhere. Instead, following the example of his birthsign, he grasps in passing, and what he captures remains as a human testimony whose status can never be diminished by the passing of time.

Like some of the characters in Guillaume Apollinaire's best poems, Henri Cartier-Bresson is first and foremost a perceptive and inspired passer-by. He is as swift in his movements as Apollinaire was in words, and like him seeks a *summa* of revelatory images which can take the apparent banality of our world and turn it inside out, like a dirty sock, to uncover and bring out its secret reality. He does it with much humour and a little friendly cruelty, the two essential qualities for portraying this world and the more or less extraordinary figures who inhabit it.

Much has been written on the early, pre-war phase of Henri Cartier-Bresson's art; I would simply emphasize – greatly though I respect aesthetics – that there is nothing of the aesthete in this photographer; he never goes after a pretty picture. For him the beauty of the picture is to be found in unveiling a certain mystery, and in the shock of the fantastic, where tragedy is mixed with comedy, even caricature: rather as in the best stories of Hoffmann, Poe, Balzac, Kafka and Maurice Blanchot, or in the old Chaplin and Keaton films, which must surely have helped him find his way. In these photographs, faces and attitudes so natural as to be positively incredible are in some way 'justified' by their strange setting or by the objects around them – such as the little hatch-like windows where

Mexican prostitutes were required by the police to expose their huge breasts and over-made-up faces. From these, Henri Cartier-Bresson moved on to real portraiture, photographing the face or the whole body of an individual who interested him from other than a formal point of view. The most frequent causes of this interest are friendship, admiration, and curiosity as to an achievement or a social role.

In time this new photographic pantheon spans the half-century from 1932 to 1982, with a short period of renewed activity in 1984 and 1985. I admit to having been not a little moved to find there a picture of myself taken by Henri in Parma – or possibly Livorno – in the spring sunshine of 1932, in which I am smoking a cigarette for perhaps the last time in my life. I merge into an appealing advertisement for parmesan cheese, which justifies my anonymous face, as the little windows do for the Mexico City tarts. Fine.

One of the virtues of these pictures is that they make clear yet again that in portraiture, as elsewhere, Henri Cartier-Bresson is not just another photographer, and that he does not flatter. The facial expressions which his camera reproduces are always a little disturbing, if not dramatic; they are no embodiment of grace and charm – as is seen, for example, in most of the women and poets caught by the lens of Man Ray, a true aesthete and lover of beauty for whom I also freely confess a great admiration.

Most of the characters, generally famous, who were captured by the small camera from which Henri Cartier-Bresson was never

parted, seem to have been touched by a wand, whether or not a magic one. Glorified (perhaps), to me they look transfixed: frozen for an age, if not for ever, by the crack of a firearm. They would be most ungracious not to acknowledge their debt to Henri Cartier-Bresson, and yet they are also his victims. As with the great writers to whom I take pleasure in comparing him, Henri Cartier-Bresson has a certain sadism in his eye and in his lens. Almost as much as in the pen of his old friend Mandiargues.

In addition (or better still): there is a metaphysical element in the portraits before us, and most of these subjects – well-known, if not all equally famous – seem to have received some revelation of their destiny which keeps them torn between anxiety and resignation. An angel has appeared, announcing to the men and women of his choice that henceforth they exist, it is too bad if it embarrasses them, and they will have to get used to it. From that point of view, I think the picture I find most moving is that of the Joliot-Curies; they both have their hands clasped, or nearly so, and their faces are tense as if in apprehension of some unspoken fate, their eyes drawn to the camera as by an invisible string. Never, in all the old-master paintings where the traditional angel of the annunciation appears, has the face of the recipient of the message appeared so troubled.

François Mauriac, again with hands more or less clasped, has his vigil made more comfortable by the back of his armchair, but from his bent head, pursed lips and distant gaze it is clear that the angel has passed this way too, and that the hard awareness of existing has

penetrated his consciousness. Sartre on the bank of the Seine has no doubt received a revelation of his 'abyss', so tightly does he grasp his pipe in his hand. I must take this opportunity to say that a pipe in a man's hand, quite apart from its element of sexual exhibitionism, often gives me the impression of a moral prop and stay, a remedy for the fear of existing. Hence its frequent appearance in pictures of those who go to a photographer, or who get him to come to them. Matisse in one photo is hiding as best he can behind the plants in his garden, and in another has his finger to his lips, which could be a question or an admonition to silence. Braque and Rouault are surely crystallized in and by their old age, far away from the troublesome world. Pierre Bonnard seems to be praying; or he stoops in a corner of his studio as if he were reading a judgment in his hands and accepting a destiny that was, after all, magnificent. Let us not forget Pierre Colle, lying face down beneath a sheet on his frantically chaotic bed, while three shoes lie loathsome on the floor: those, no doubt, of a madman and the (one-legged) angelic messenger. Picasso, over-protected against the cold by an artless woollen garment, is reminiscent of a matador or fencer who knows he is above all danger. Christian Bérard, bearded, is poised amid his *angst* and his books on the very edge of an unmade bed which looks like a rough sea. Miró is himself, pure and simple, as he always was, as if astonished at the beauty of his own paintings. What is Aragon watching for, head propped on his arm and hand, if not the return of the always beautiful Elsa? But Elsa dwells in a different time, similarly propped in

front of a picture of their wedding or some similar occasion. Paul Valéry in front of his own aggressively white bust – and, unbeknown to him I think, the reflection of his profile in the mirror – is a triple spectre who is located in Time thanks only to a bow tie and a photograph of Stéphane Mallarmé. But I wish I were capable of seeing what Samuel Beckett's gaze has suddenly lighted on, unperceived by any less gifted or tenacious mind, or what has caused the anguish of Lili Brik, her head clutched in her hands. And like the much-cherished, the blessed Alberto Giacometti, I wish I could blend in with the dilapidated walls and battered chairs, the ancient floor-boards, the piles of old newspapers, the litter: for such is the sanctity of the artist and poet. The most triumphant example of that entirely private sanctity is surely represented here by Ezra Pound in 1971, when he had lived through the best and the worst, and passed beyond everything; his hands are together, and his eyes are riveted on distant wonders which he contemplates like Moses in sight of the Promised Land. A supreme image of serious and sacred goodness, in which Pound joins his master Dante, for whom love was the prime mover of the universe. Jean Genet allows the possible future to merge with the rejected past in his indifference to the present, which was perhaps what kept him going when he was in jail. Roger Caillois is grieved to have to turn his back on the subtle elegance of his library. And Claude Levi-Strauss knows too much of the future world of men not to accept his entry to the contemporary Pantheon with a somewhat forced smile.

This procession of the famous is enthralling because these people, who have enjoyed some degree of 'success' as the truly inspired or the deceivers of this world, have been paralysed for an instant, while on stage, by the sting of Henri Cartier-Bresson's lens (the comparison with an insect is his own). In our eyes, they have received an annunciation or an inoculation which affirms their uniqueness as individuals once and for all. Consider, if you will, the features of André Malraux, Igor Markevitch or Henri Laurens. What has befallen these men to enable them to portray catastrophe – which really means the overthrow of a person or thing that has for a moment stood upright – with all the compelling power of figures in a Shakespearean tragedy? Or (I am tempted to add, staying with Henri Cartier-Bresson's beloved England) like the subjects of Francis Bacon's pictures; the portrait of that painter, leaning towards his dark side in a 1972 shot, comes at the right moment to bear me out. Having emerged, it seems, from some strenuous activity of the flesh, he is the antithesis of Julien Green, who personifies the desire to live in a spiritual seclusion. The stars of the characters in *Macbeth*, and those of a host of public figures in our world, shine with equal brilliance; the poets knew this, but no photographer has ever shown it so decisively. Of course Henri Cartier-Bresson, who is kind and reassuring in his rare conversations with critics, has spoken of 'connivance' between himself and his subjects, whom in fact he always treats with his habitual grace and politeness. As he has said: 'At times a veil of shyness or distrust must be pushed aside to establish

mutual confidence.' More often, and perhaps more accurately, on the subject of his professional attitude, he has referred to a kind of 'summer lightning' (*fulguration*), a phenomenon which according to the dictionary is 'a flash of electricity in the upper atmosphere without the noise of thunder': silent lightning, in short. I think I come closest to the man I so admire when I recall that according to the ancient Romans fulgural science was divination by lightning. This accords perfectly with a title which, in all seriousness, I have sometimes taken pleasure in giving him, that of Great Revealer. Perhaps from his memories of reading Poe and Baudelaire, there is a fantastic Hoffmannesque strain in the view of man and woman that we obtain through his portraits. Nearly always, an enigma is posed.

To be fair as well as truthful, it must be said that a small number of celebrities put to the test have undergone it unperturbed, light-heartedly even, without any dramatic reaction. Some are close friends of the man behind the camera, such as Jean Renoir, with whom Henri Cartier-Bresson worked for a long time, and whose peaceable image could be that of a monk observed in a state of beatitude; others are strangers or distant acquaintances, like Carlo Levi with his evident happiness at being alive and his obvious confidence in his own well-fleshed person. The jazz trumpeter Jo and his wife make a couple without equal, and of such striking presence that when the shutter clicked that time it was undoubtedly the photographer himself, whose love of black beauty I know and share, who was bewitched. And in this connection I must mention André

Breton, himself an enchanter, who smiles a strange smile as he toys with his African, Mexican and Polynesian statuettes; for the revealing lens could find nothing to unmask in this great and mysterious master.

When exploring for the first time this Conservatory of our age — where men and women, mostly taken unawares, are pinned down at a vital moment in their lives — the eye soon begins to wander at random. It lights upon Sarah Bernhardt's former lady's-maid, who is either the guardian of the relics or a moral portrait of the Sarah who still lives on; upon Leonard Bernstein, in a prodigious shot of the conductor unleashing, spurring on, calming, releasing, the soul-searing demons of music; on Sam Szafran, turning away, albeit tenderly, from the outside world depicted in an insignificant background; upon J.M.G. Le Clézio, giving life and stability to a single moment in time to which his hand, wrist and watch attach him; upon Pierre Jean Jouve, just as I knew him, protected by one of those new suits of his, à propos of which he used to tell me that his literary royalties were barely enough to pay his tailor's bills; upon Neruda, a sublime poet with a parrot's head and a permanent look of surprise. When we come to Somerset Maugham, with one foot on the lush tapestry of his throne, the unhappy great man seems to be proclaiming: 'I am a success.' The ash of Marcel Duchamp's cigar is all that is needed to bury with him a good few of the high priests of our new Pompeii. And, tragically, does not the large hand that hides Martin Luther King's forehead suggest that the other hand is in the process

of writing his last will and testament on one of the scattered sheets of paper? Malcolm X is as tranquil as any panther, even a black one, after eating his fill.

The meeting would lose something of its *entrain* and good humour without Jacques Duclos and Maurice Thorez, who stand in total contrast to the stark seriousness of the two Japanese who follow them, shortly before a strange picture of that strange man Dino Buzzati, in whom death seems already to have taken up residence.

I did not much like Paul Léautaud, whom I met many times in the post-war years; and this was no doubt due to that scornful ease, mixed with aggressiveness, which stands out in the portrait as if in moral relief. Open All Night, Closed All Night: that great nocturnal creature Paul Morand shows little interest. He has reached the stay-at-home age, the age of giving up, and in his armchair he takes no further interest in the planet Earth, her moonlight or her life-giving sunshine. Still more curious in her seclusion is Colette, whose thought, in front of the camera, is like a question that expects no answer. I would put her not far away from Louise de Vilmorin, with her hands folded on her chest below her pearls, confronted in anguish by the unfathomable part of herself. Marcel Aymé, who always seemed to us to have his feet a little too firmly on the ground, joins those to whom Henri's Leica presented a question, if not an annunciation, that was difficult to accept. I confess that I should never have pictured Aldous Huxley (whom I very much admired at one time) with so self-satisfied a smirk, so kite-like a pose, or so

horrific a tie. But with one of today's great poets, Yves Bonnefoy, seated in front of an array of books, his daughter drinking on his knee, the picture is as charming as the composition is perfect. And I come to more books, piled up in a room where we often saw the handsome face of Jean Paulhan, here looking as though he has just posed a riddle. 'Which pictures do you prefer, Braque's or Fautrier's?' Henri Cartier-Bresson was once asked (he told me) by Jean Paulhan in the company of a stranger; and Paulhan then introduced him to Fautrier just as Henri, aware even so of the trap, was replying 'Braque's.'

Then suddenly we are transported into another world, or, more simply, into the next world, by a prodigious picture of Bogwan Sri Ramana Maharishi, taken on his bed on the last day of his life, making a gesture of farewell, rather like a final convulsion, next to a poster of Gandhi. At the moment of the great mystic's death, Henri Cartier-Bresson was among those who saw a fireball move slowly across the sky to the place where he died. He was buried in an upright position rather than cremated, because the cycle of his reincarnations had drawn to a close. Gandhi, seen from behind, vouchsafed the photographer a glimpse of his hand fluttering in the air; the photograph was taken a short time before the assassin struck. The lightness and grace of this last picture lend it the authority of a transcendental illumination.

That is not all; for among these portraits whose titles are the names of their subjects – the famous, or those who in some way have

been of note in a certain sphere for a certain period of time, along with friends and family friends – Henri Cartier-Bresson has happily intermingled anonymous pictures, which are in part the result of his pursuit of man and woman. A sort of trawl, as they say nowadays, designed not so much to bring in bodies as to appropriate the appearance of bodies and faces drawn from the crowd in a sublime moment: moments which are less rare than many would think who have not learnt to use their eyes.

Endowed with uniqueness, marked as often by happiness and zest for life as by unhappiness and awareness of death, or indeed by glorious indifference, these are voluntary or involuntary actors in a theatre of the fantastic, characters in stories which never have been, nor will be, written. A click of the Leica is enough to pluck these nameless, priceless beings out of the Time into whose depths they were about to disappear, and to hold fast their moment of brilliance. It is a rape, really, but a rape with a happy ending; and most of the victims have not even noticed. It is, if you prefer, a rescue operation.

Among these survivors, who are often more beautiful than the 'beautiful people' to whom Henri Cartier-Bresson opens the doors of his Pantheon, I would like to mention a black woman proudly attached to a tall dustbin in Mexico, a Cuban worker smoking a fat cigar while operating the machines in his factory, the old man in Newcastle upon Tyne whose magnificently serene gaze rests on the fragile edifice of rubbish which is no doubt all he possesses, the nicely dimpled Polish girl transported to fabulous Hollywood by a

Texan hat on a poster, a worthy Frenchman barely surfacing out of a sea of laid tables and chairs, the courts of India, a clan of Iranians on the verge of turning nasty, a black farmhand beginning to get tired of cotton-picking in Louisiana, an old French man and woman who have perhaps lived only to find themselves existing in and through the memories of their illusions. Between light and shade, a tweed-wrapped Irish citizen twiddles his thumbs and looks at the outside world through half-closed eyes, like many a Joycean hero. In Chicago, amid the terrible loneliness of an iron architecture which seems to have no end and no beginning, a wretched specimen of the human race makes his way towards unspeakable nights. In India a bearded man, half-naked, contemplates death on his way towards a new life in which he will have no more say than he has in the life that is ending. In France, behind a gate with vertical bars (it is only the gate of a narrow garden) stands a weird character dressed in horizontally striped material, beneath shutters with horizontal slats: a human being, amid the geometrical contrast of which he is a part, is dehumanized at the click of the Leica. In Mexico an impish little girl romps around, laughing and spreading out before her a rather sordid health poster, like the mask of some Californian lovely. Still in the United States, a huge black woman draped in a vast white gown presents the onlooker – and even the photographer – with the ideal mother figure of the Spirituals. Three beautiful women's faces, in Egypt, shown unveiled: what can one say except that sorrow, death and burial are the words that they convey to us? Enormous,

beautiful and shocking, the Mexican mother, very pregnant, holds her last baby in her arms with the rest of her progeny beside her, arranged in order of age and height against a wall, in an endeavour to tug at our heartstrings. Still in Mexico, naked urchins run riot, and the Leica preserves their wild faces; each bears the trace of a moustache which will soon be that of a man. Who are those amiable workmen with their arms folded, or those formidable ladies festooned with medals? Who is this man with a little beard who is carrying a plaster figure simply in order to set its white face against his own grey professorial head? Probably nothing other than the recollected emotions of the photographer at his best; and to my mind the most outstanding anonymous portrait is still the one from Israel on the first page.

It is perhaps unnecessary to repeat what everyone knows, that about ten years ago Henri Cartier-Bresson put aside his camera and now limits his work – hard work – to painting, and especially to drawing, the arts to which he devoted himself in early life. It is well known, too, that Man Ray did the same in his later years. Why not? It was their right; and, as for Henri Cartier-Bresson's work, we shall always take pleasure in his present-day drawings and the few paintings that he has allowed to survive from his youth. But although he has called a halt – temporarily, it is to be hoped – to the activity which has made him so famous, it would be wrong to conclude from this that there exists a kind of hierarchy in the arts, a scale of values on which photography ranks below painting. That his fame, which

used not to displease him, now annoys or irritates him, and that he tends to shun it, is of course all to his credit. Is this not the classic reaction of Sun in Leo, as much in the quest for fame as in the rejection of it? It is no less true that Henri Cartier-Bresson, I gladly repeat, is incontestably the most admirable photographer of modern times, and his work – through his vision of life on our planet, which may be tragic or tender, ironic or farcical, or through the present vast pantheon of men and women who at least in their own estimation have escaped from the anonymous crowd – is to us no less precious or magical than that of Sergei Eisenstein, Charlie Chaplin or Pablo Picasso, for example: three great names that I have chosen deliberately because mediocre minds all too often invoke them to obscure the fame of new-found genius.

I do not accept that painting, just because it is done by hand, is automatically preferable to photography, whose very operation depends on machinery. On the contrary, I take pleasure in the realization that photography is the offspring of the noble art of alchemy; success in either, as in poetry, is inseparable from a moral and spiritual elevation whose starting point is none other than love. Henri Cartier-Bresson, on this point at least, will certainly not contradict me.

ANDRÉ PIEYRE DE MANDIARGUES

I thank all the 'models' known or unknown,
who in the course of nearly fifty years
have allowed themselves to be caught,
and I think also of those, friends especially,
who are not to be found in this chance collection.

H.C.-B.

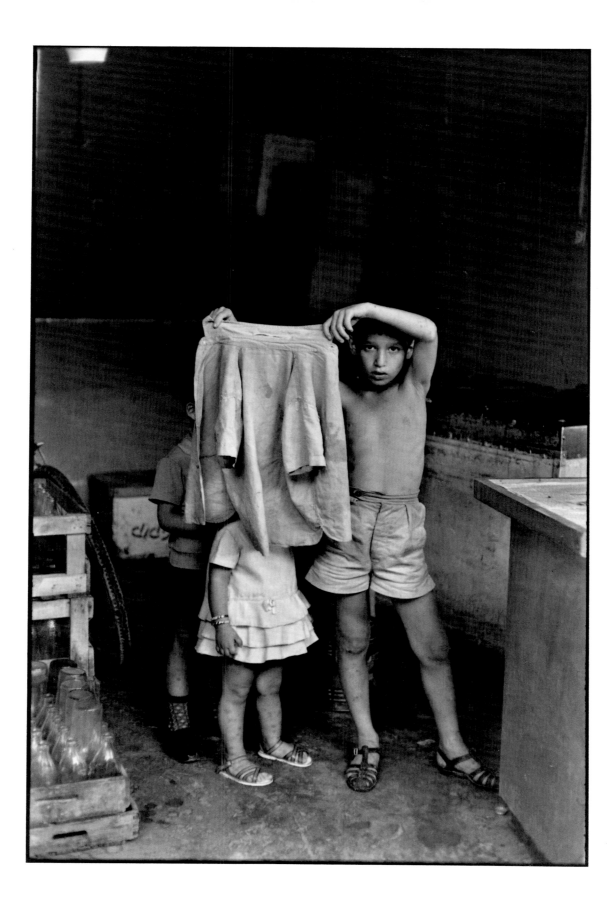

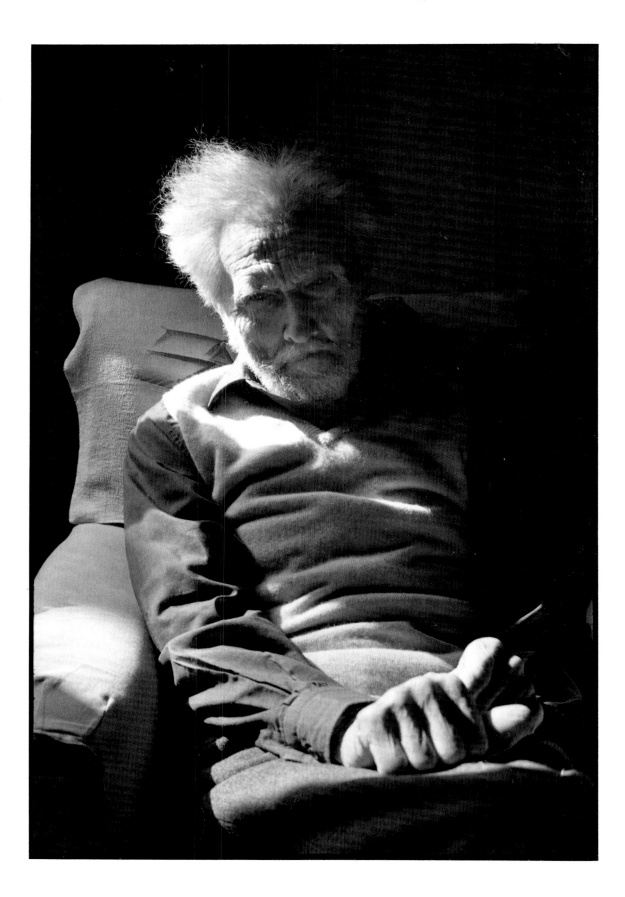

Ezra Pound

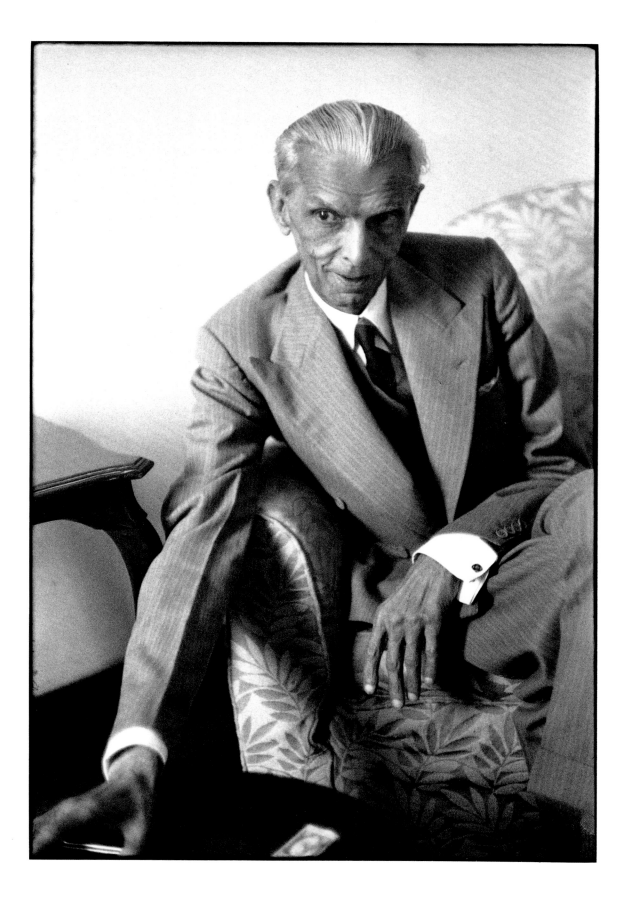

Muhammad Ali Jinnah

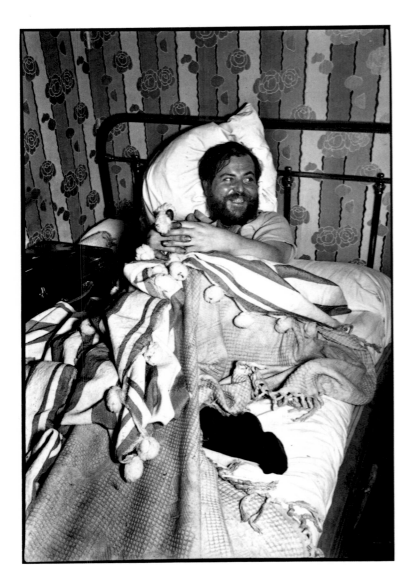

Christian Bérard

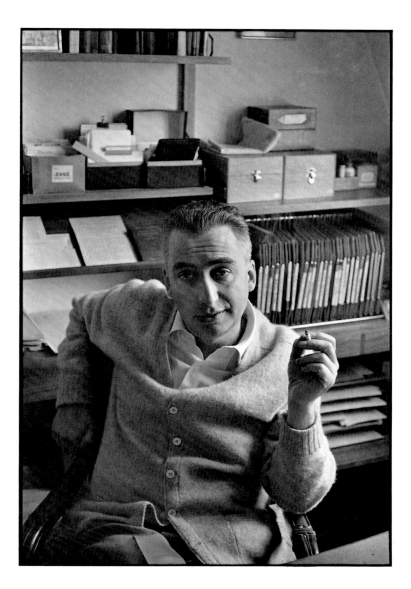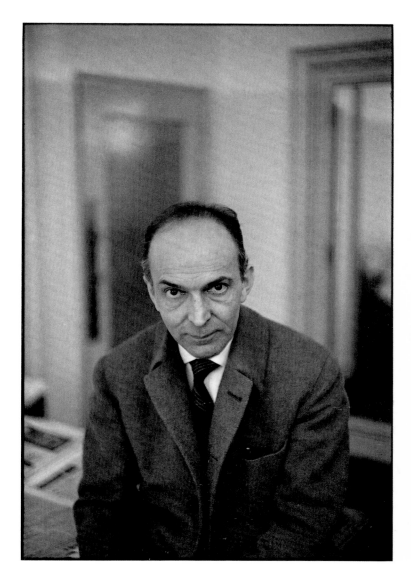

Roland Barthes Igor Markevitch 31

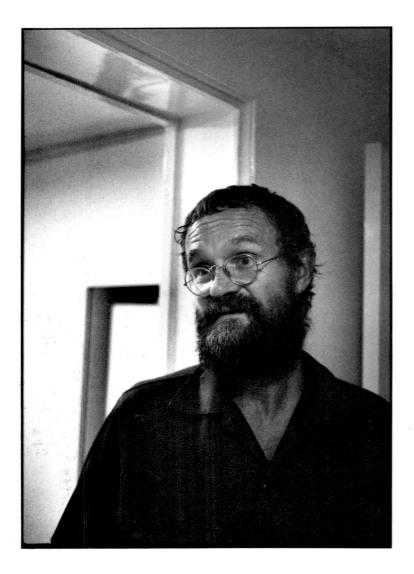

Josef Koudelka

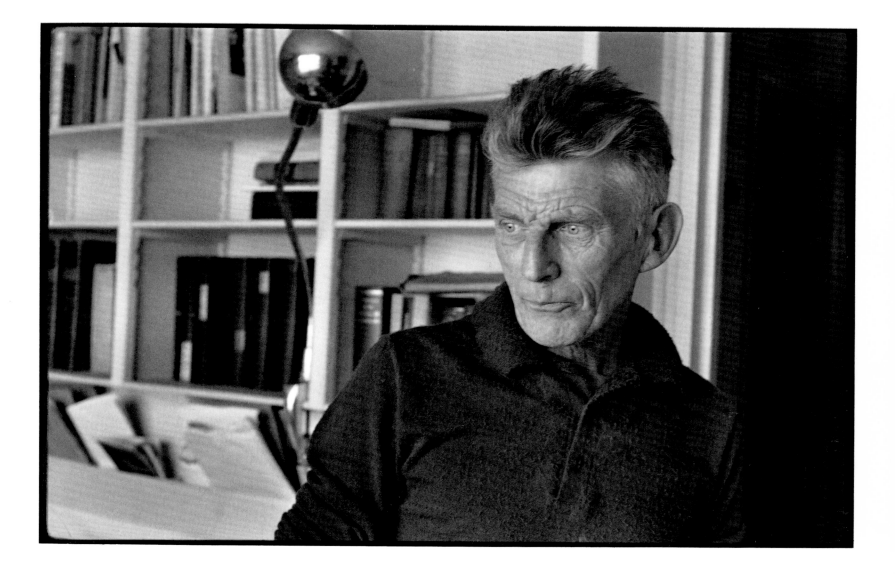

Samuel Beckett

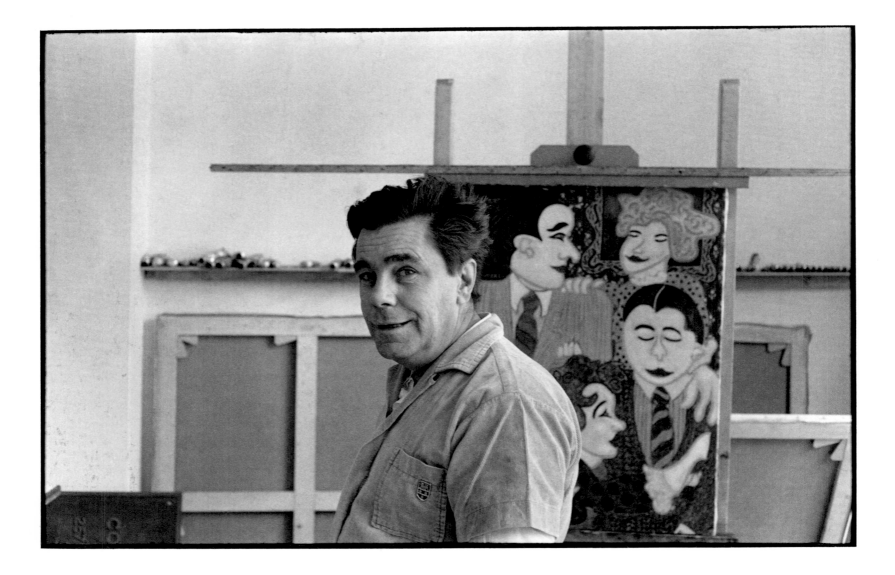

William Copley

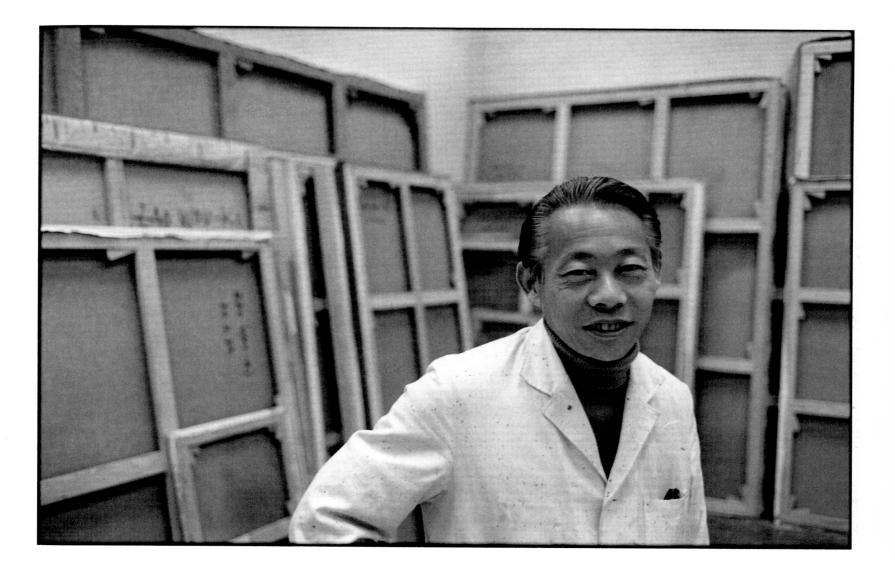

Zao Wou-Ki

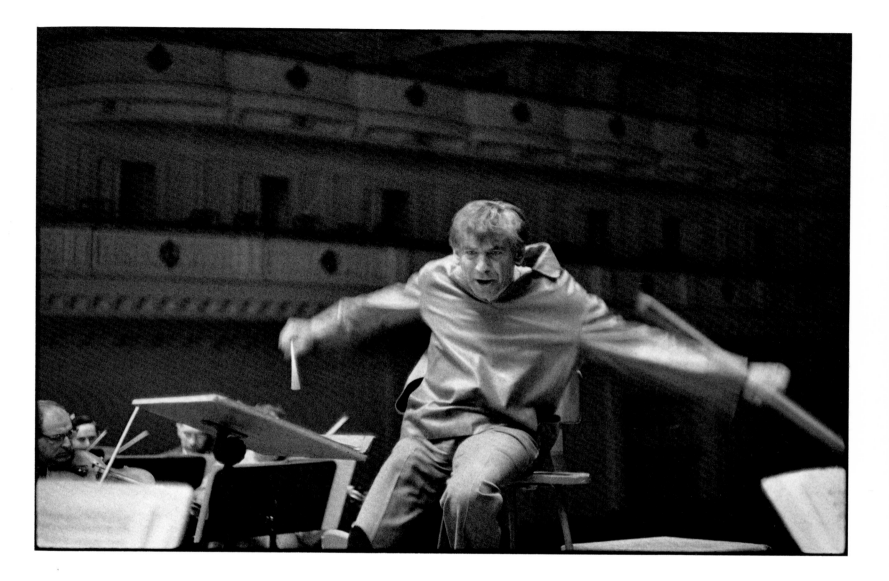

Leonard Bernstein

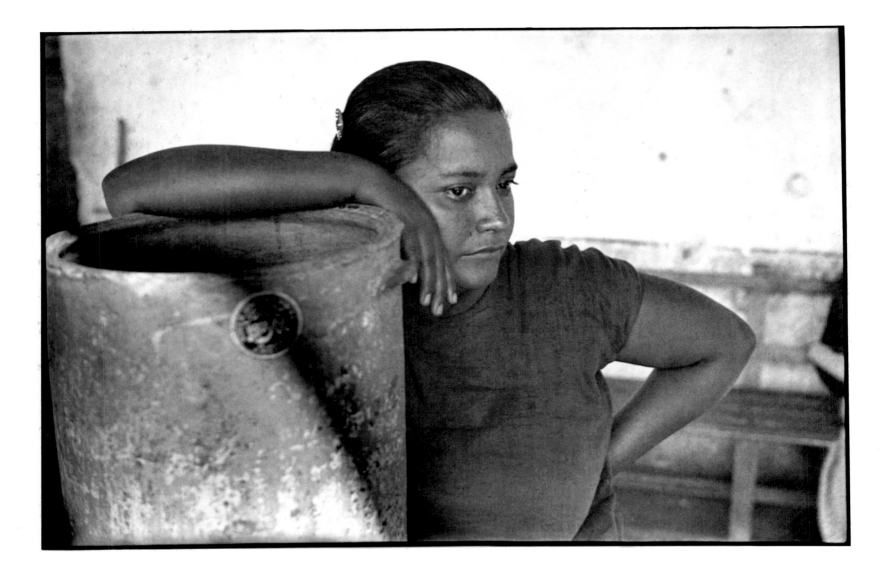

Bela

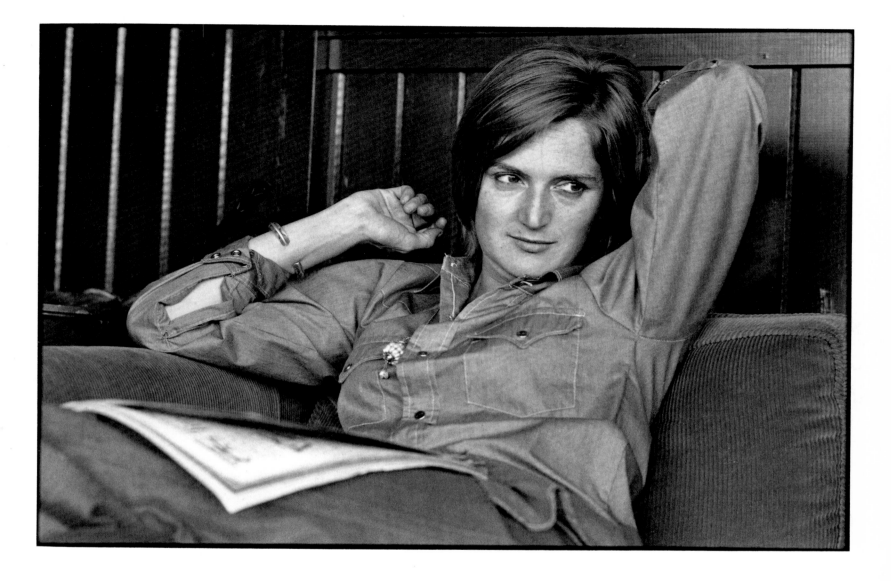

Dominique Nabokov

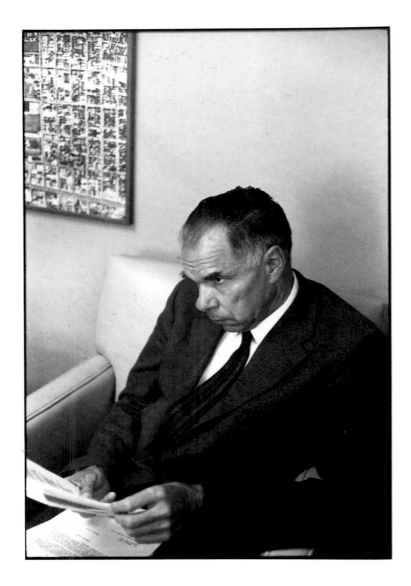

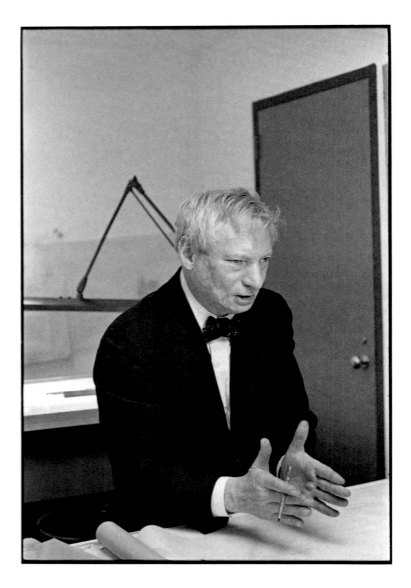

Glenn Seaborg

Louis Kahn

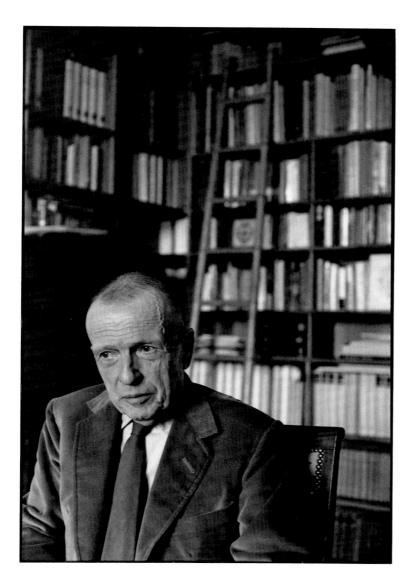

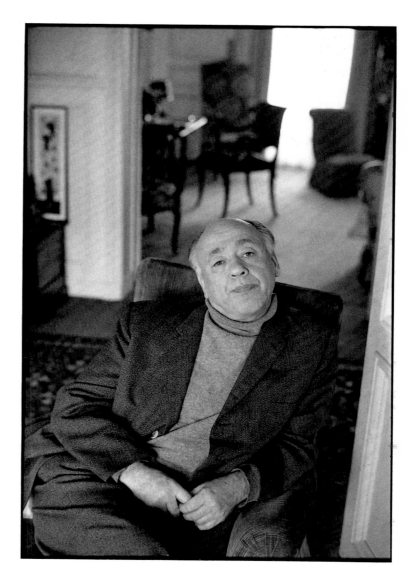

Michel Leiris

Eugène Ionesco

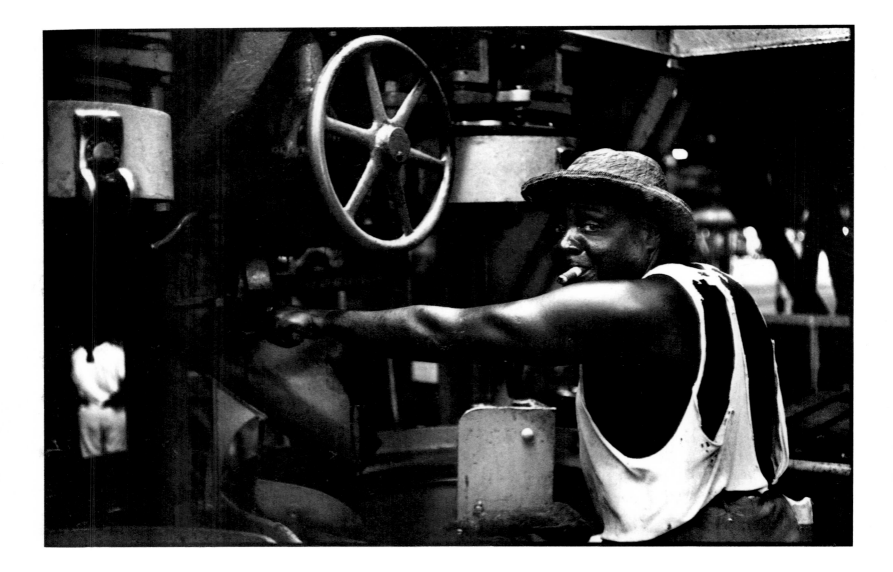

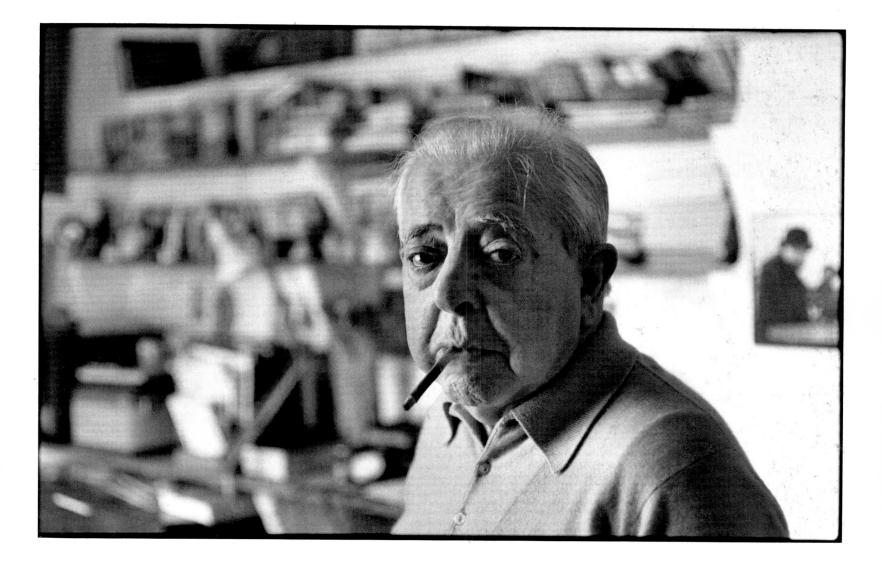

Jacques Prévert

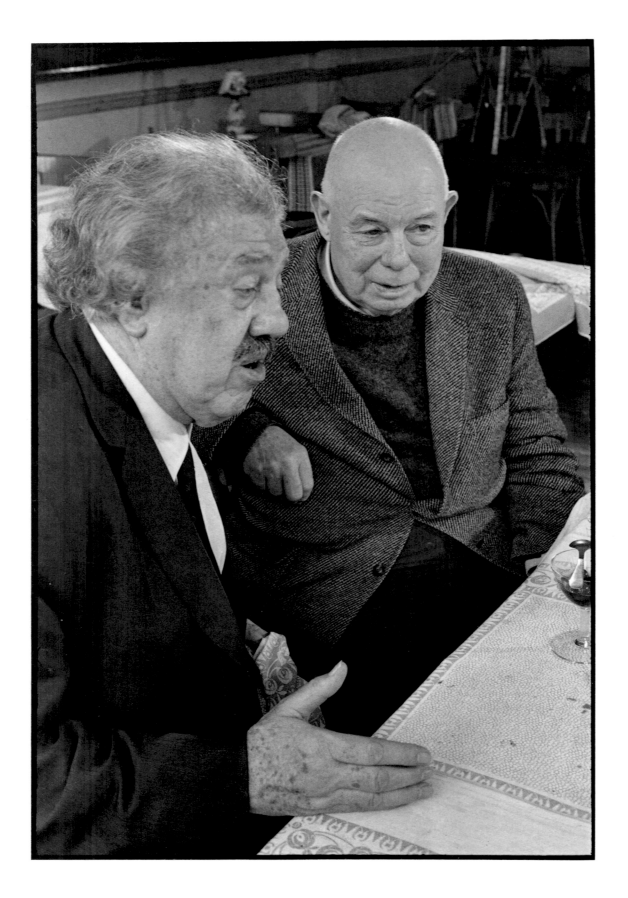

Michel Simon, Jean Renoir

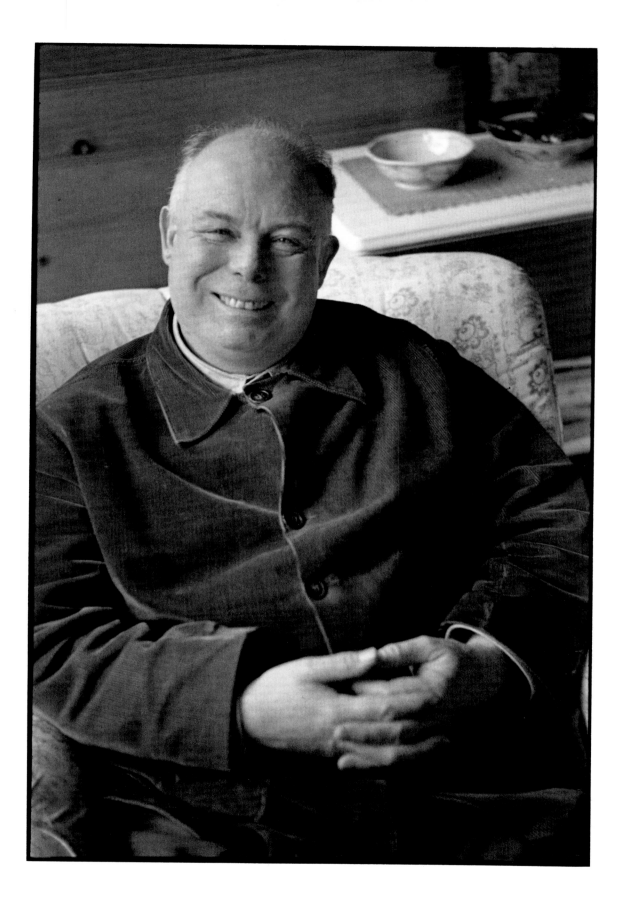

Jean Renoir

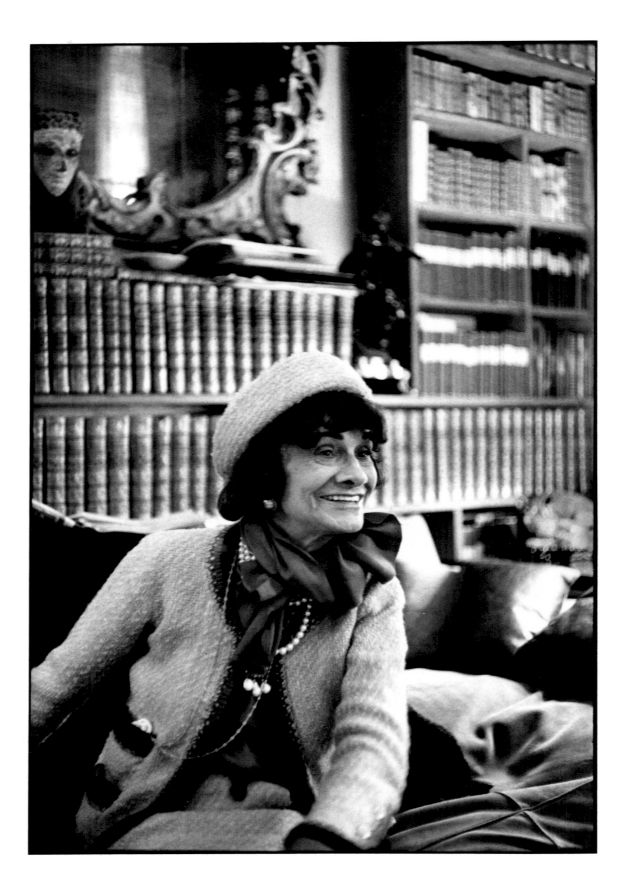

Coco Chanel

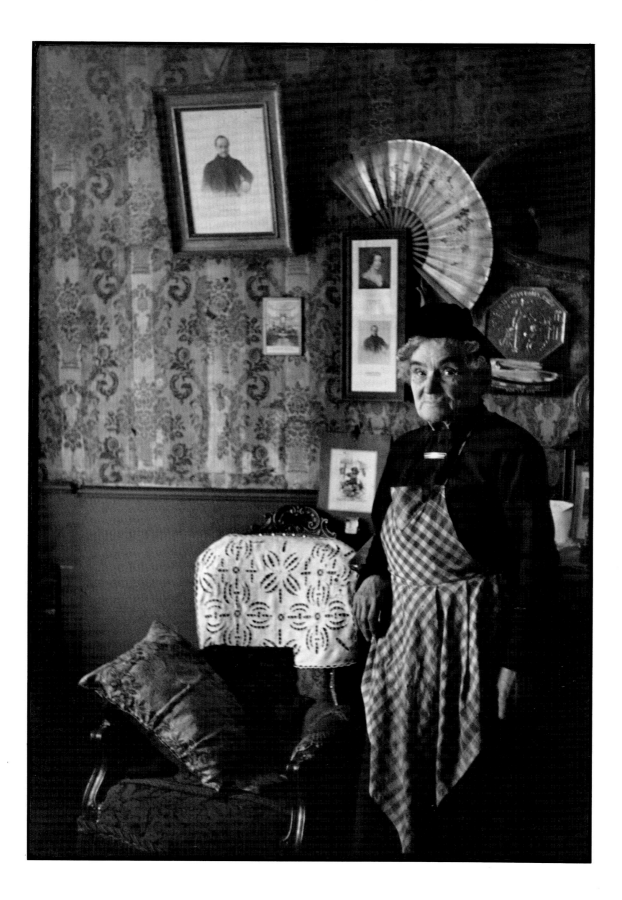

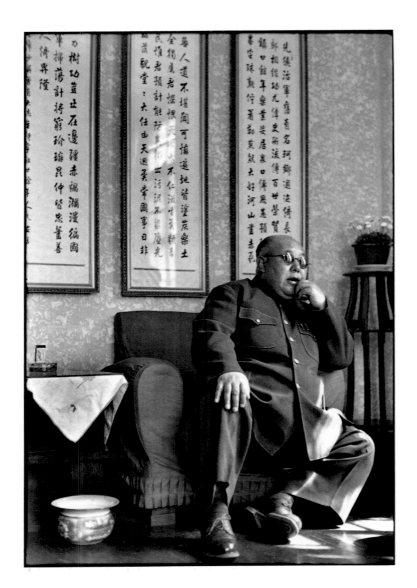

General Ma Hung-kouei

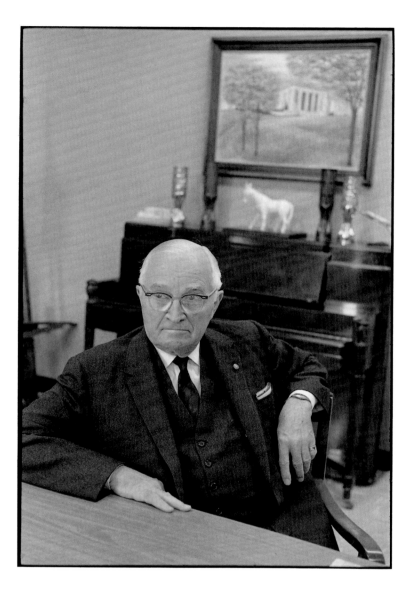 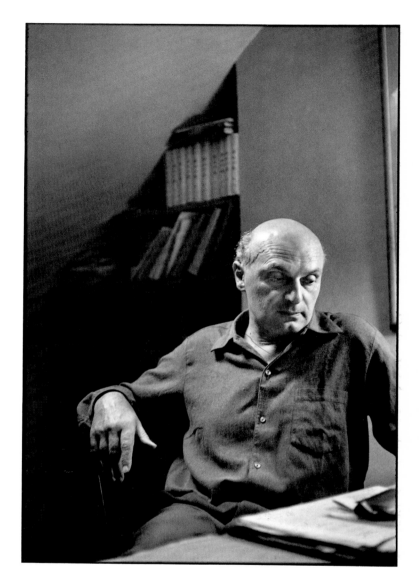

Harry S. Truman Etiemble 49

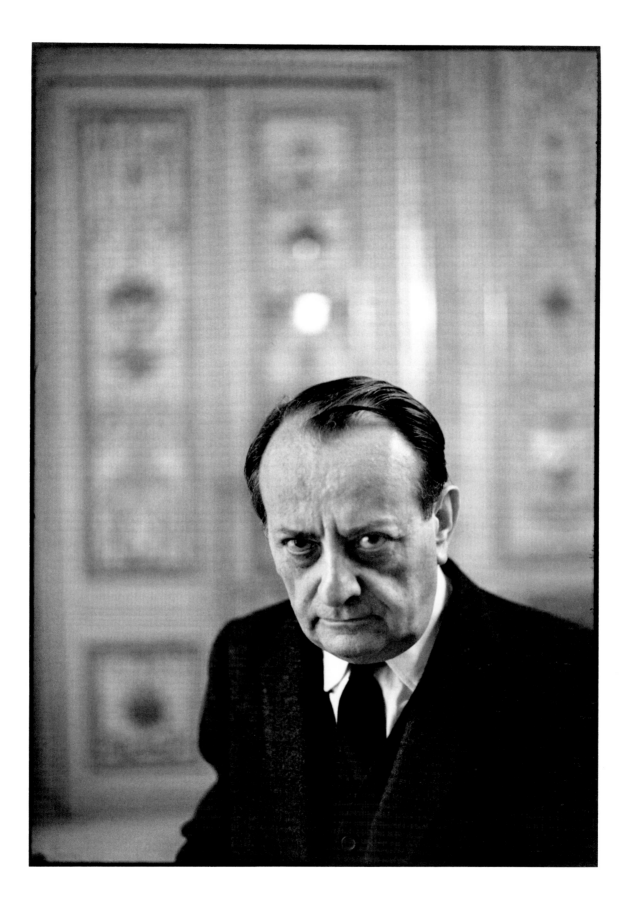

André Malraux

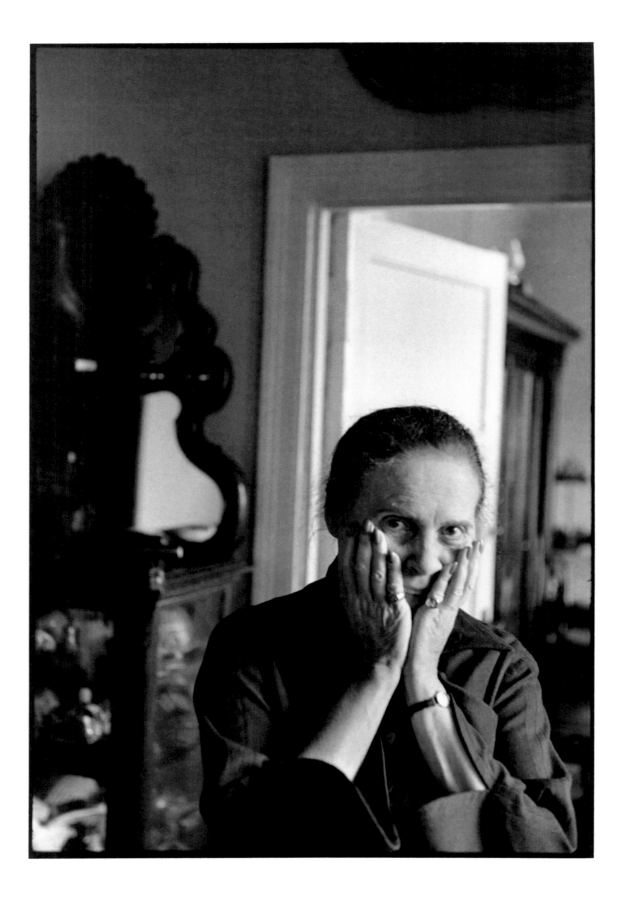

Lili Brik-Maïakovski

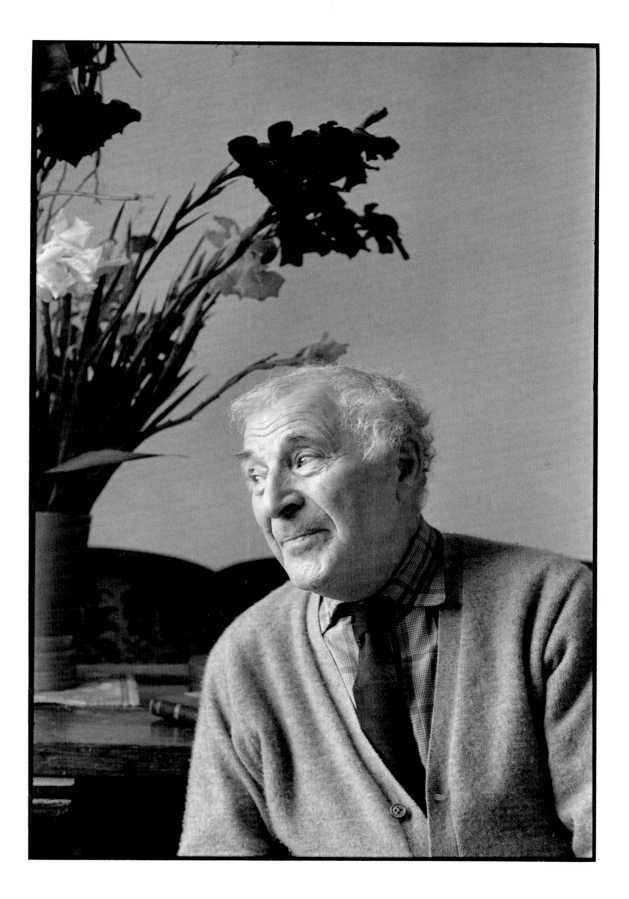

Marc Chagall

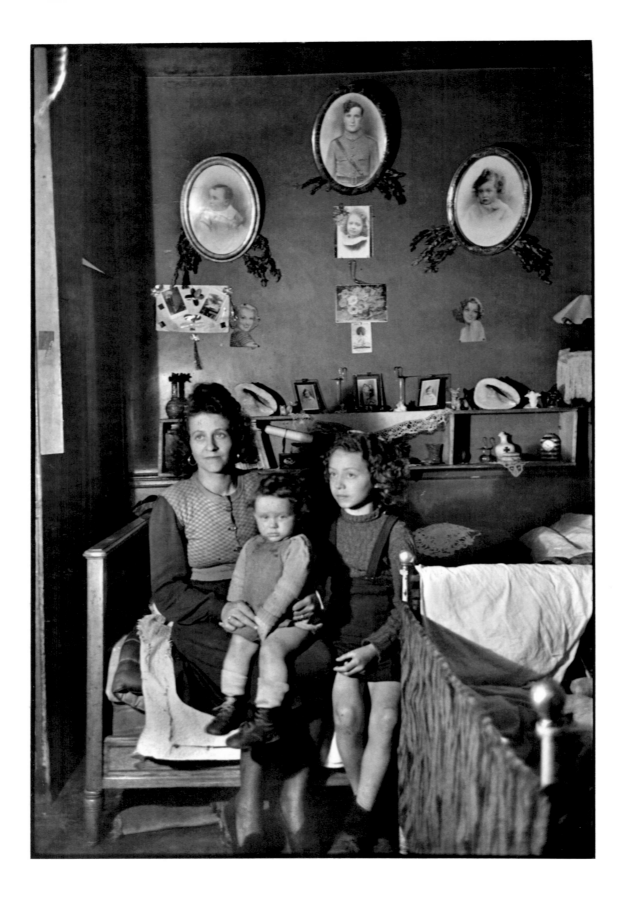

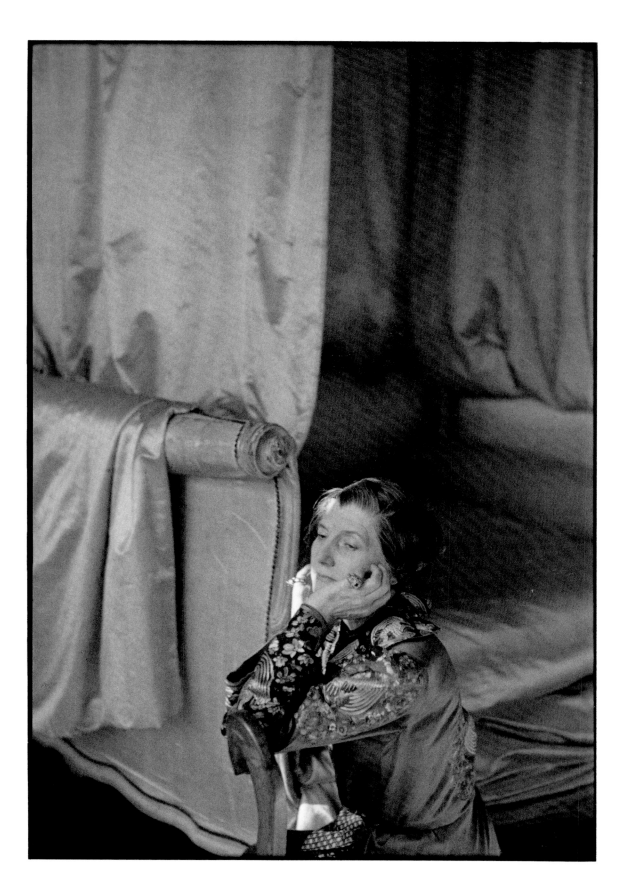

Jeanne Toussaint

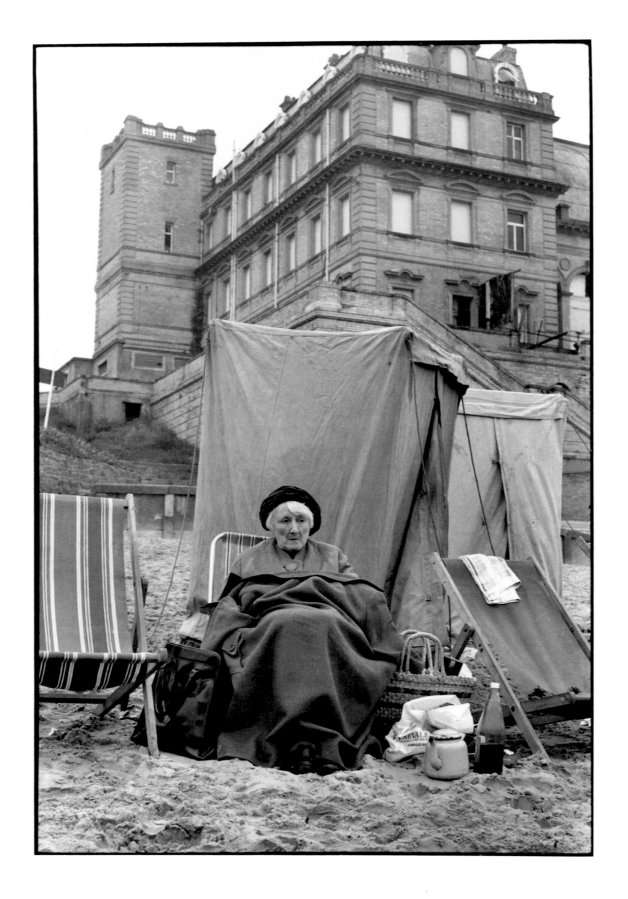

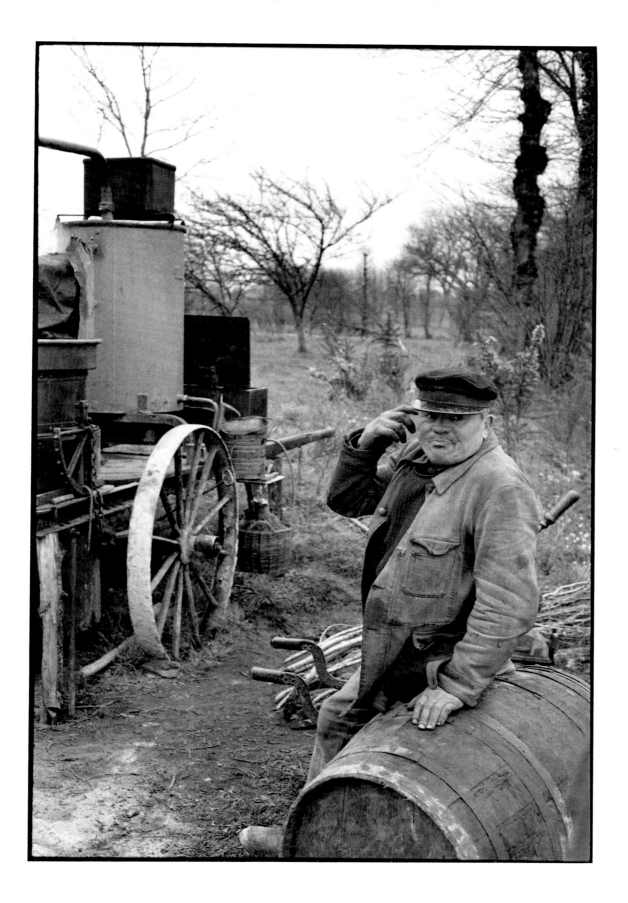

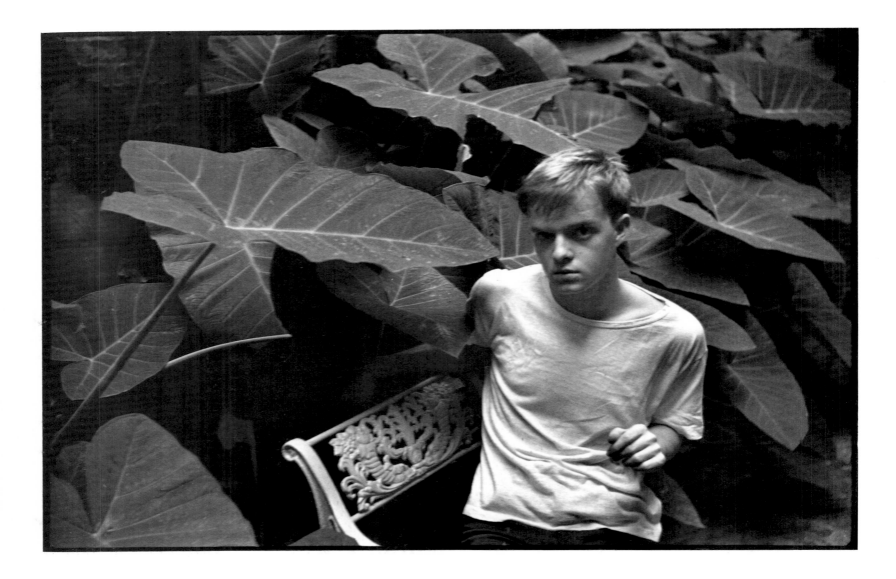

Truman Capote

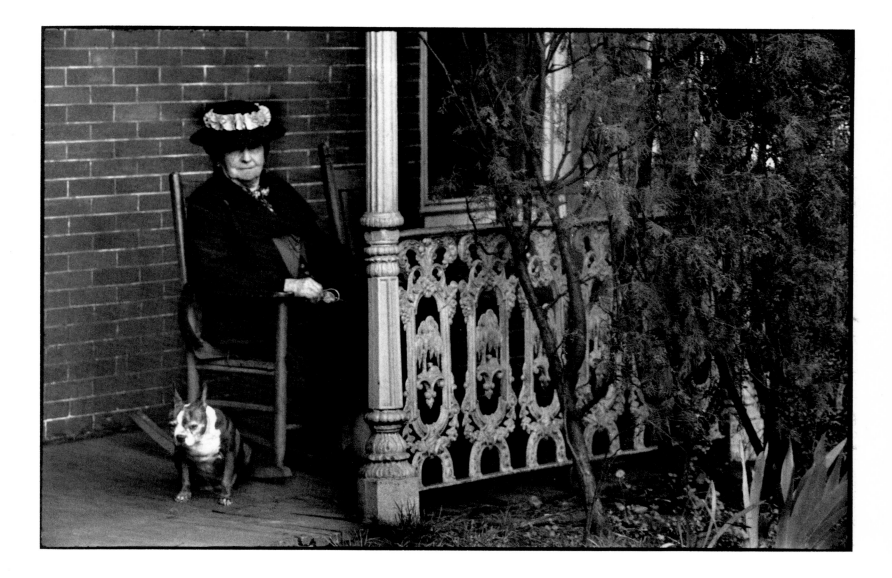

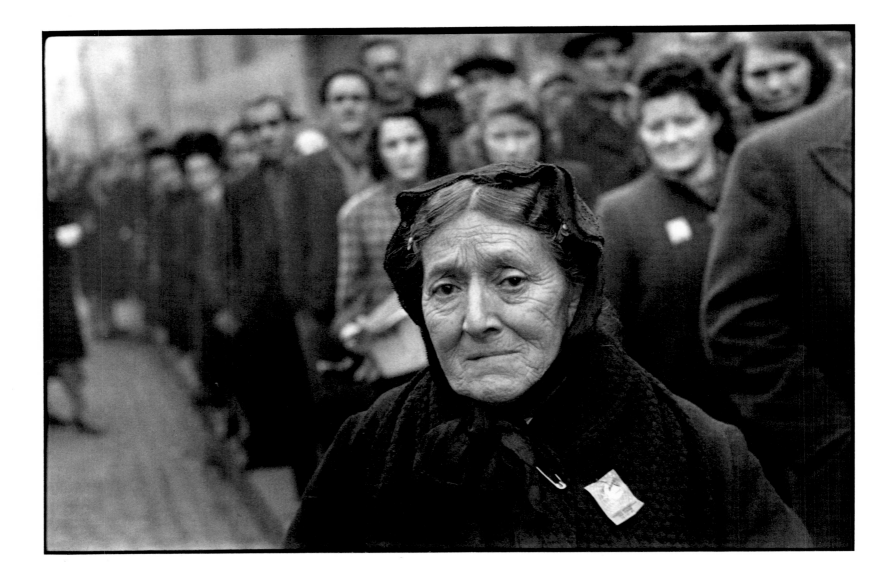

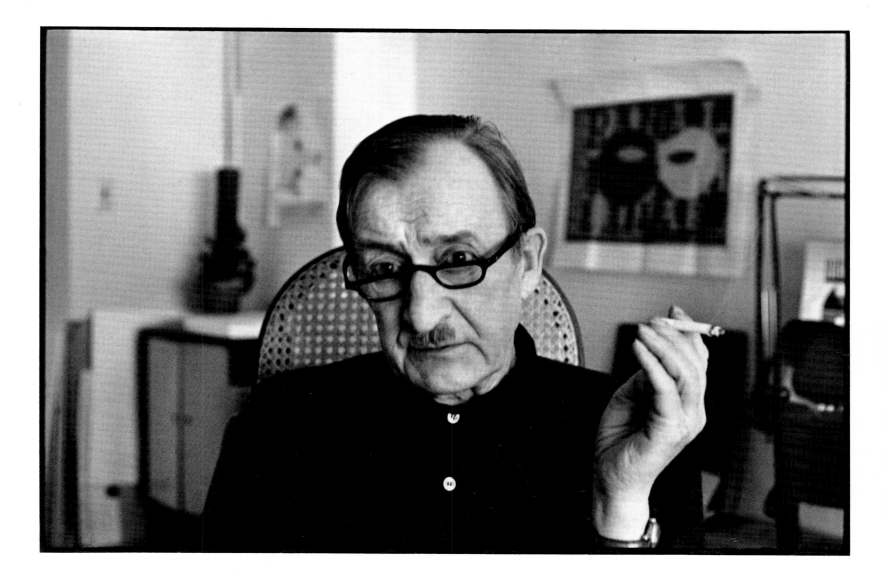

Alexey Brodovitch

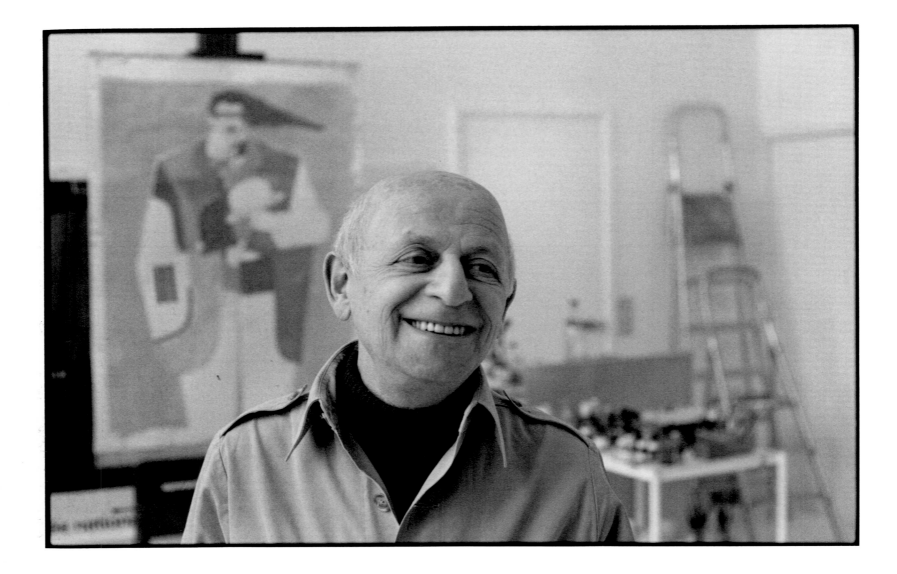

Richard Lindner

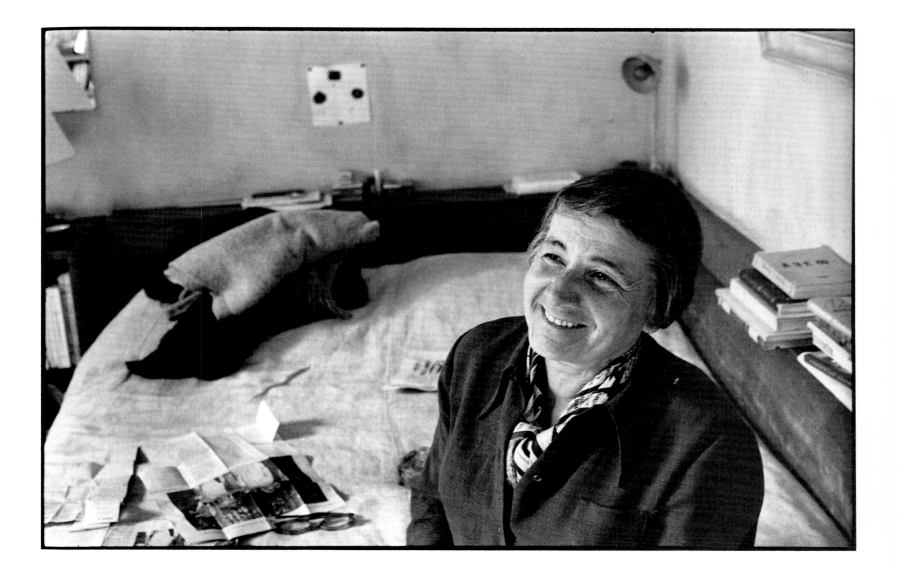

Nathalie Sarraute

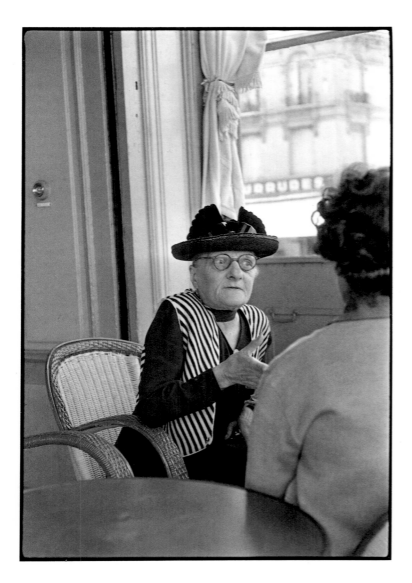

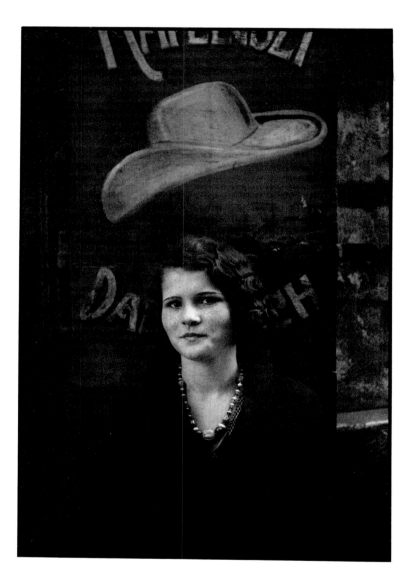

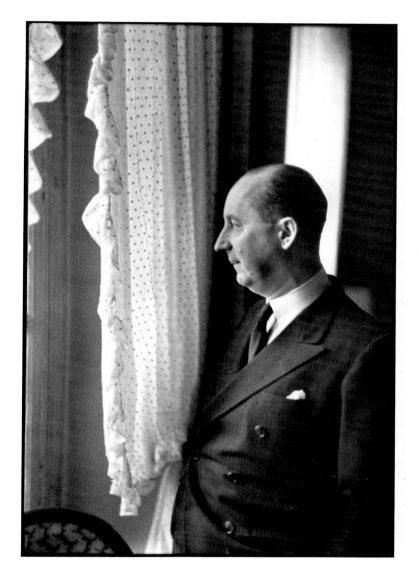

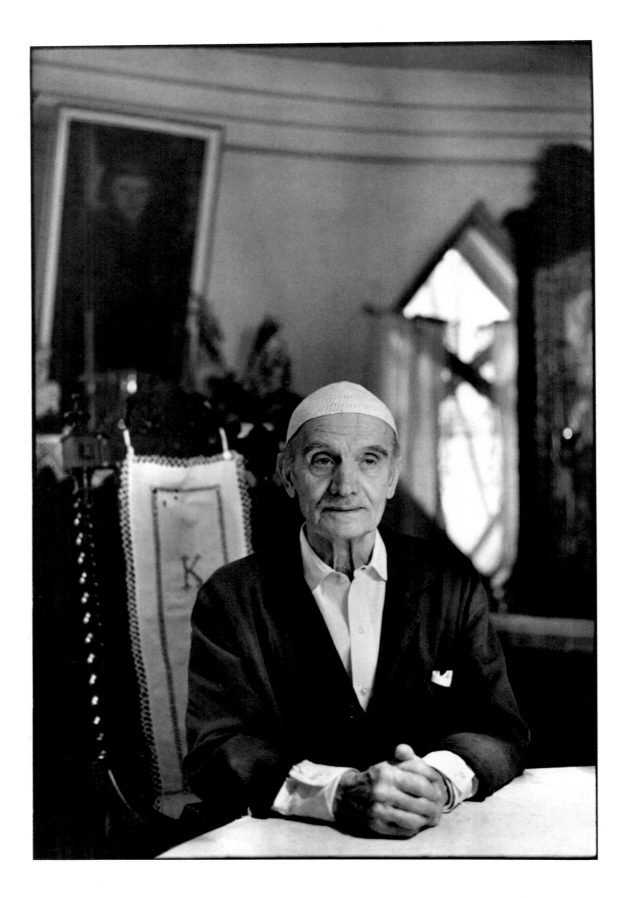

Konstantine Stepanovitch Melnikov

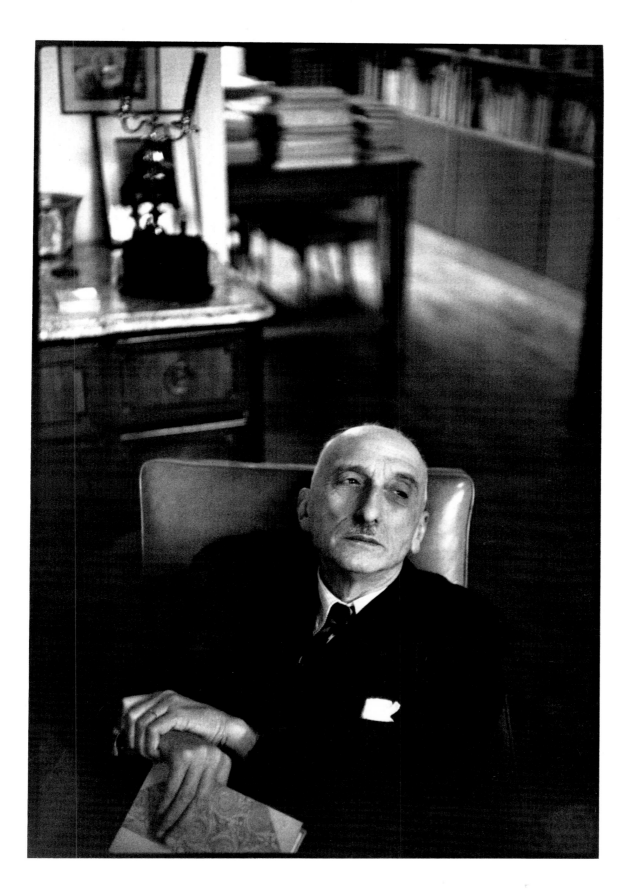

François Mauriac

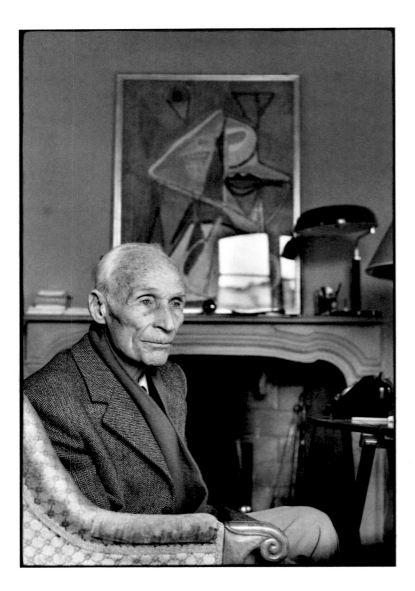

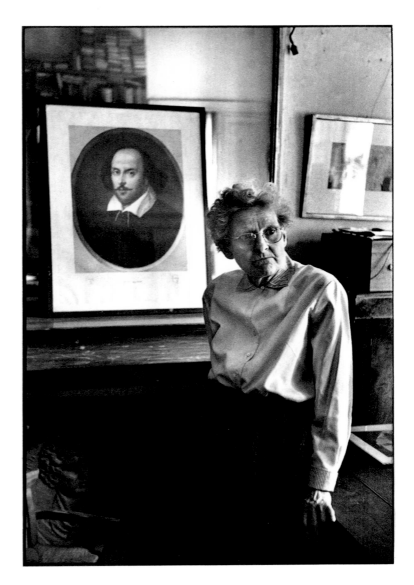

Bram Van Velde Sylvia Beach

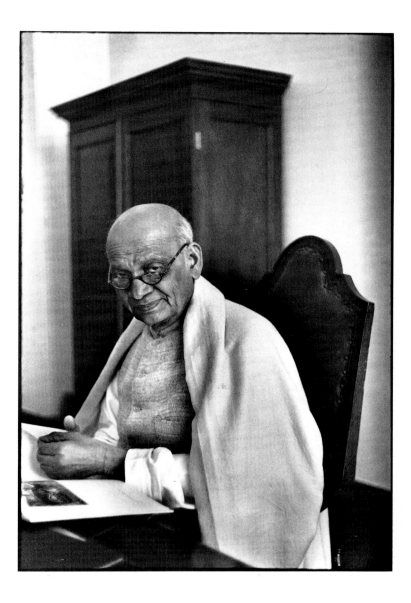

Vallabhbhai Jhaverbhai Patel

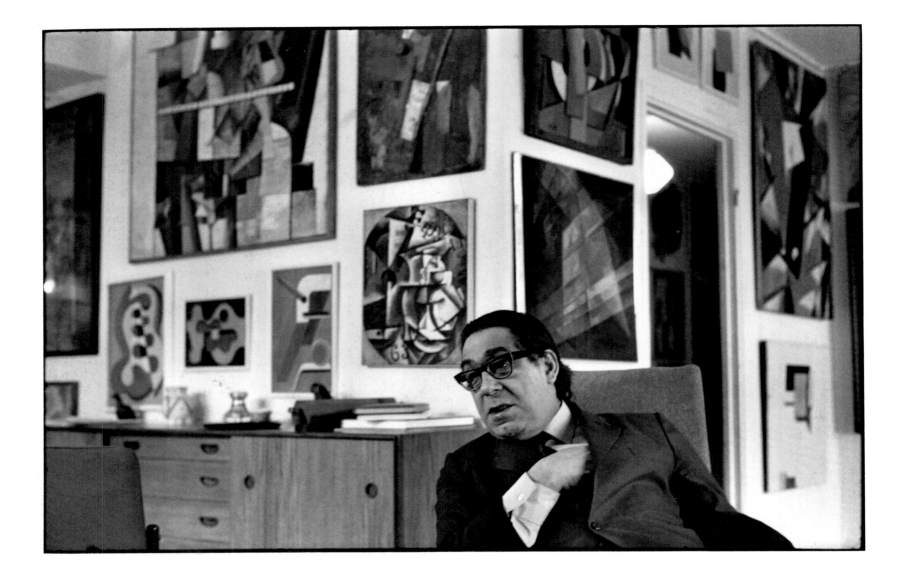

Georges Costakis

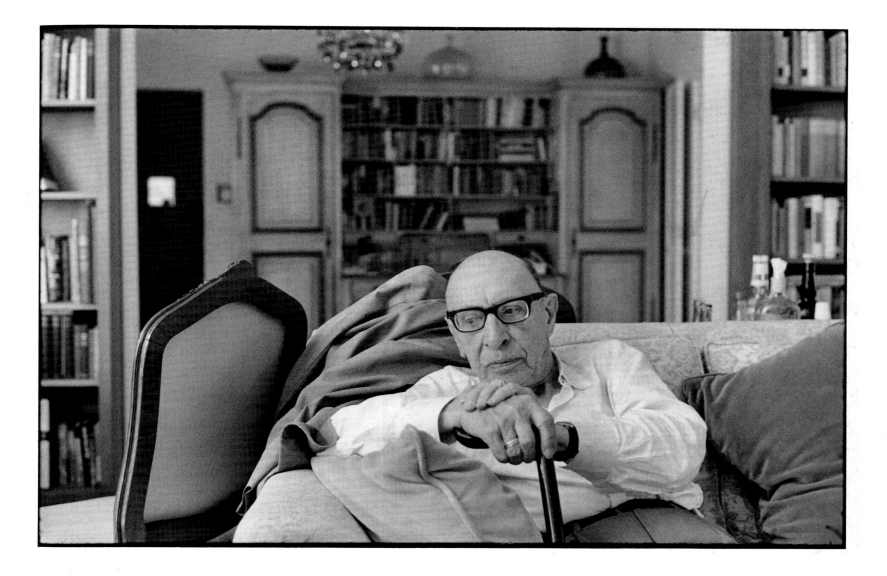

Igor Stravinsky

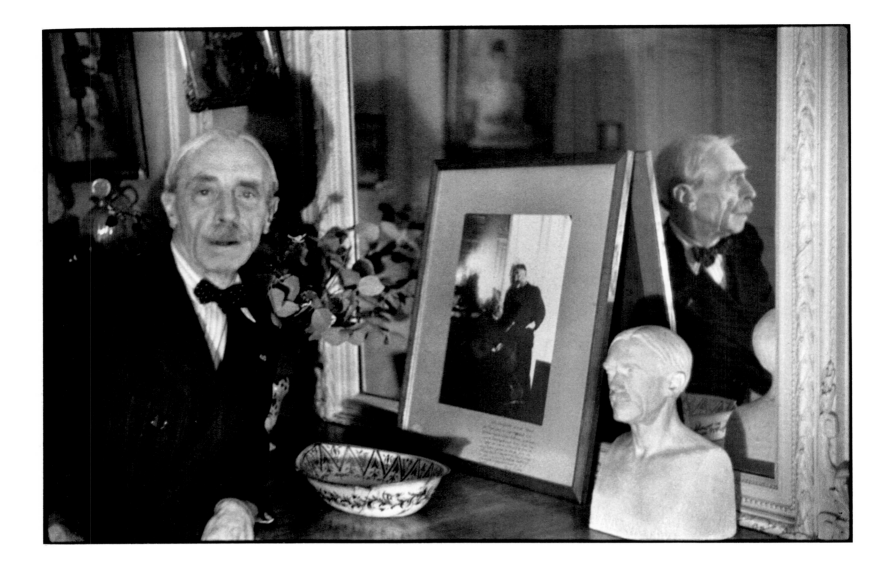

Paul Valéry

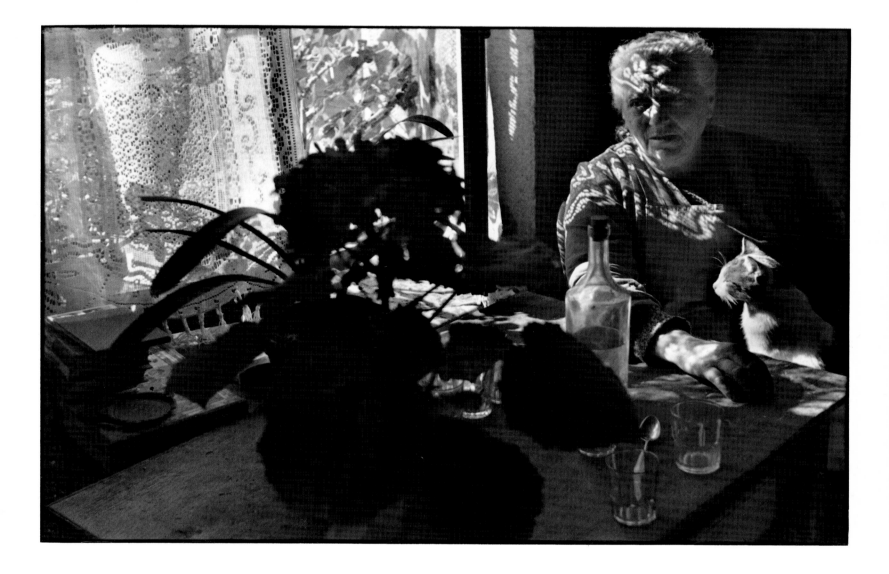

Madame Melie

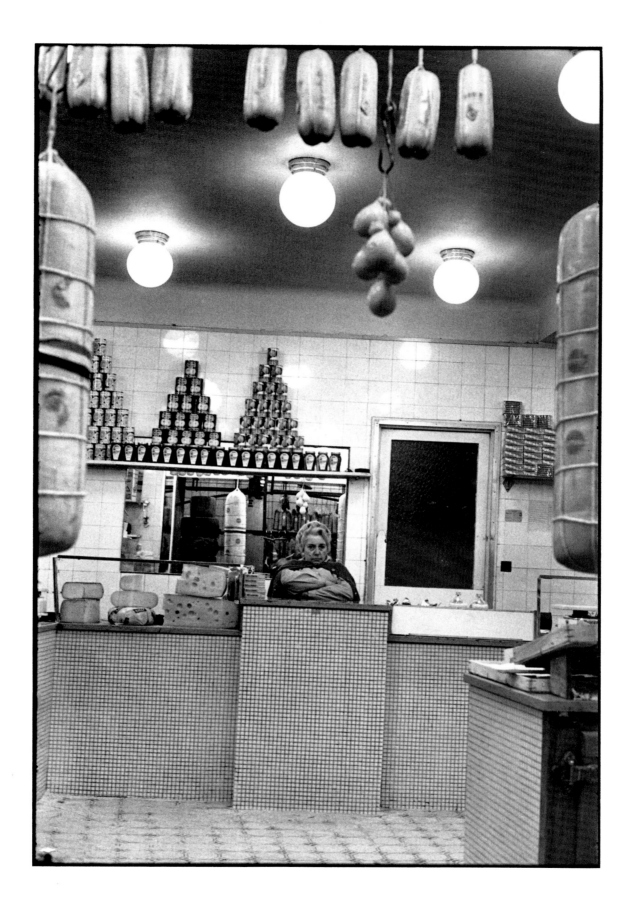

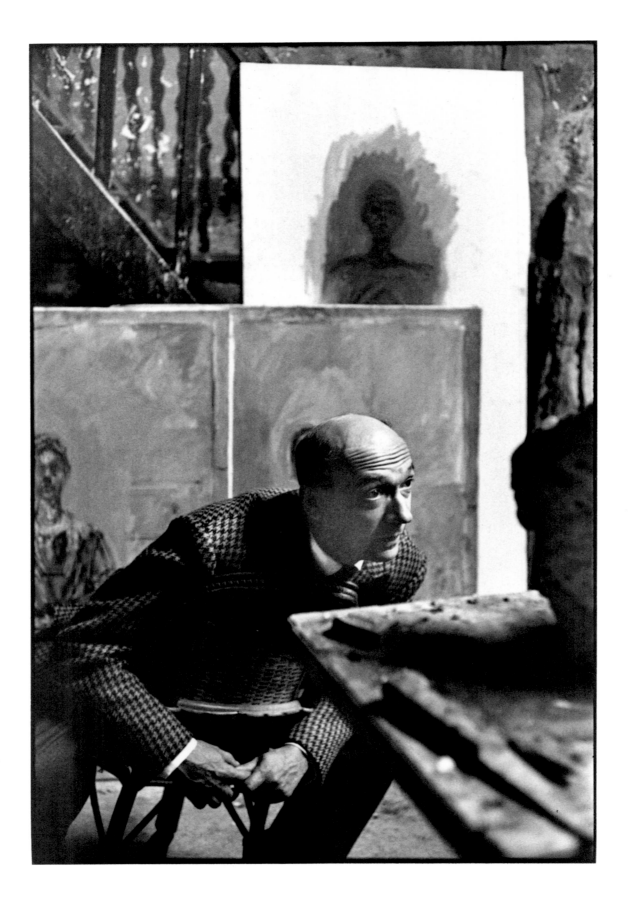

Pierre Josse

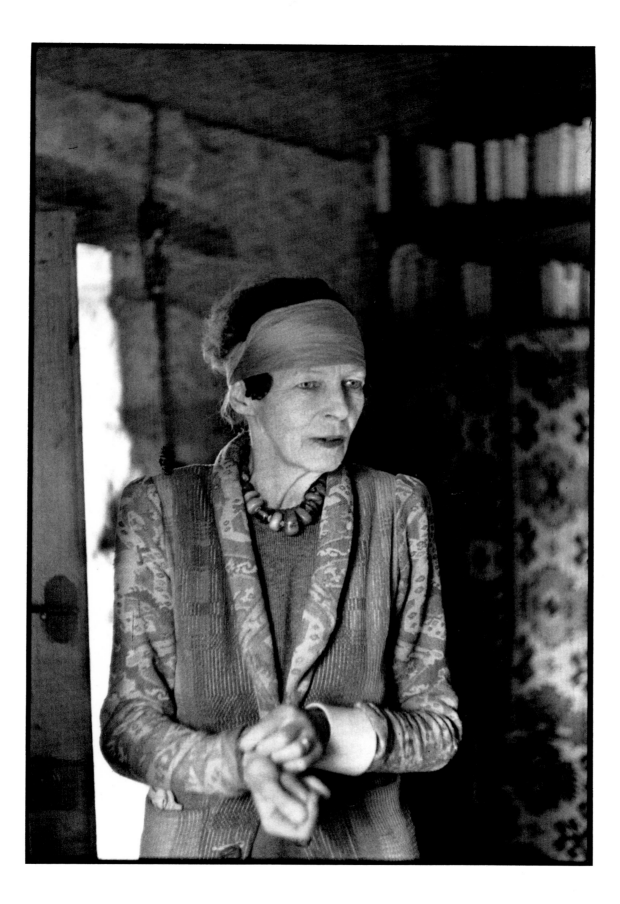

Nancy Cunard

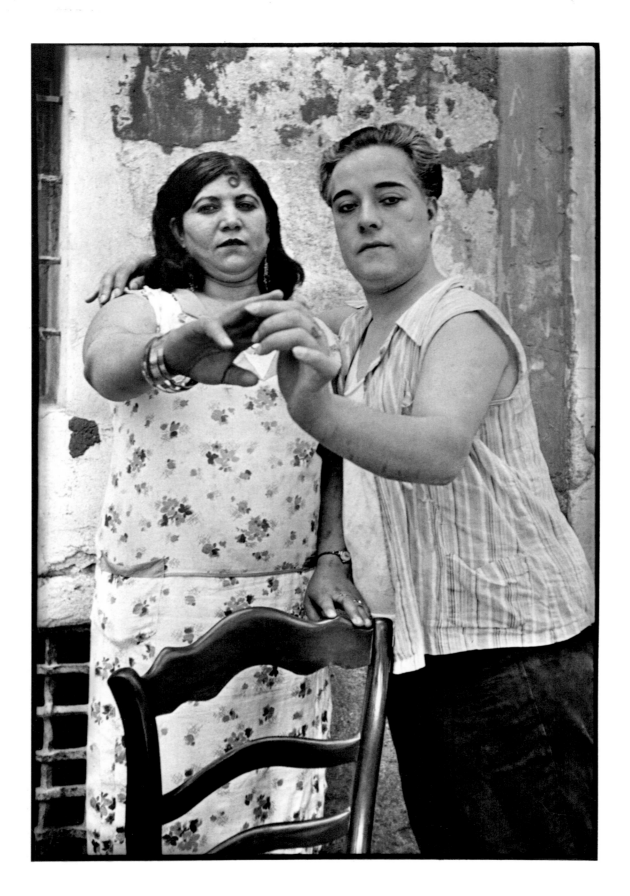

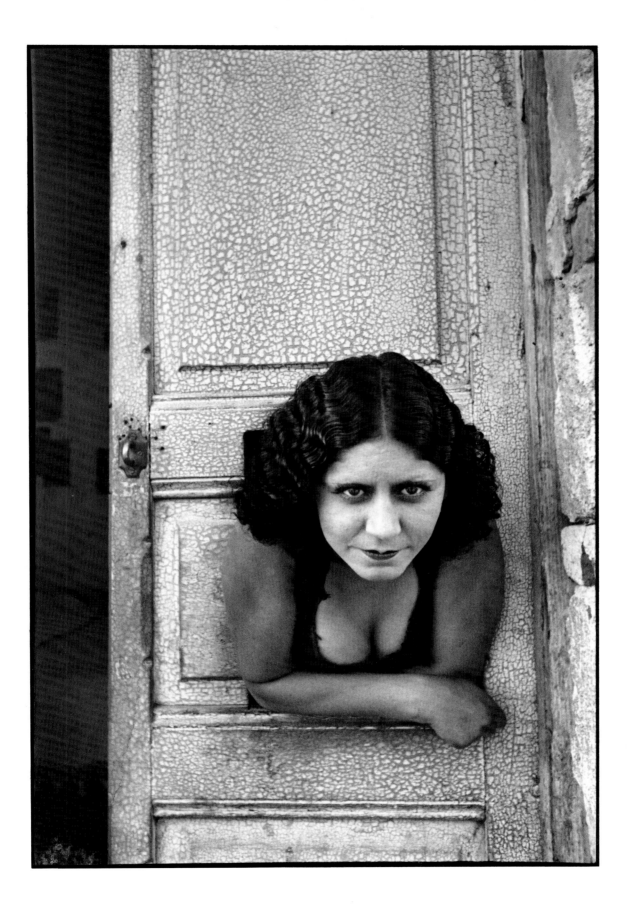

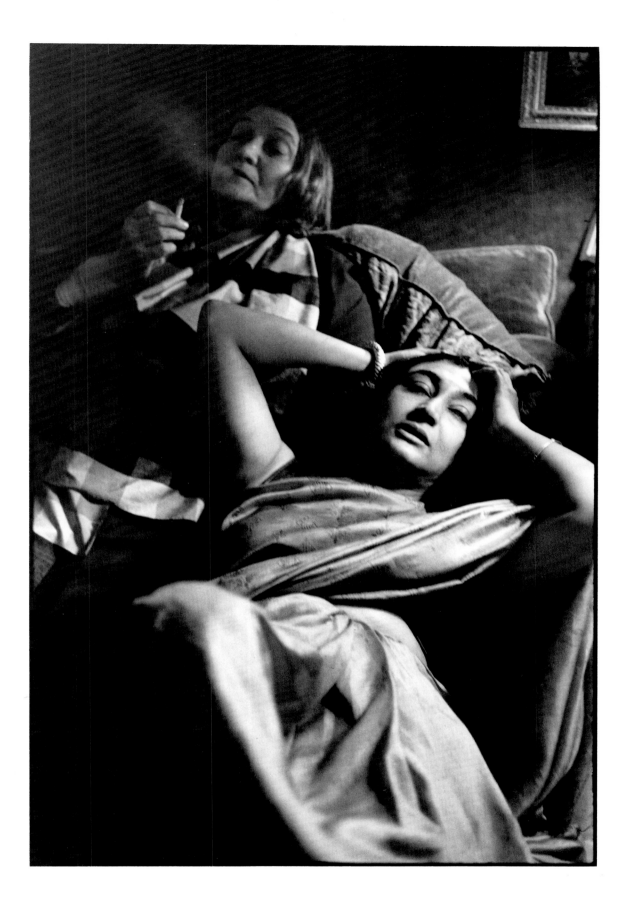

Mary Meerson, Krishna Riboud

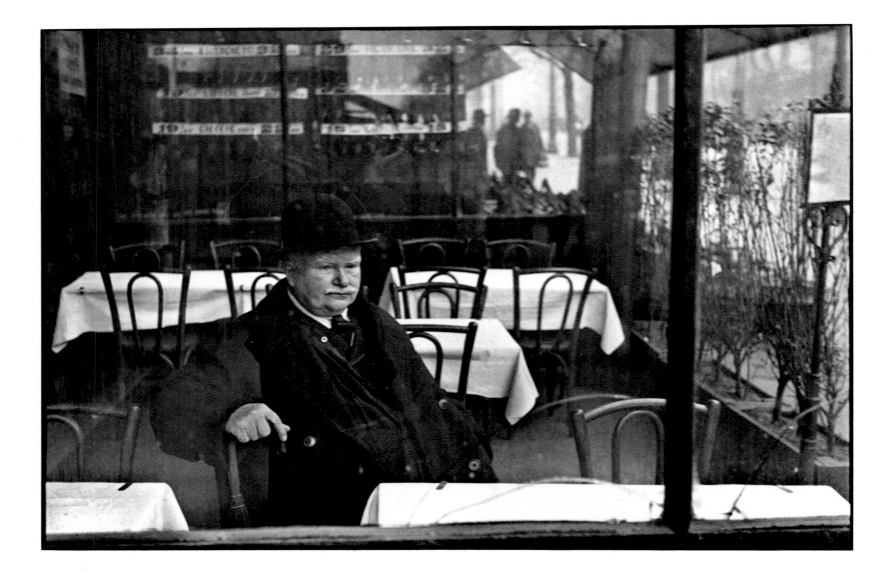

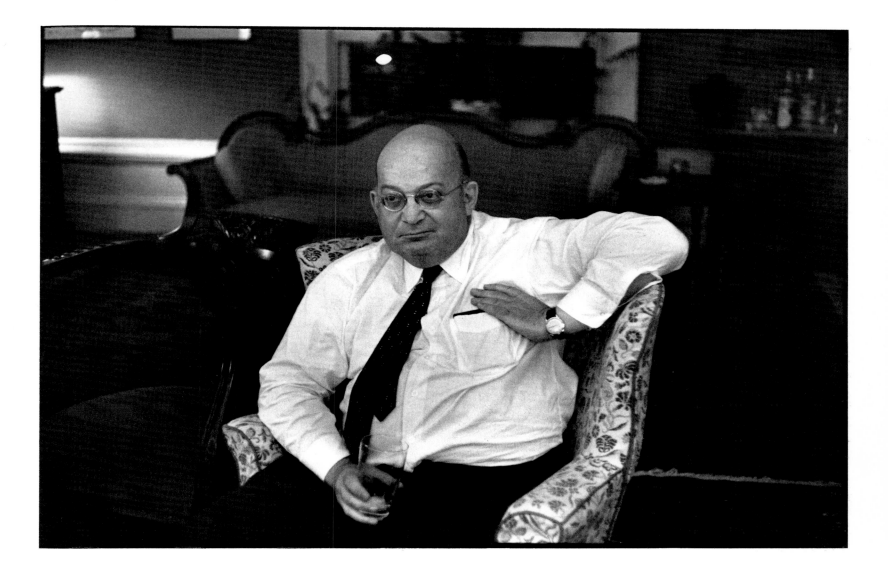

Joe Liebling

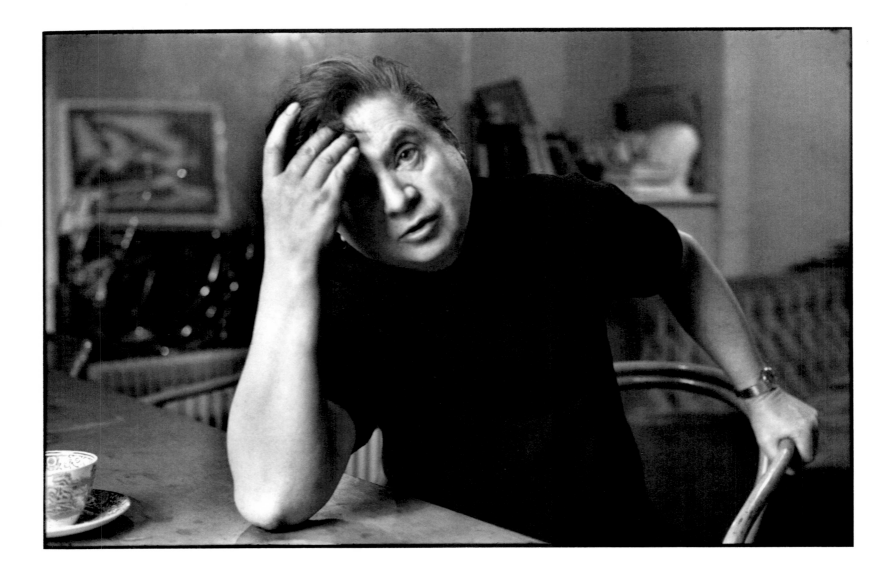

Francis Bacon

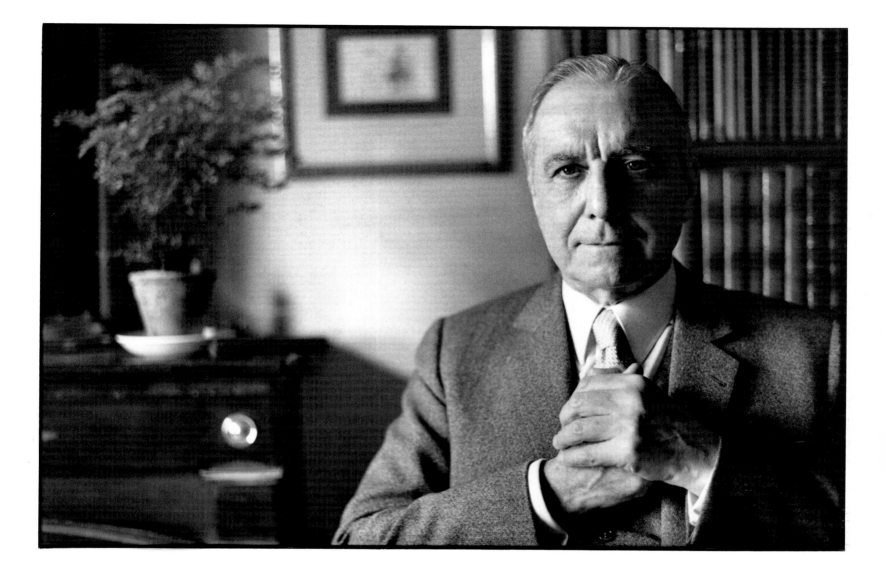

Julien Green

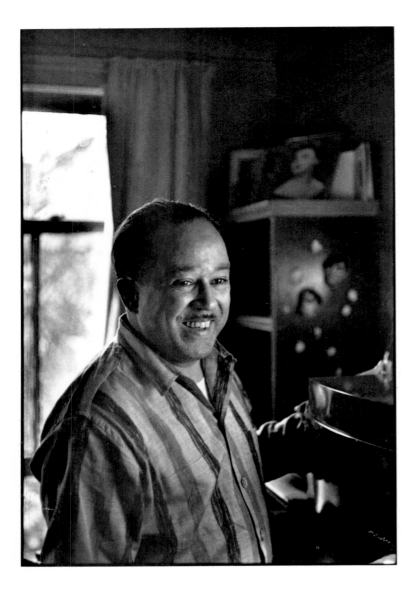

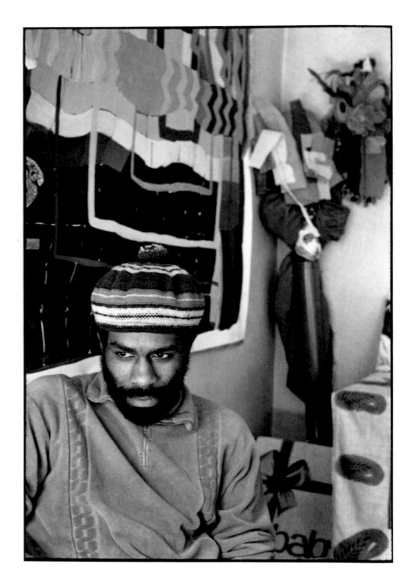

Langstone Hughes

William Melvin Kelley

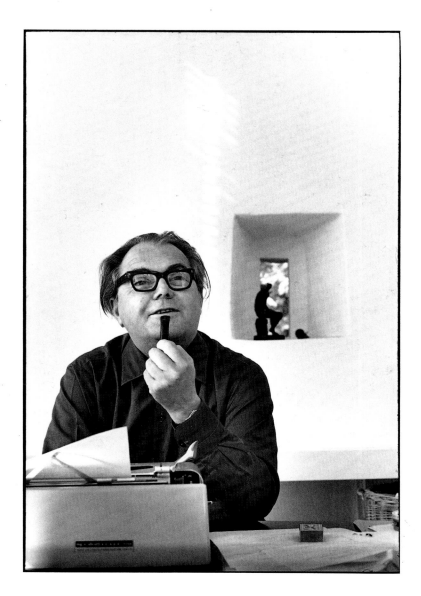

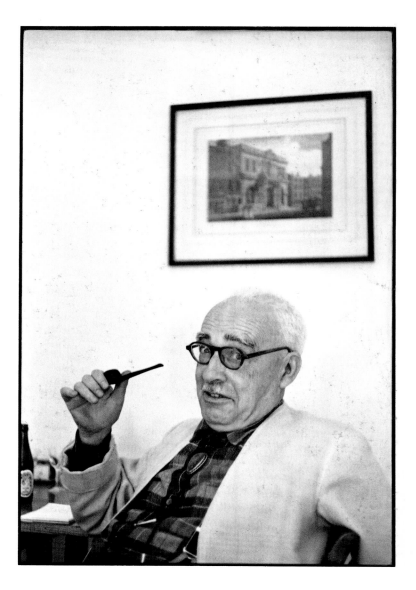

Max Frisch

Frank O'Connor

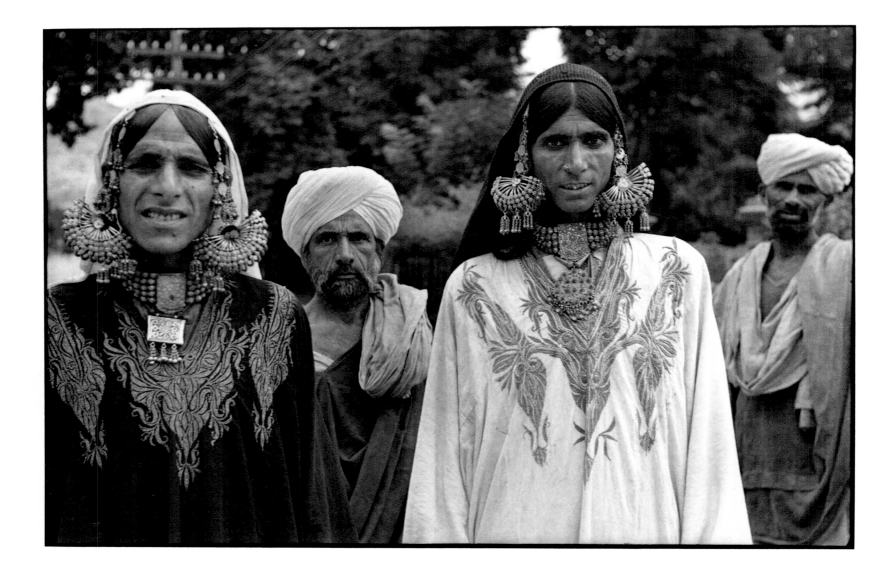

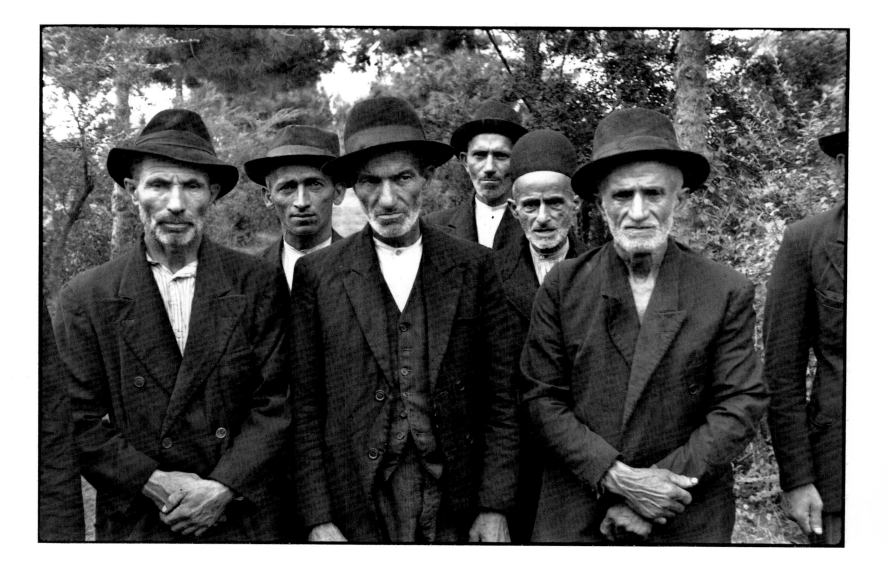

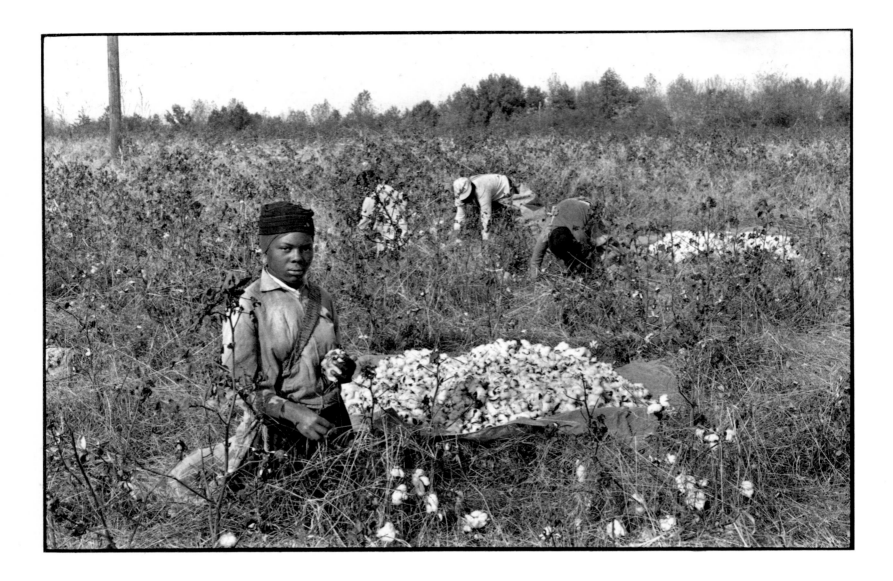

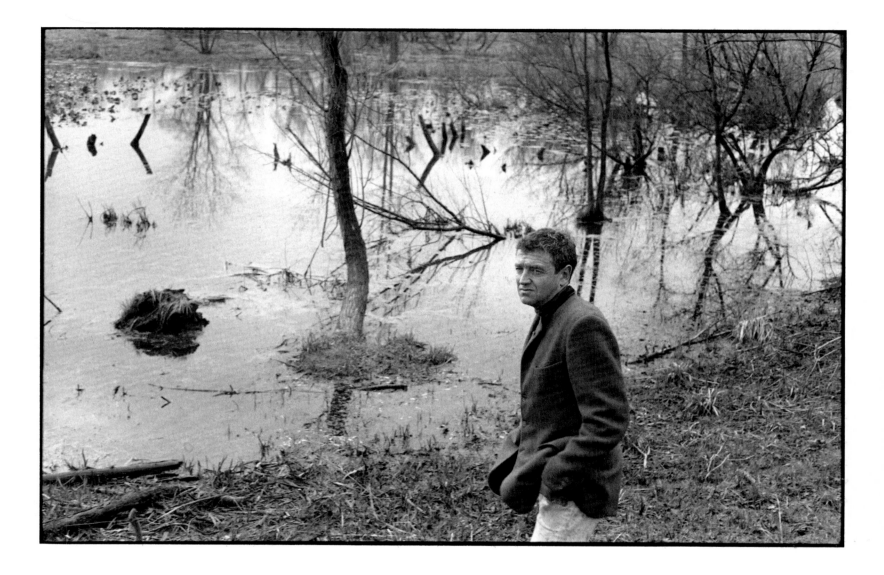

Andrew Wyeth

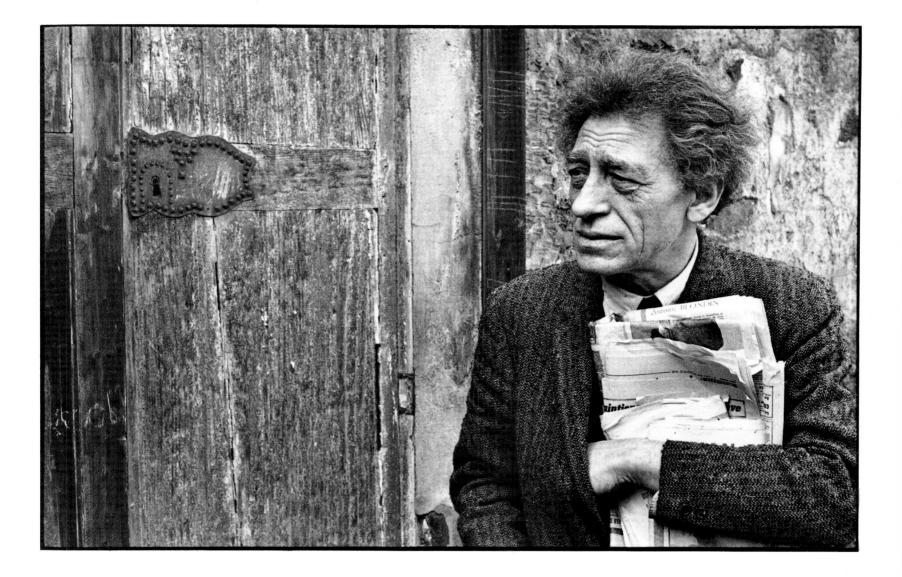

Alberto Giacometti

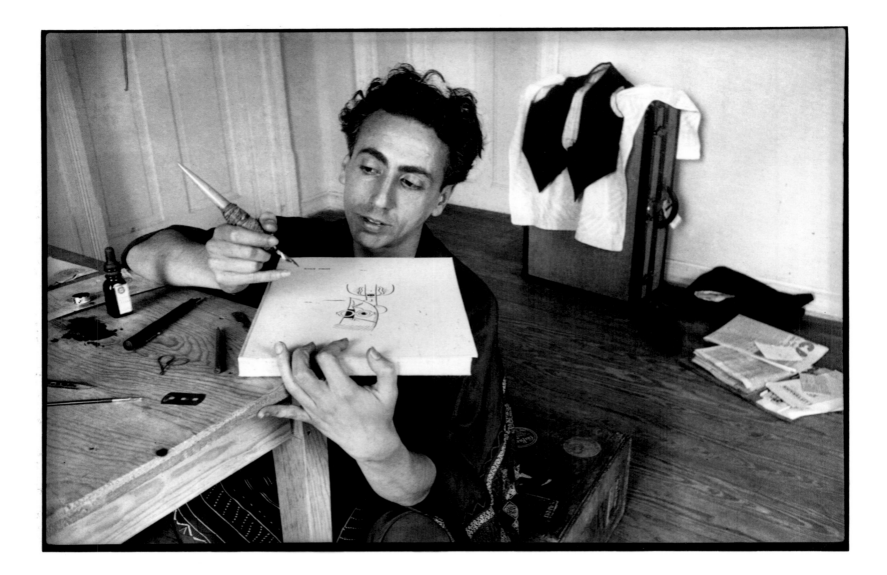

Tonio Salazar

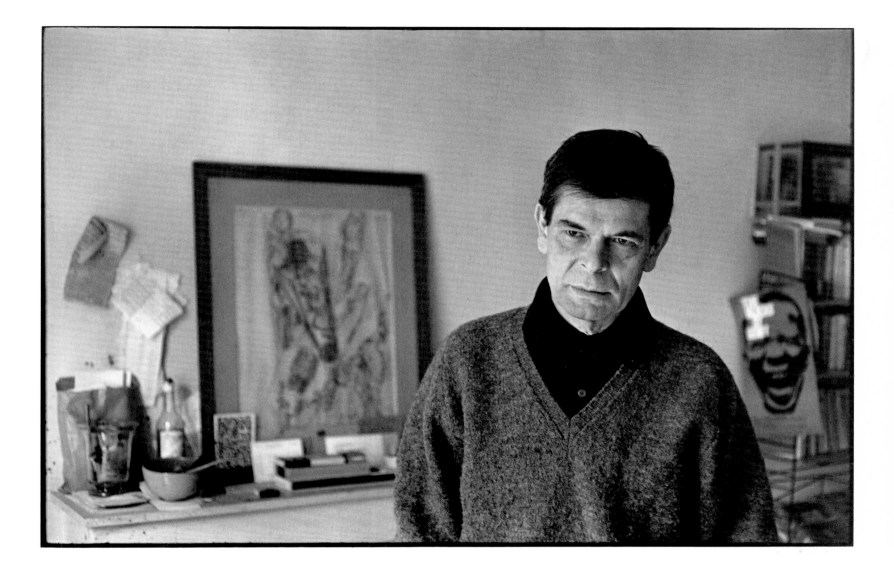

Roger Blin

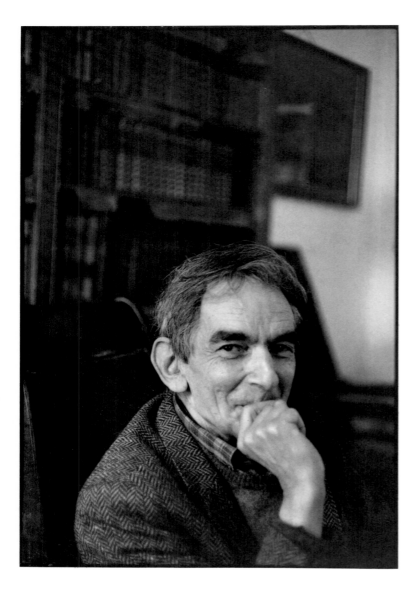

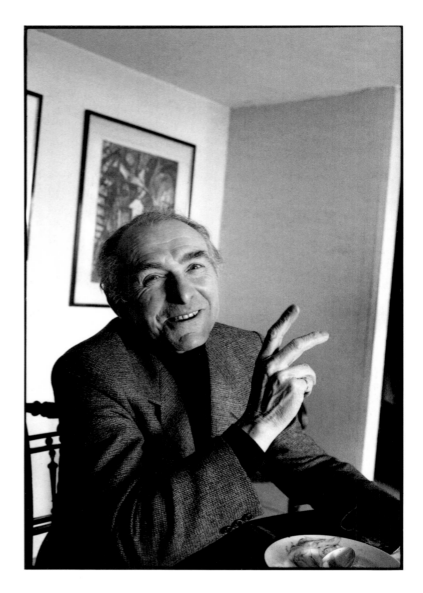

Louis-René des Forêts Robert Doisneau

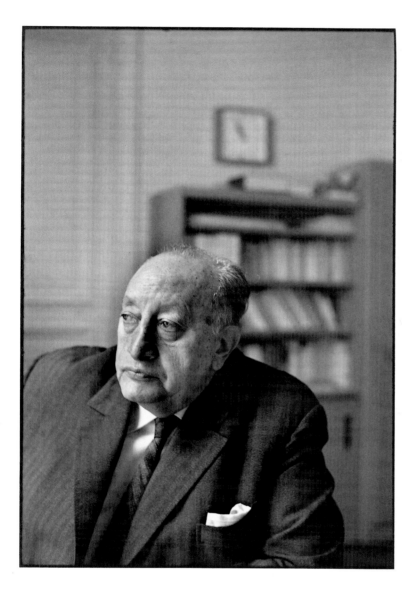

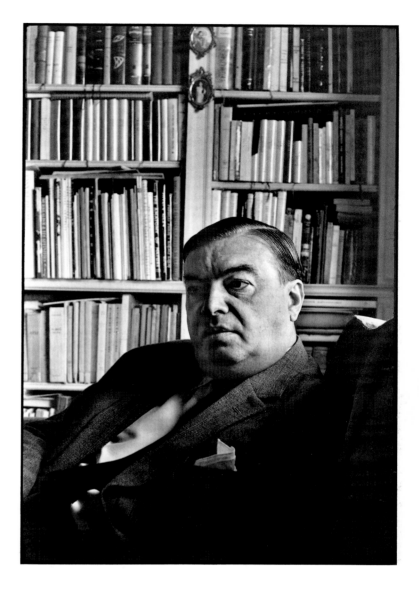

Miguel Angel Asturias

Roger Caillois

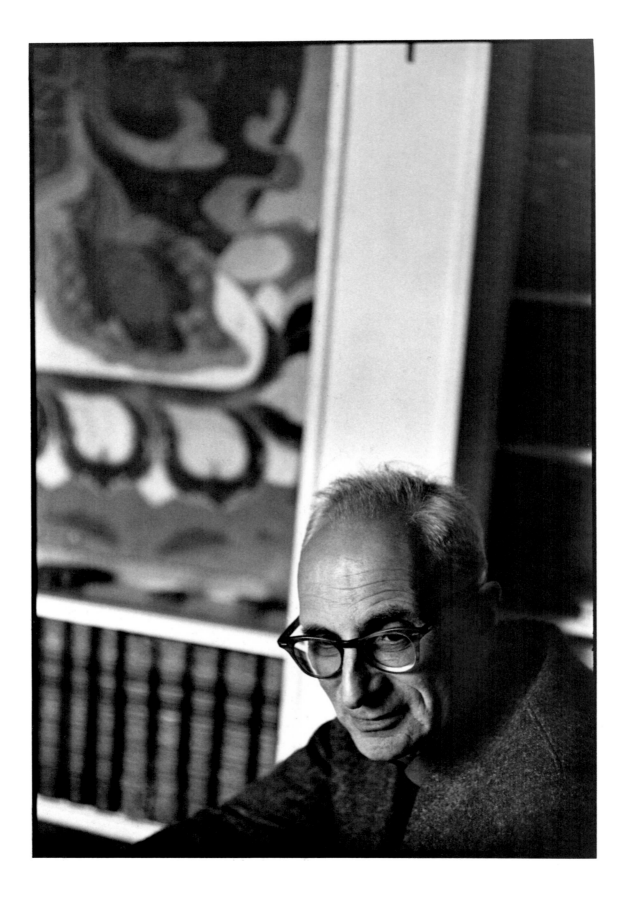

Claude Lévi-Strauss

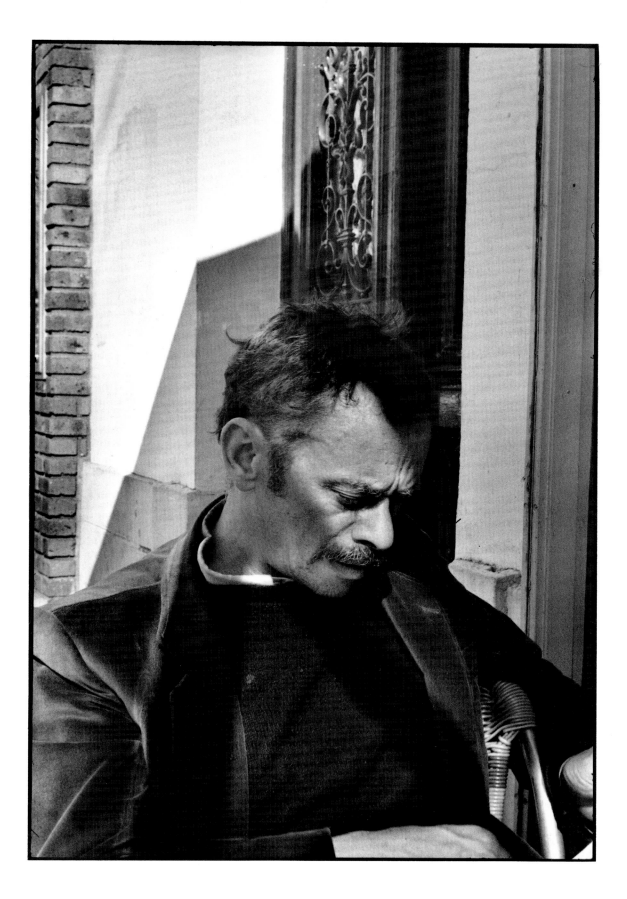

Sam Szafran

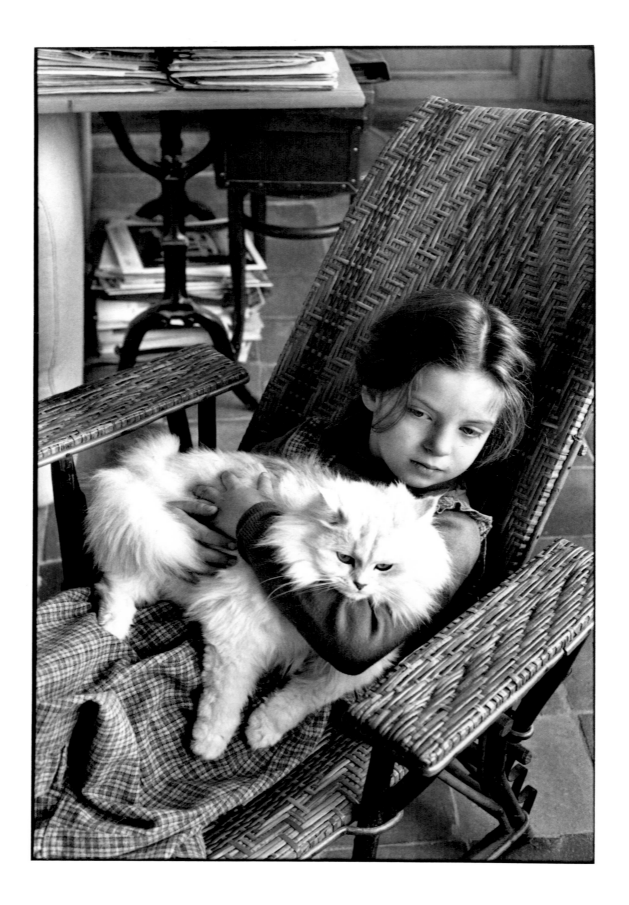

Mélanie Cartier-Bresson

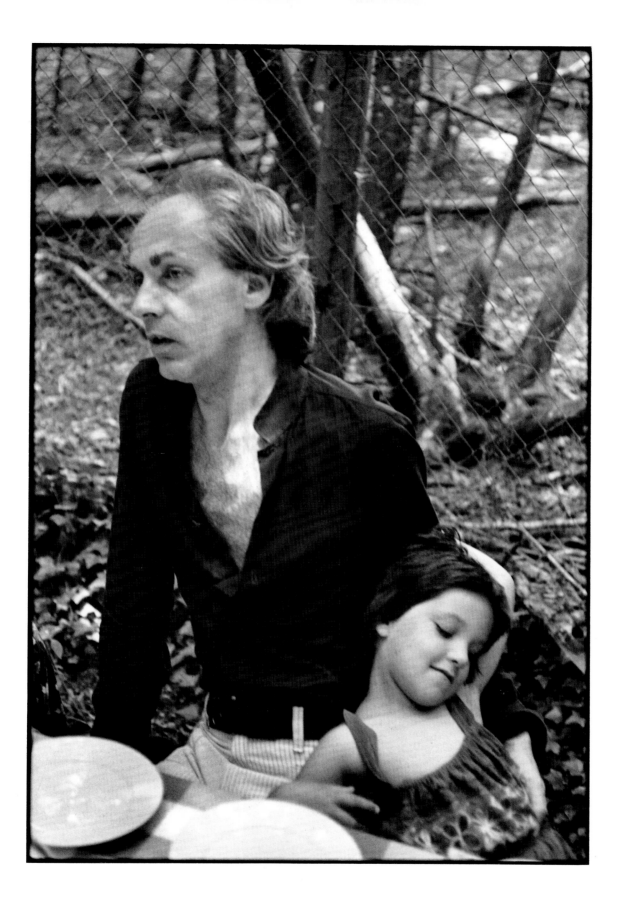

Jean Guillou

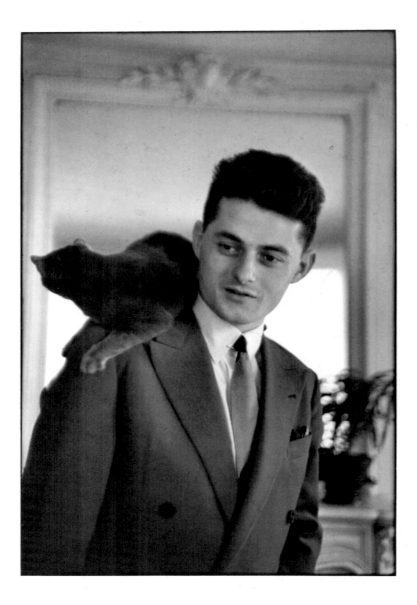

Roger Nimier

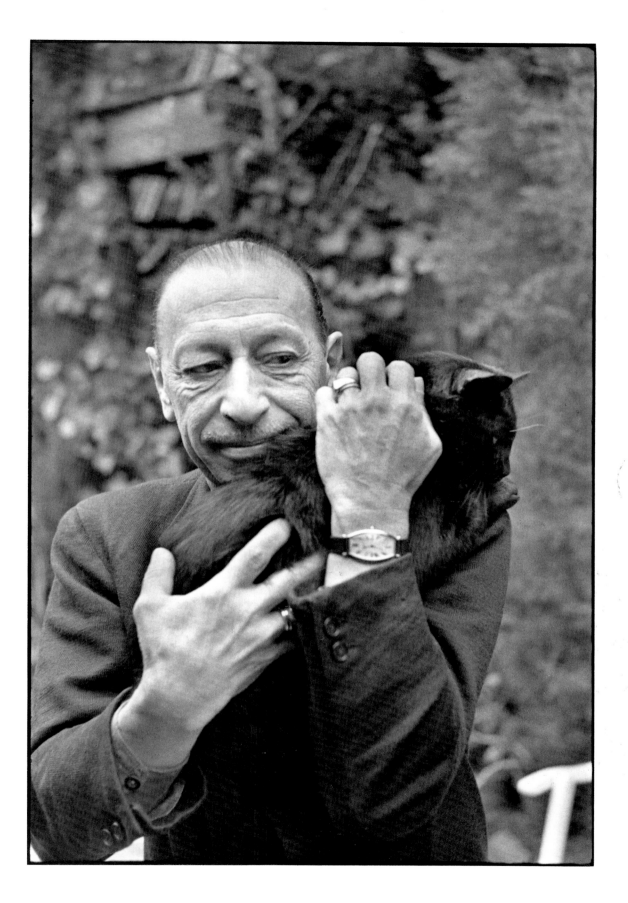

Igor Stravinsky

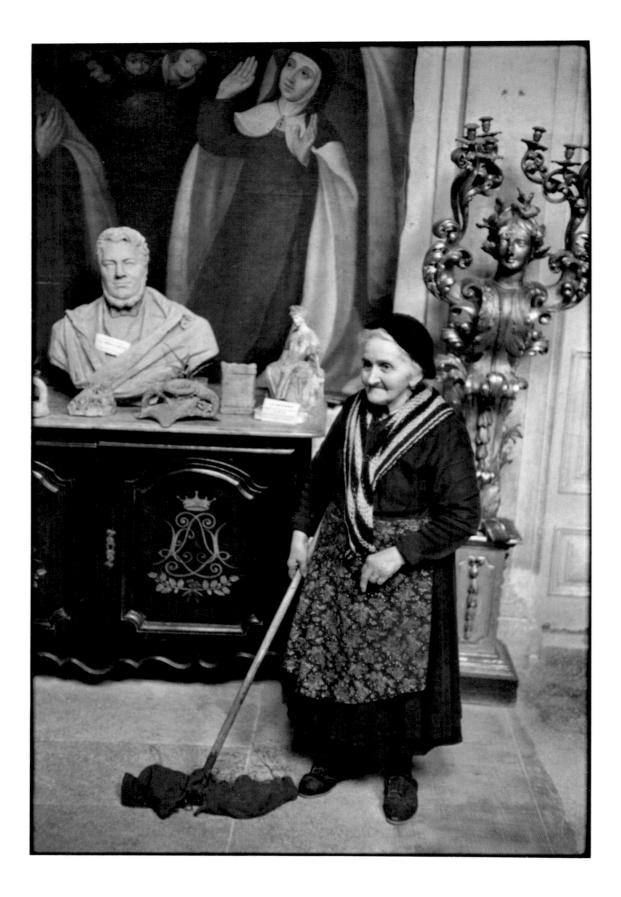

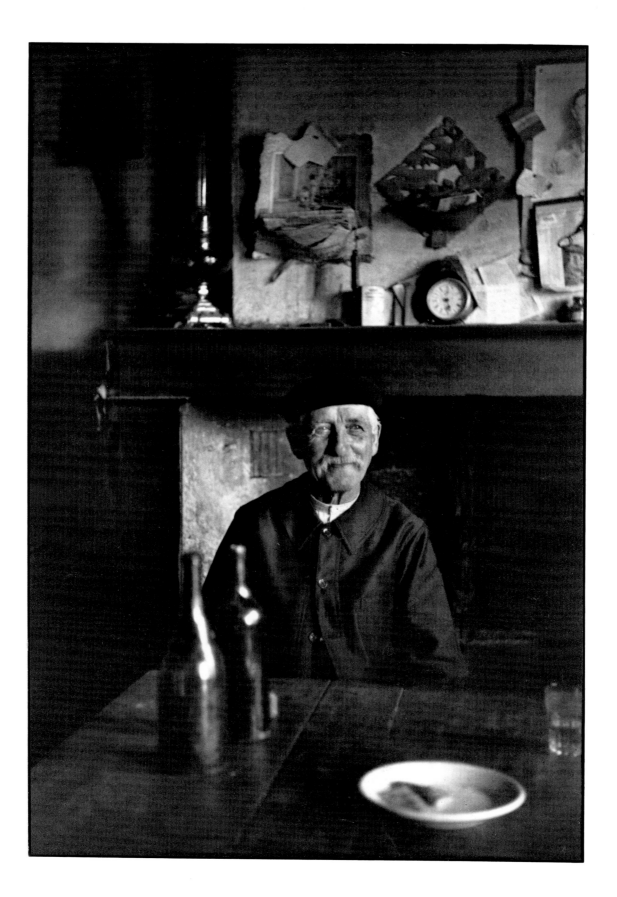

«Le baron»

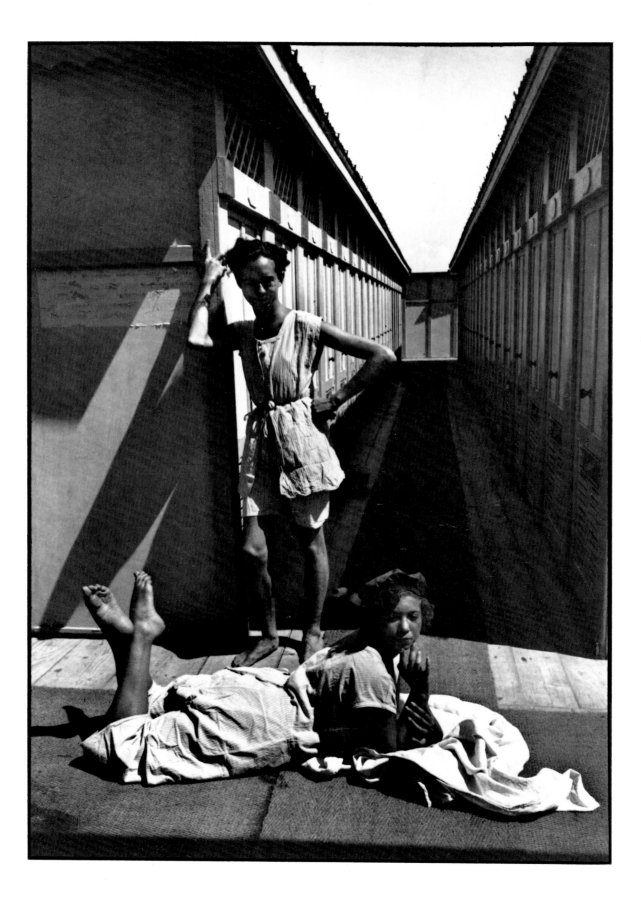

Léonor Fini, André Pieyre de Mandiargues

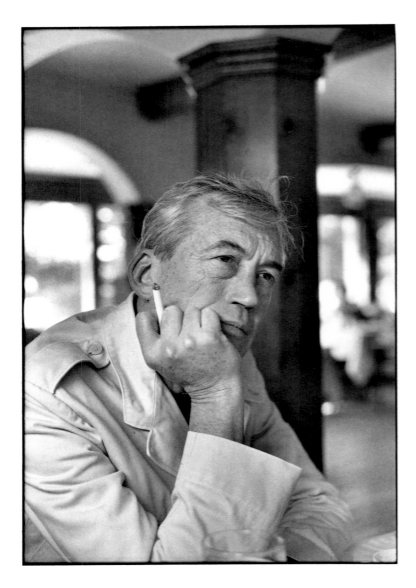 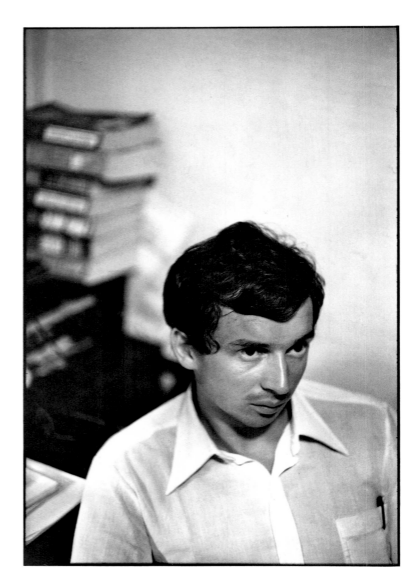

John Huston Jean-Pierre Beltoise

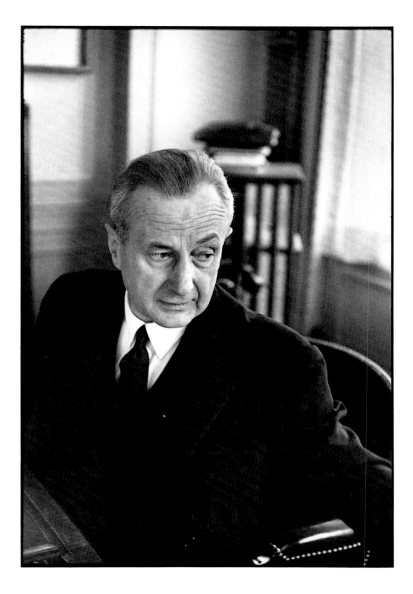

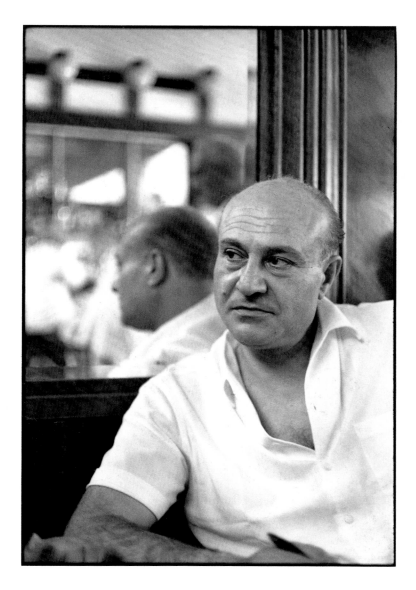

Hubert Beuve-Méry

Odysseus Elytis

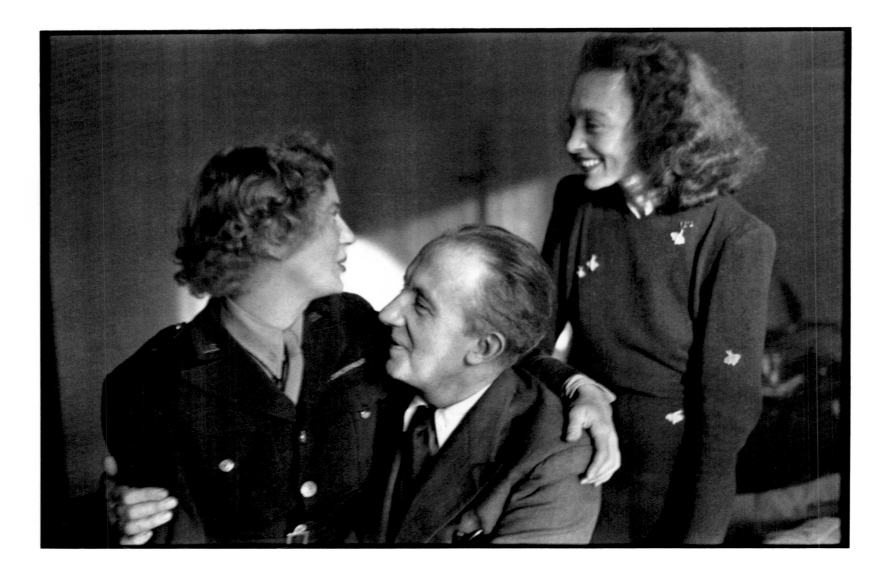

Paul Eluard, Nusch Eluard, Lee Miller

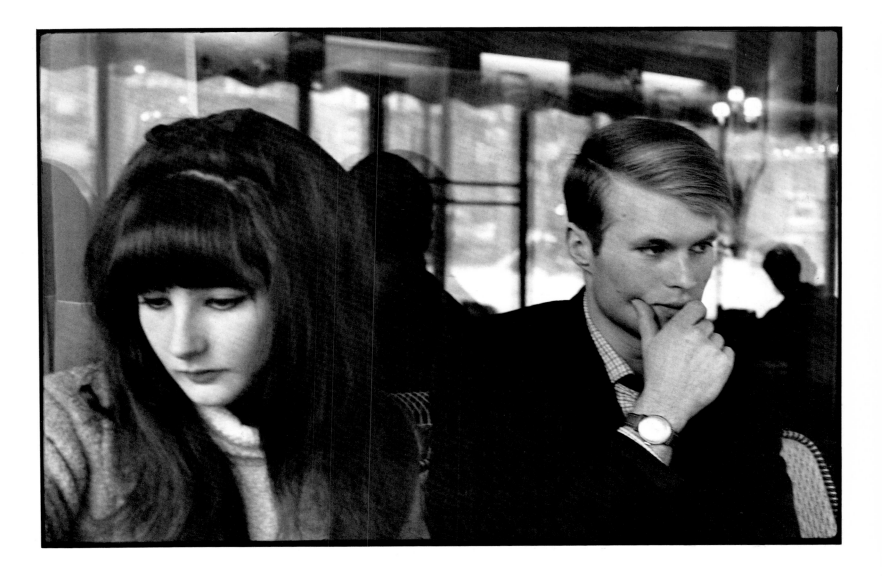

J.M.G. Le Clézio

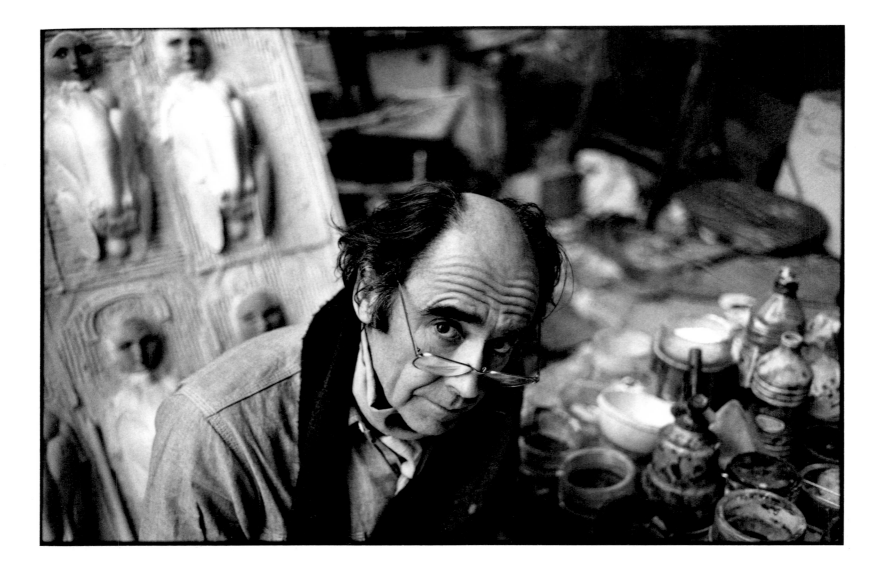

Louis Pons

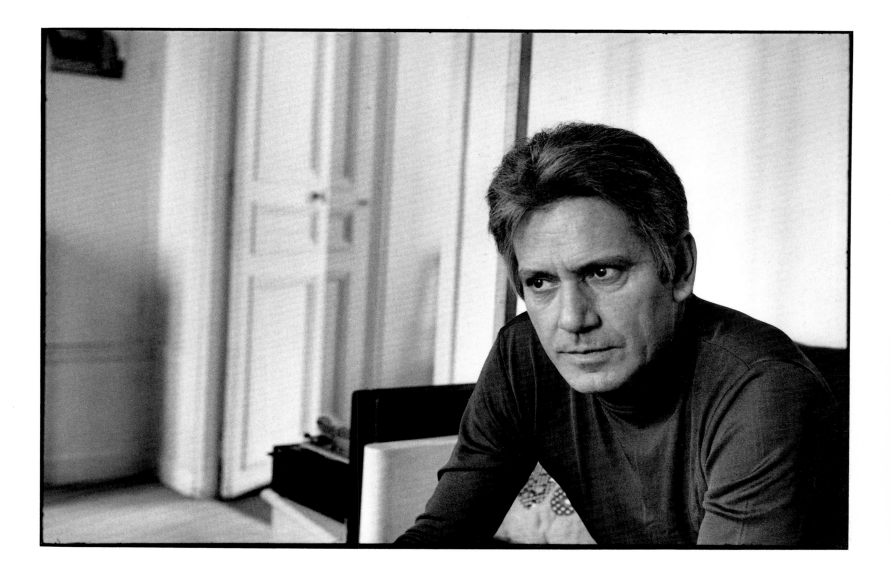

Jorge Semprun

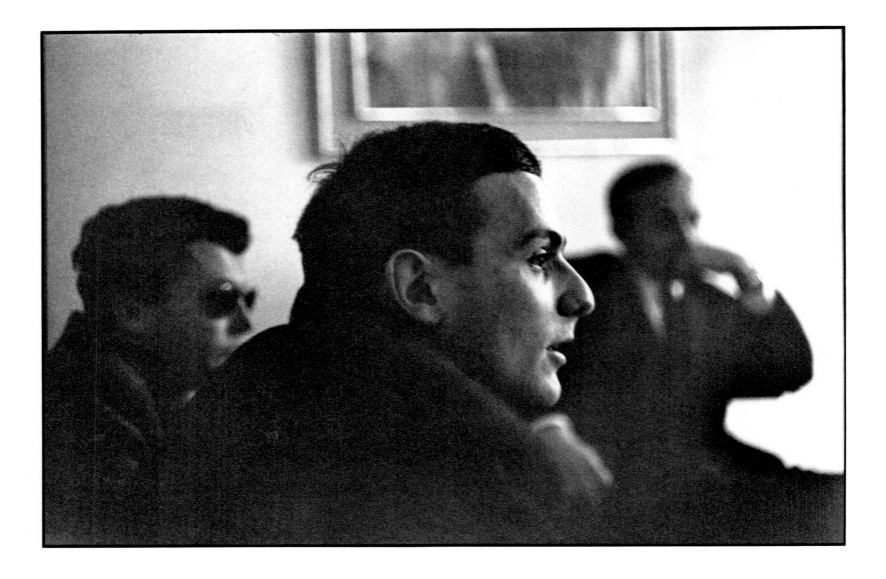

Philippe Sollers

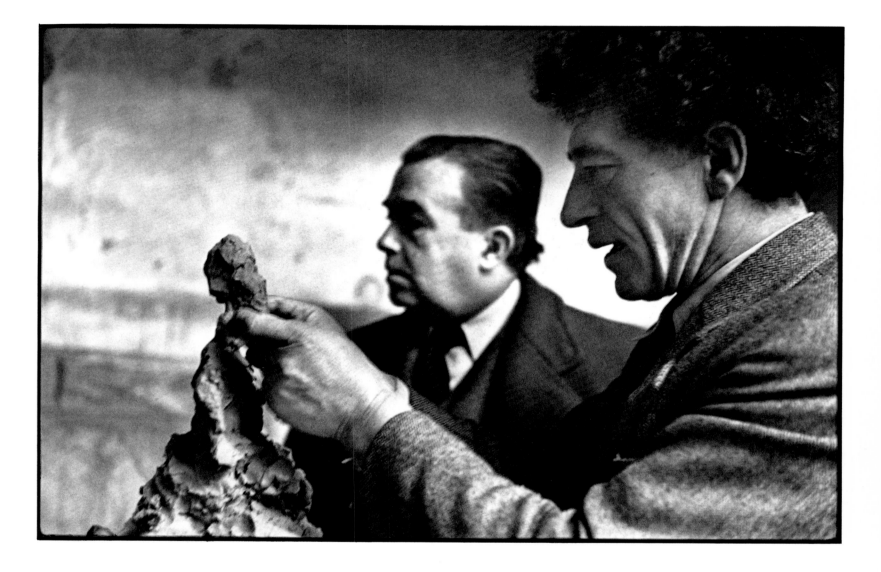

Alberto Giacometti, Tériade

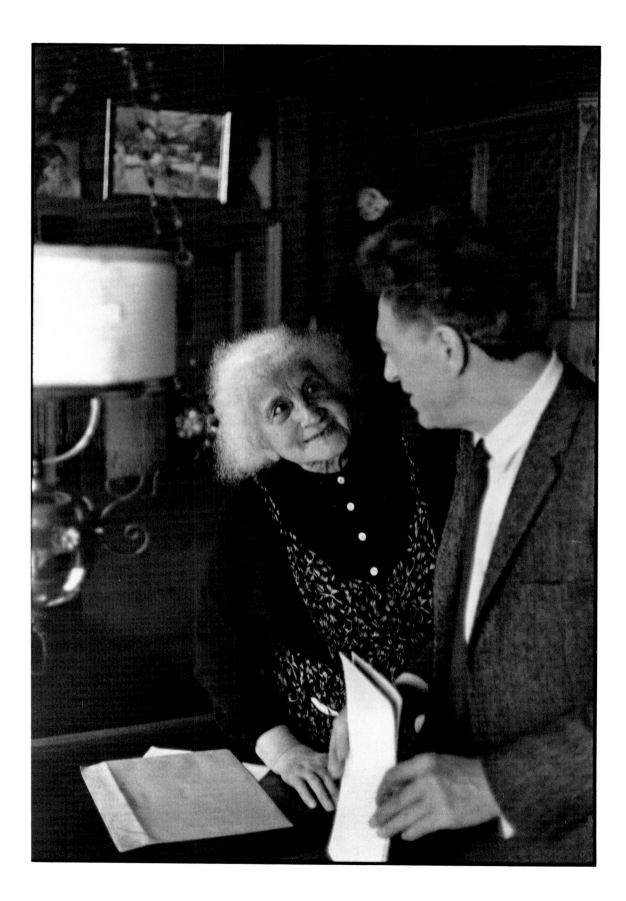

Annetta Giacometti, Alberto Giacometti

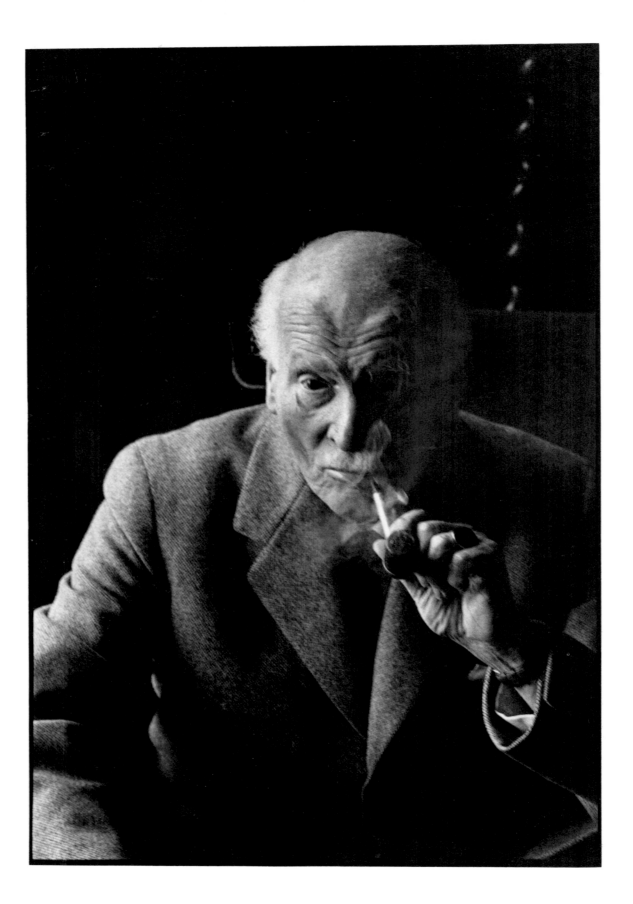

Carl Gustav Jung

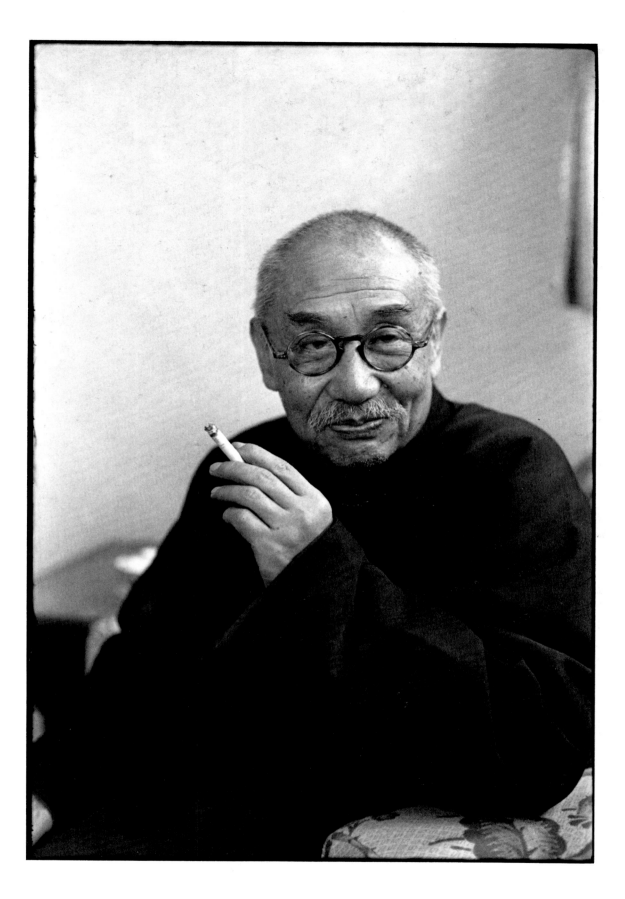

Yen Si Chan

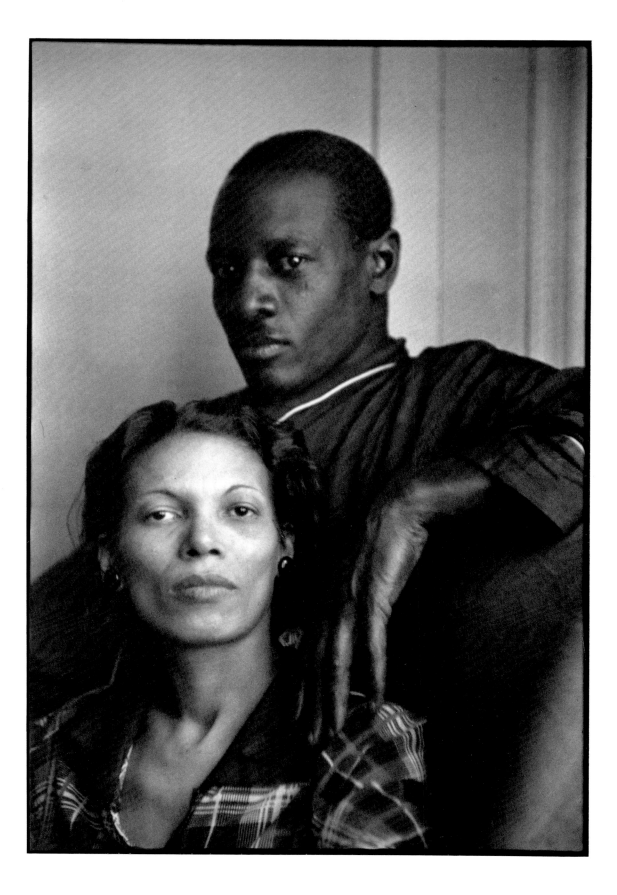

Jo

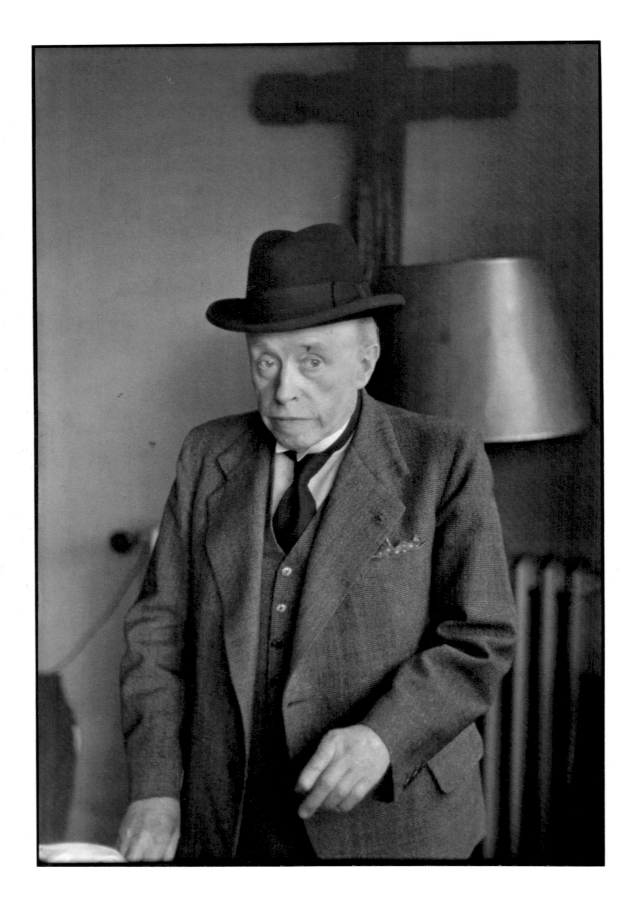

Georges Rouault

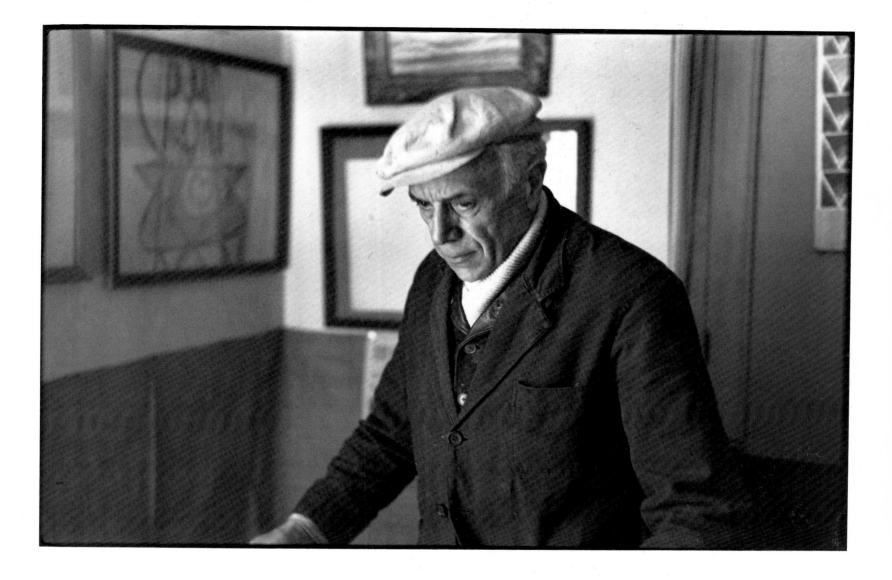

Georges Braque

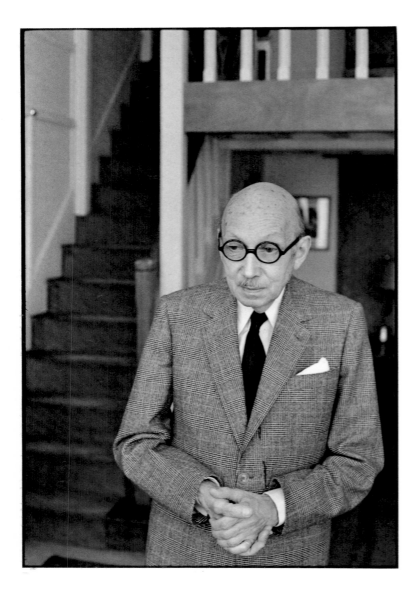 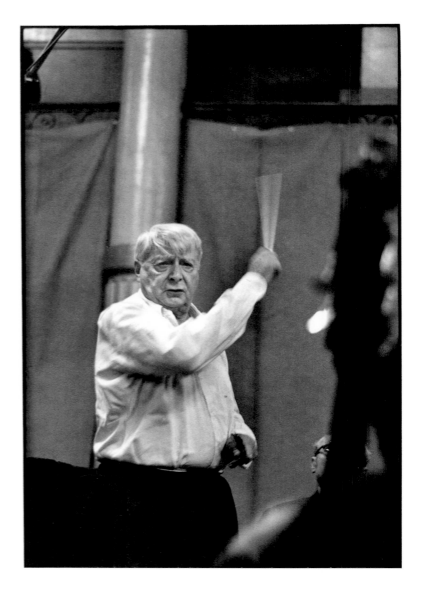

Pierre Jean Jouve Charles Munch

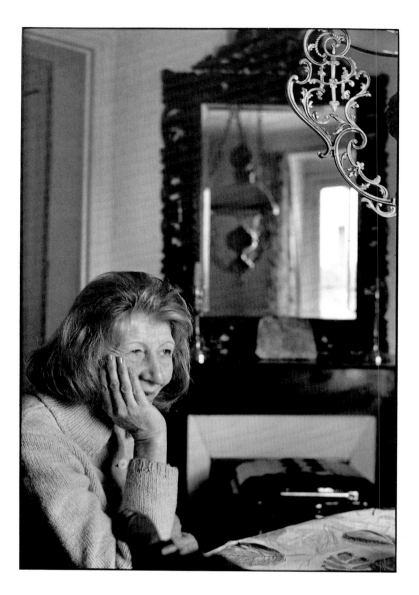

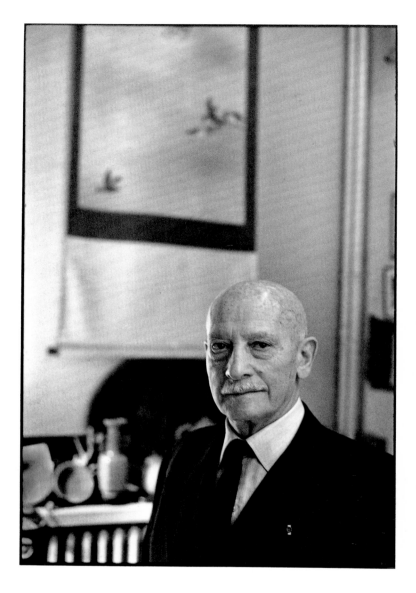

Violette Leduc General Peschkoff 125

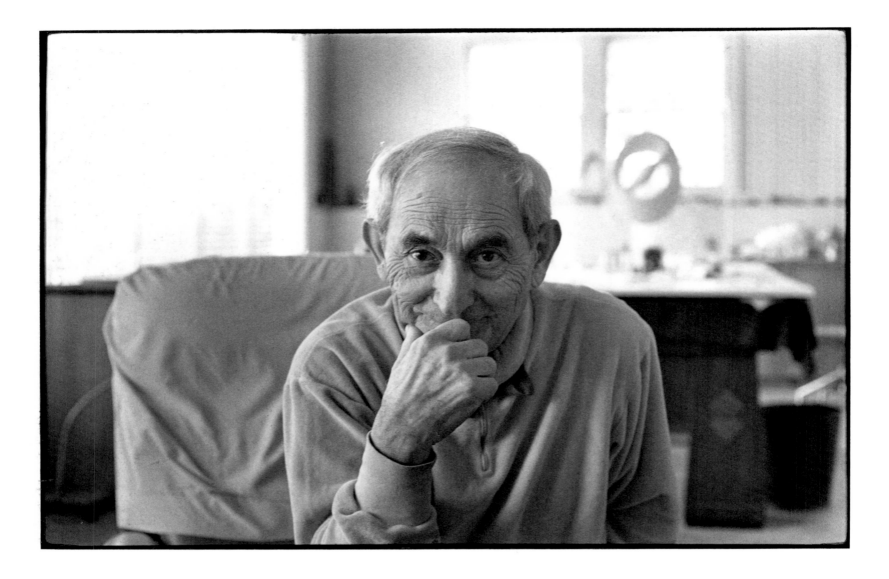

Naum Gabo

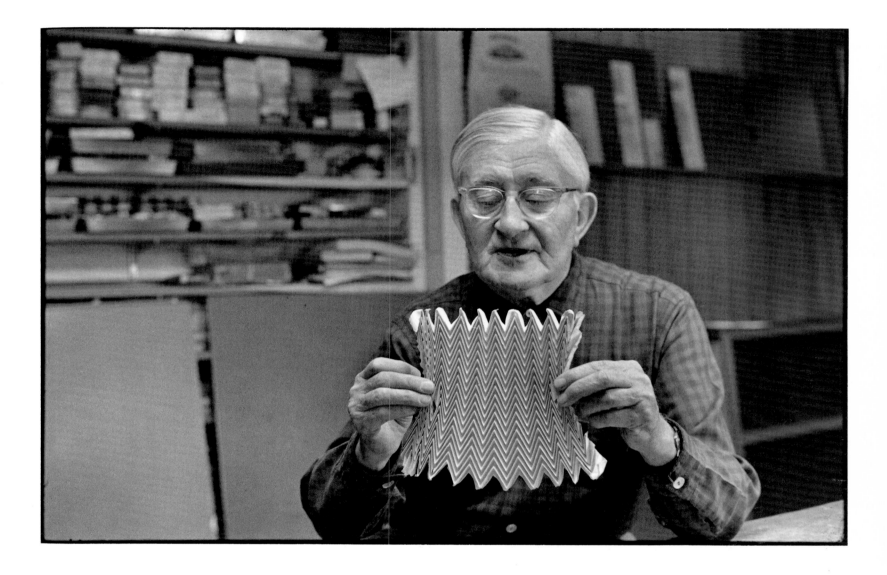

Josef Albers 127

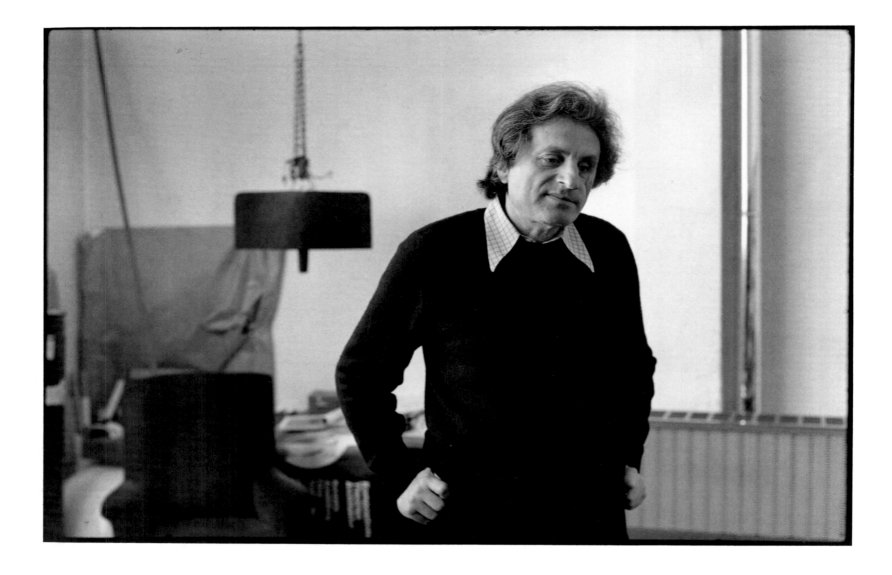

Yannis Xenakis

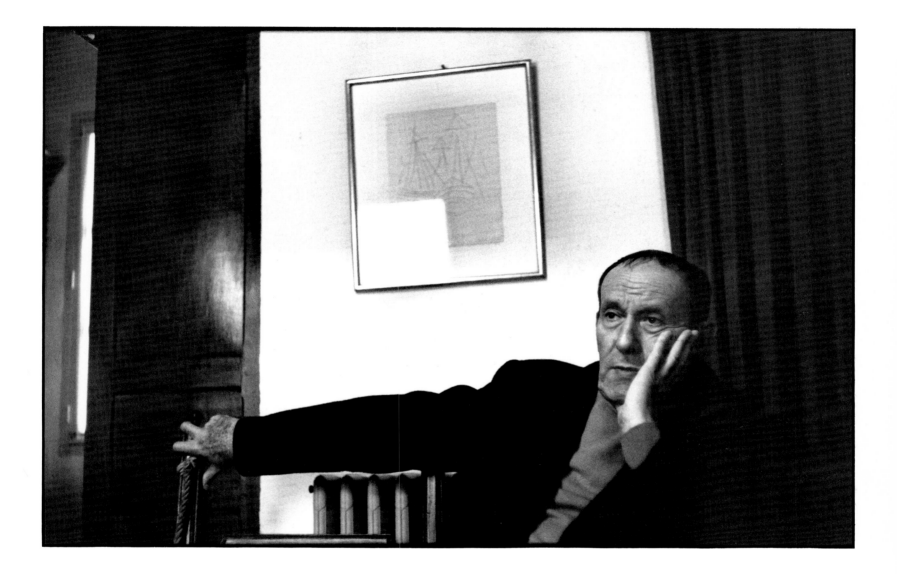

René Char

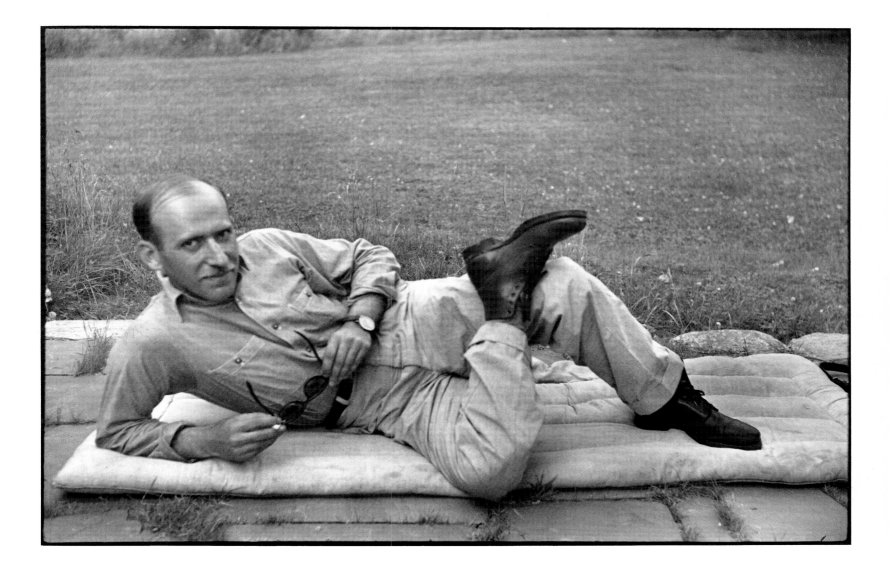

Saul Steinberg

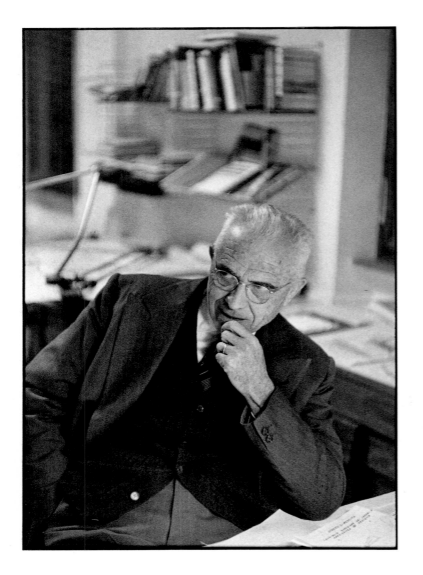

Pier Luigi Nervi

Avigdor Arikha

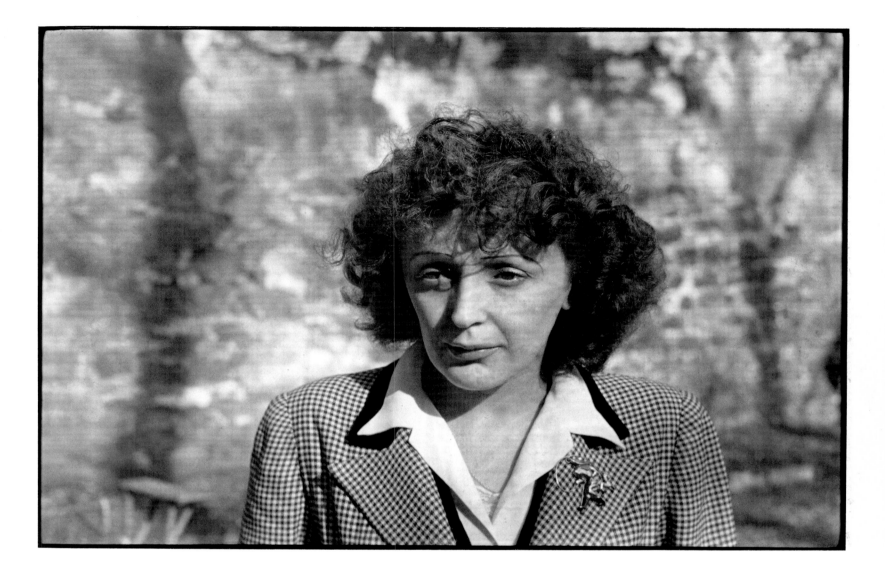

Edith Piaf

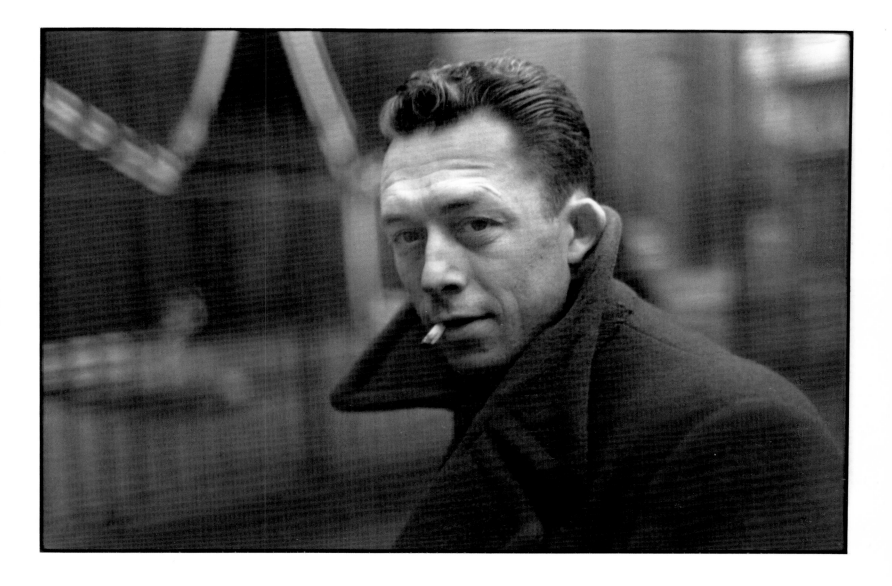

Albert Camus

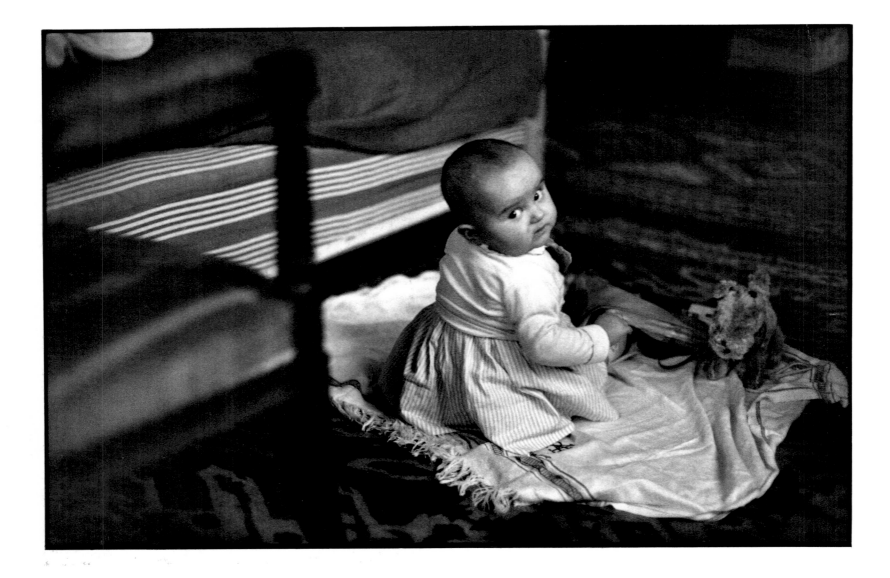

Catherine Riboud

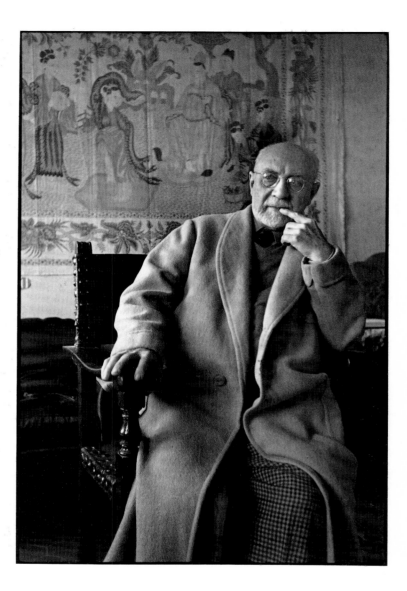

Henri Matisse

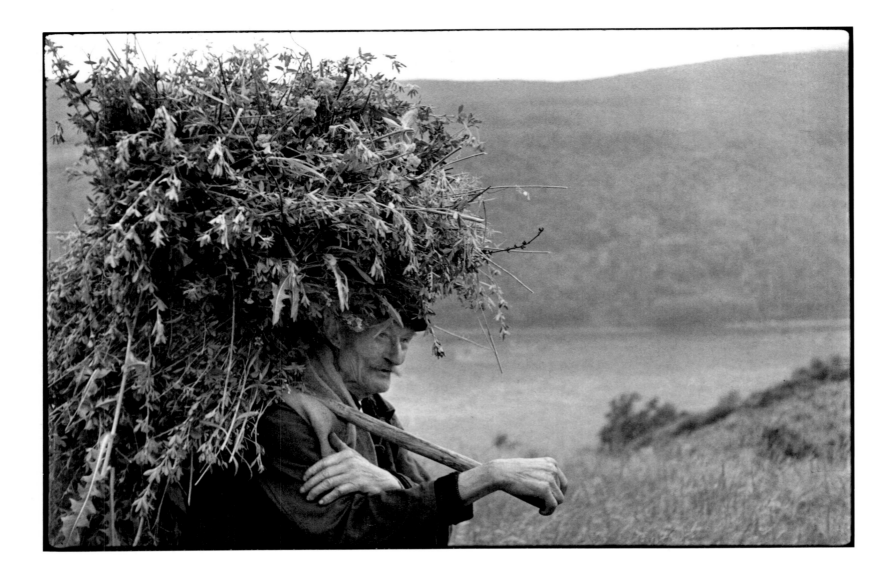

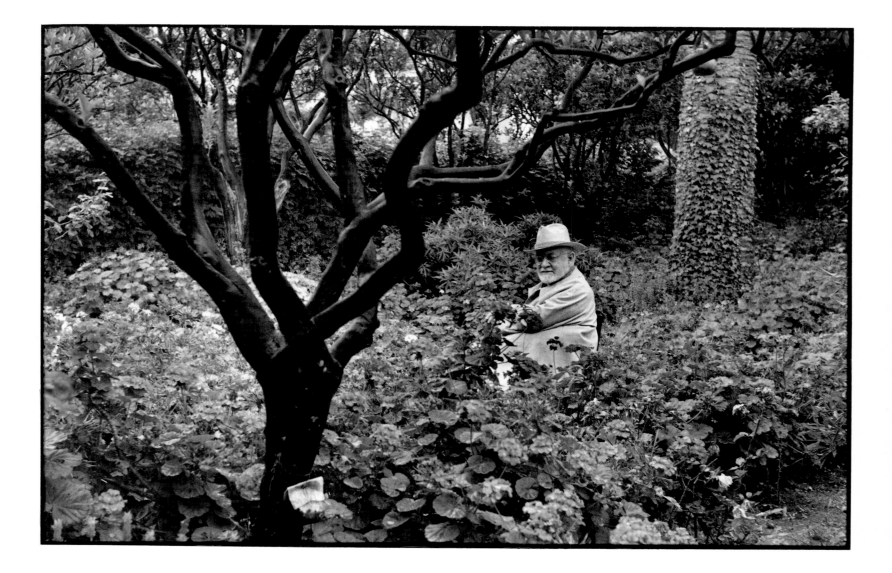

Henri Matisse

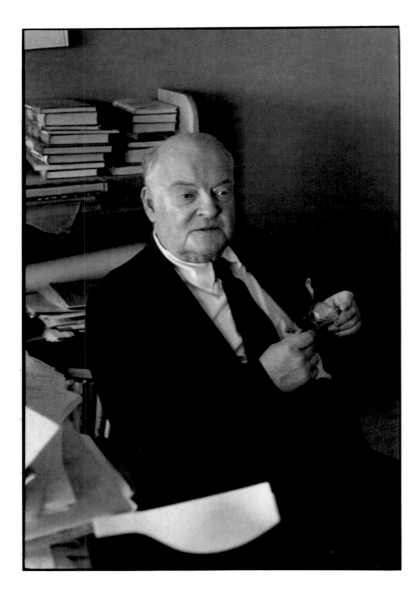 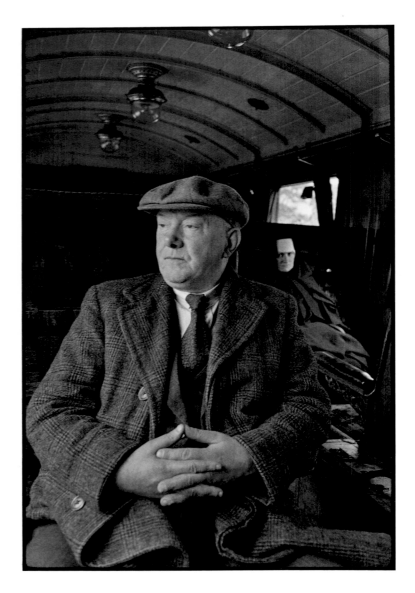

Edmund Wilson

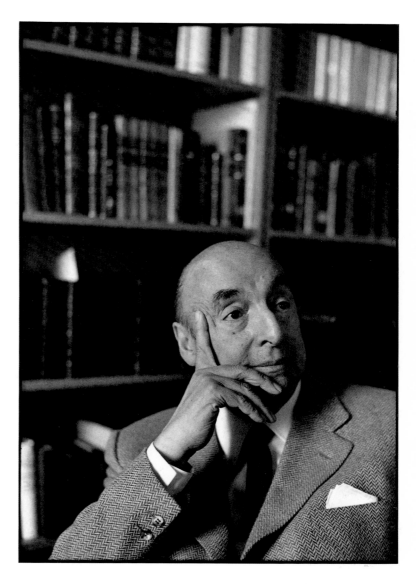

Pablo Neruda

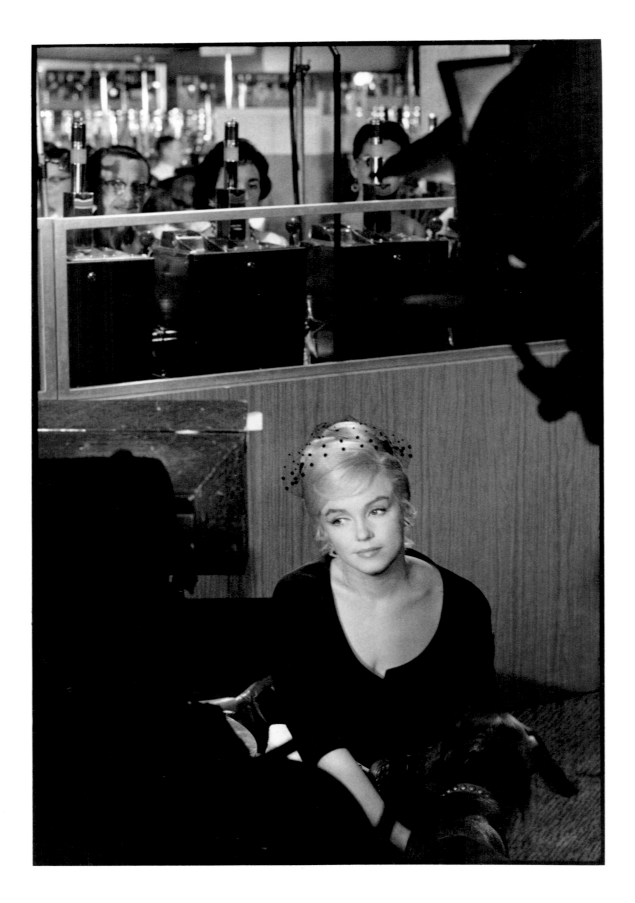

Marilyn Monroe

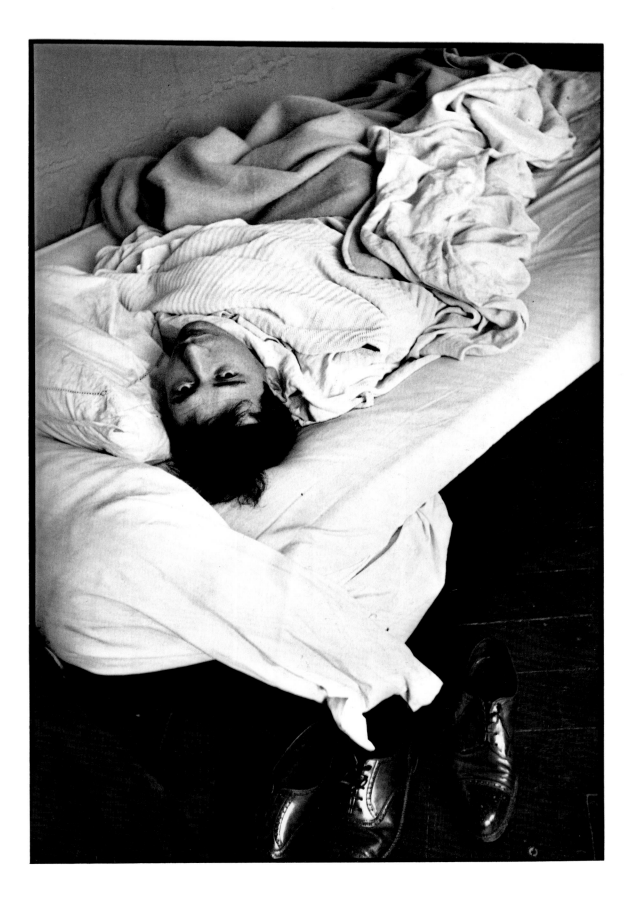

Pierre Colle

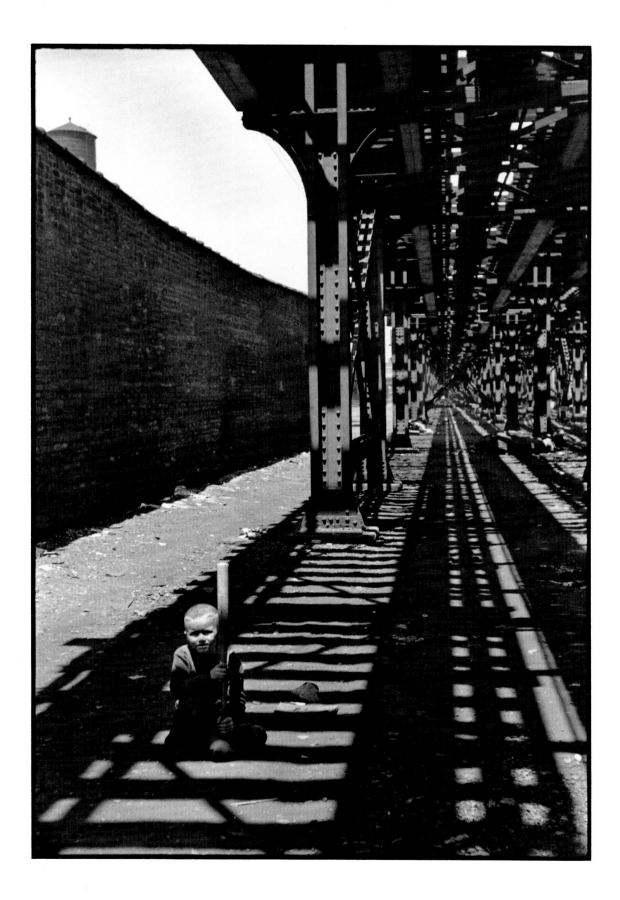

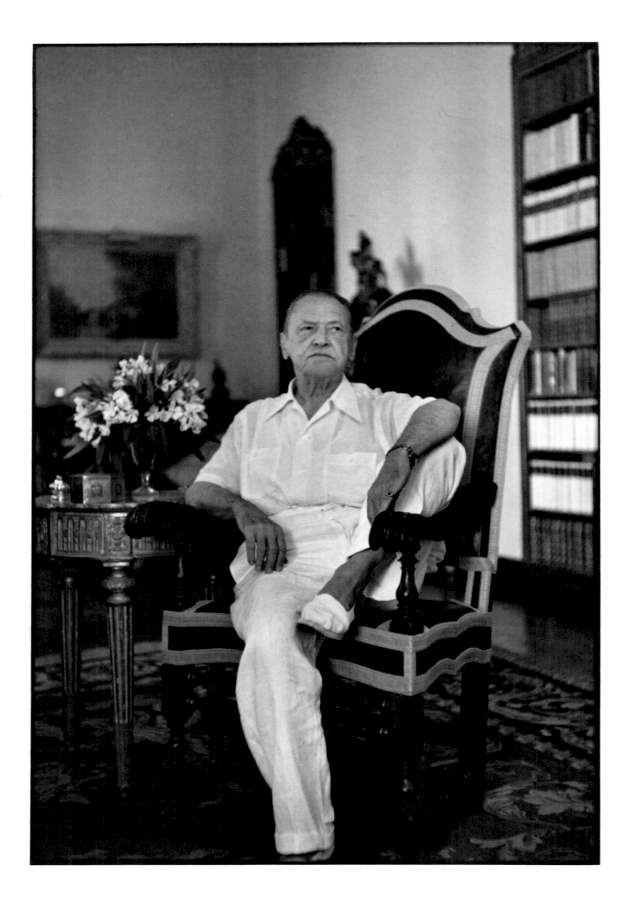

Somerset Maugham

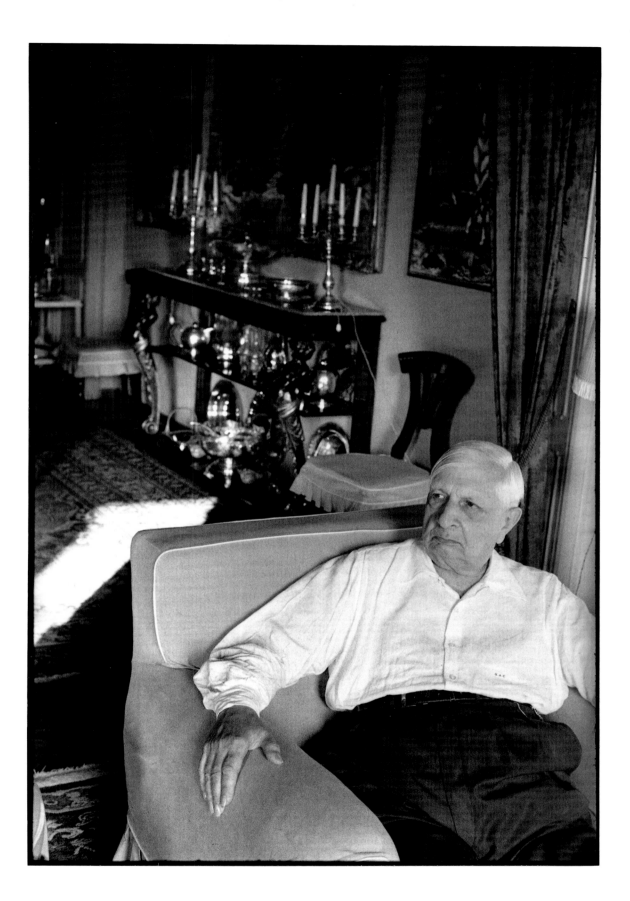

Giorgio de Chirico

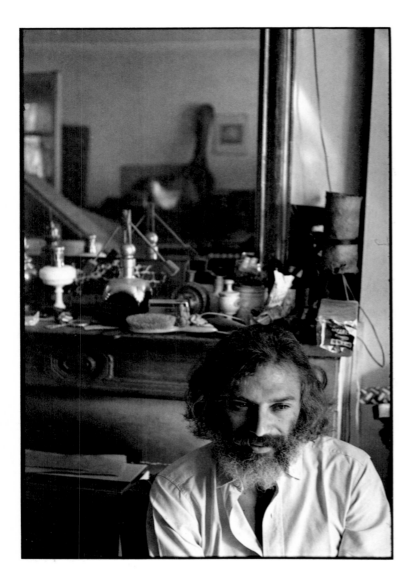

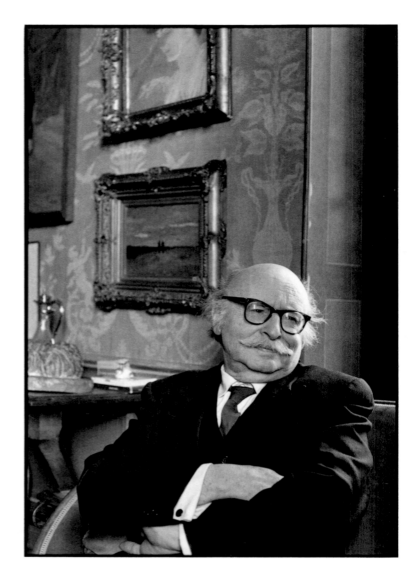

Georges Moustaki Jean Rostand

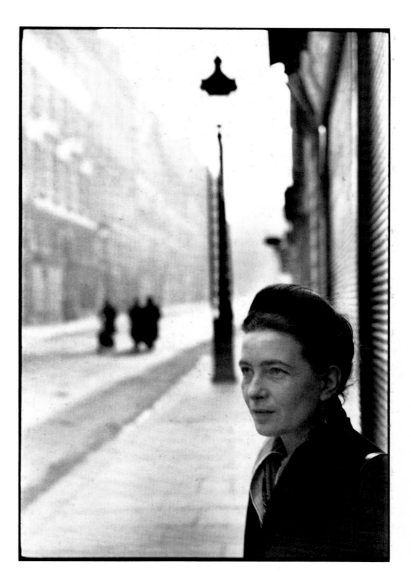

Simone de Beauvoir

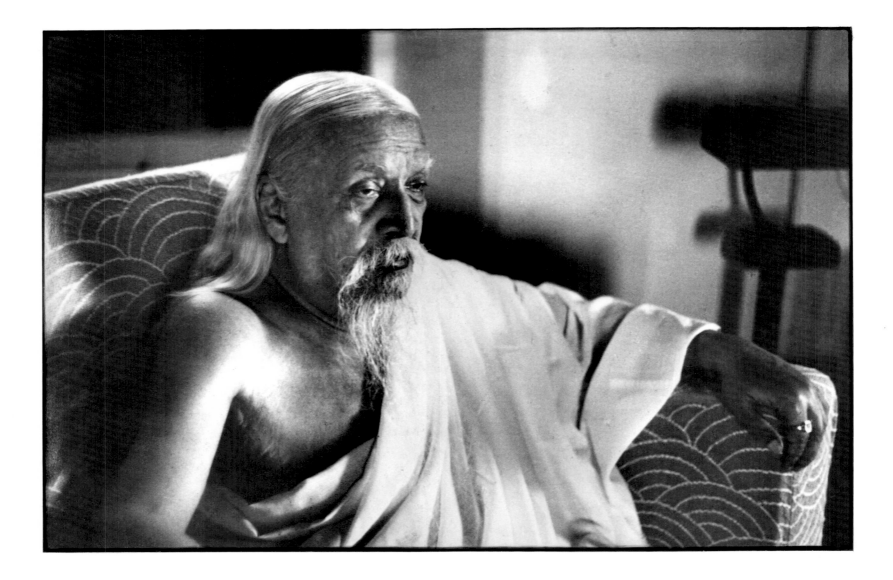

Sri Aurobindo

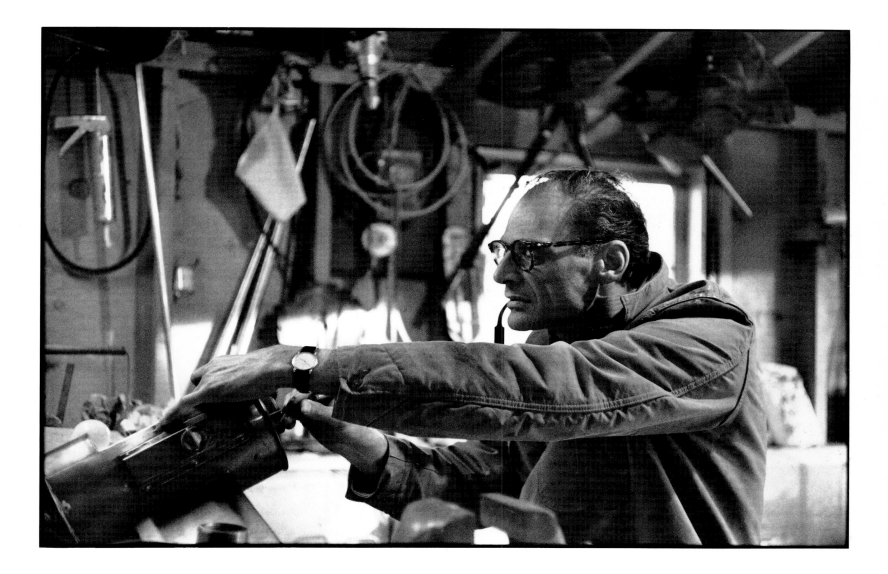

Arthur Miller

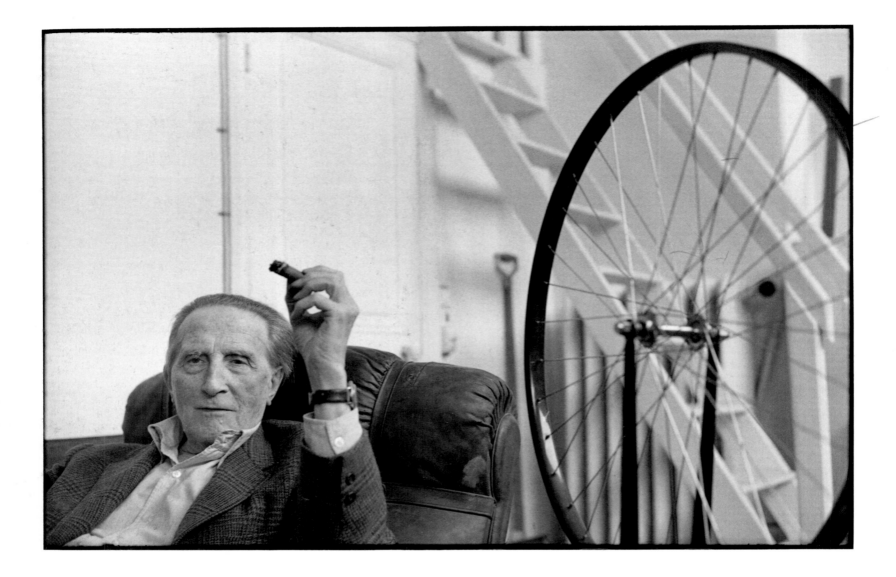

Marcel Duchamp

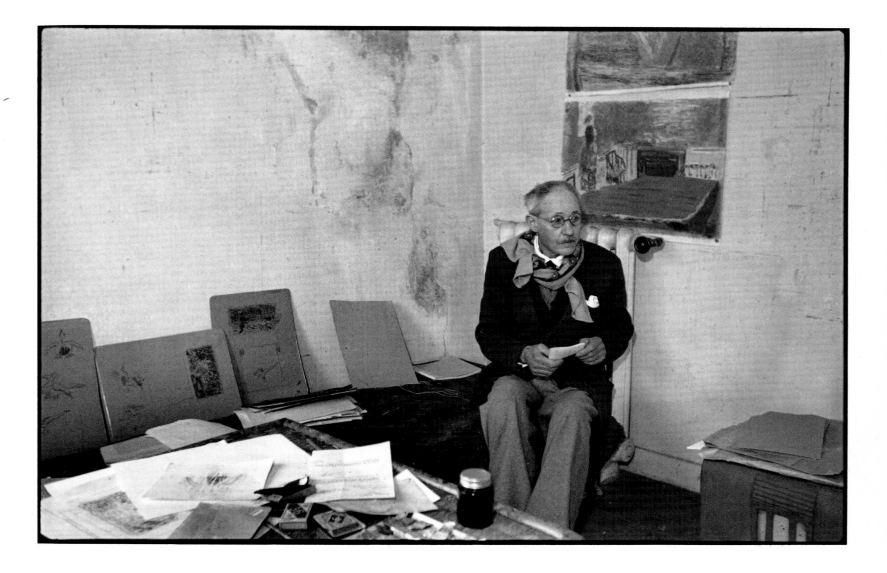

Pierre Bonnard

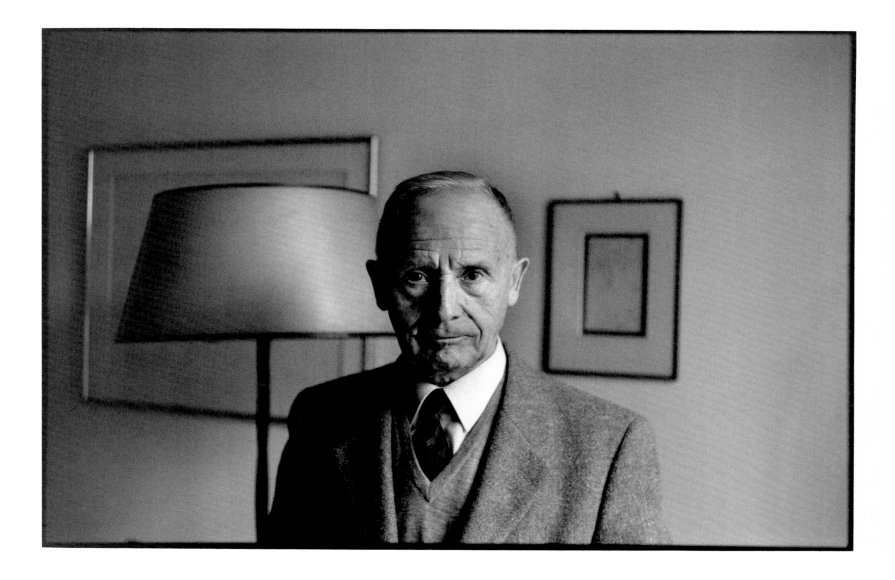

Julien Gracq

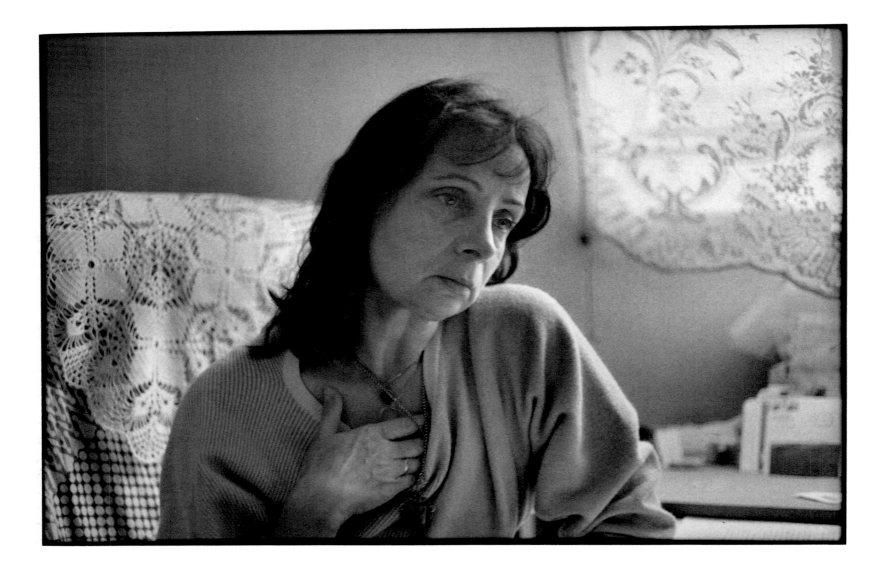

Vera Feyder

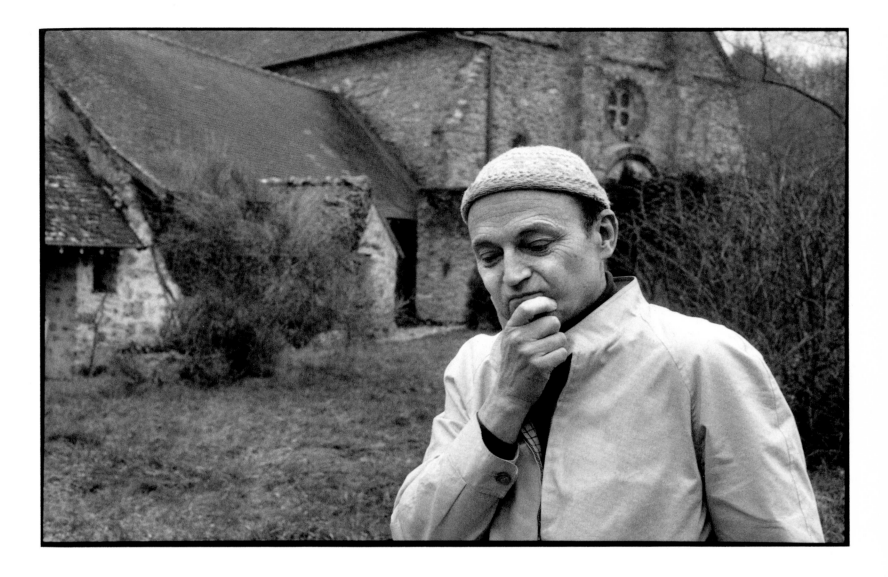

Michel Tournier

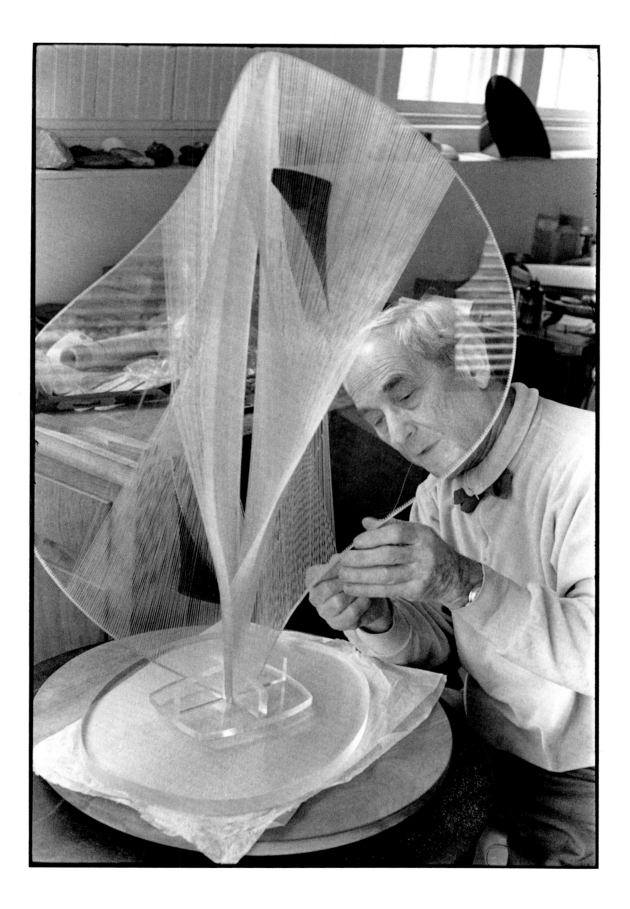

Naum Gabo

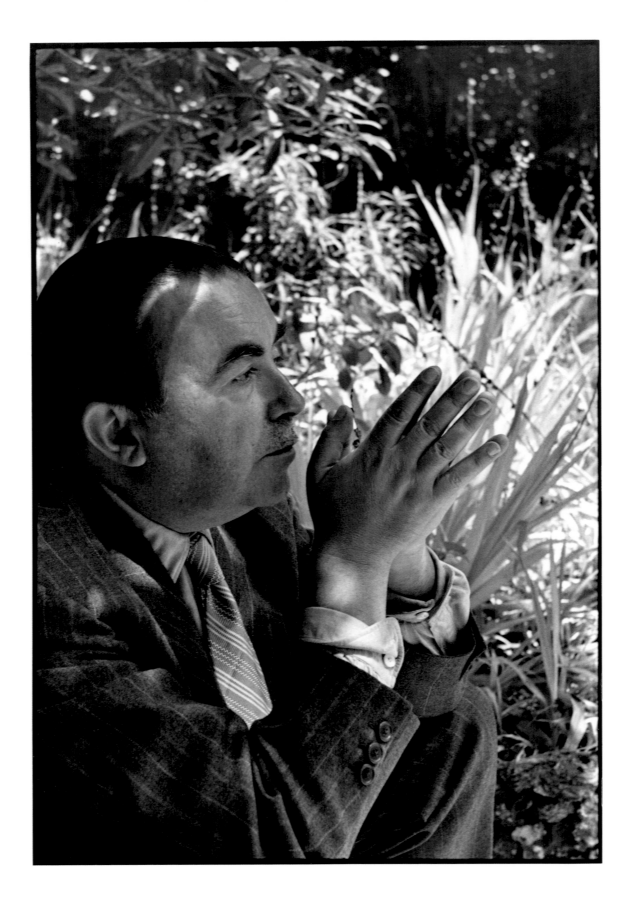

Tériade

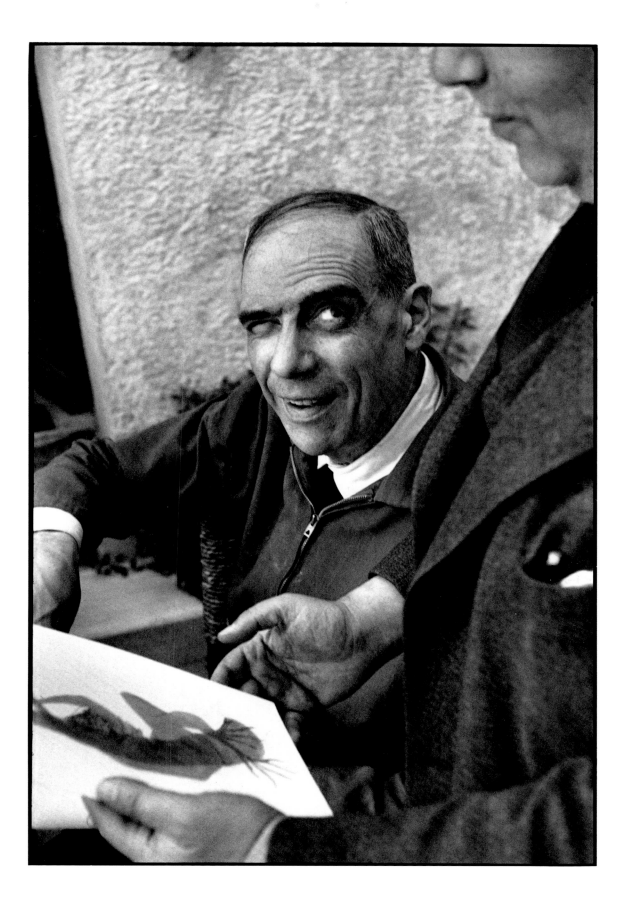

Henri Laurens, Tériade

163

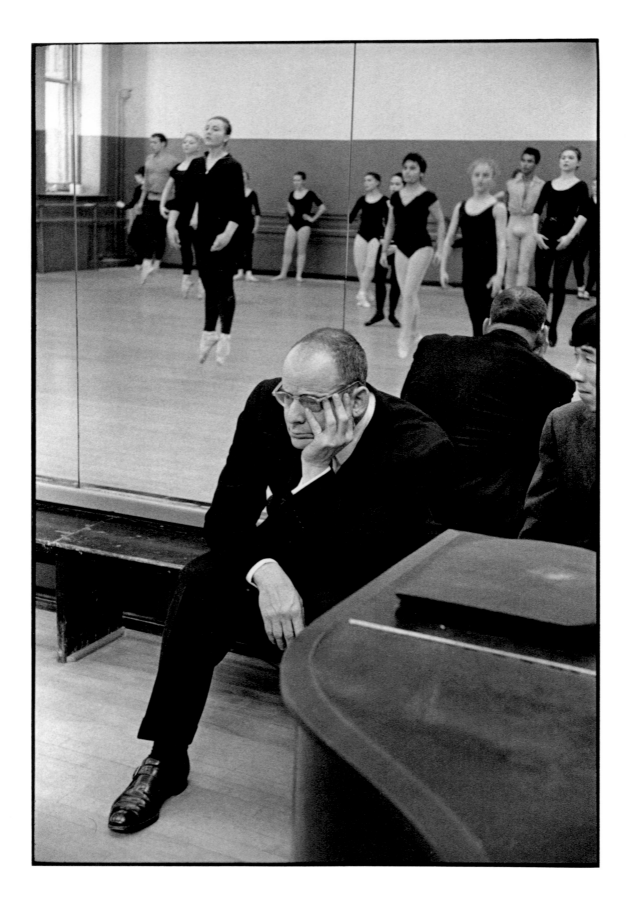

Lincoln Kirstein

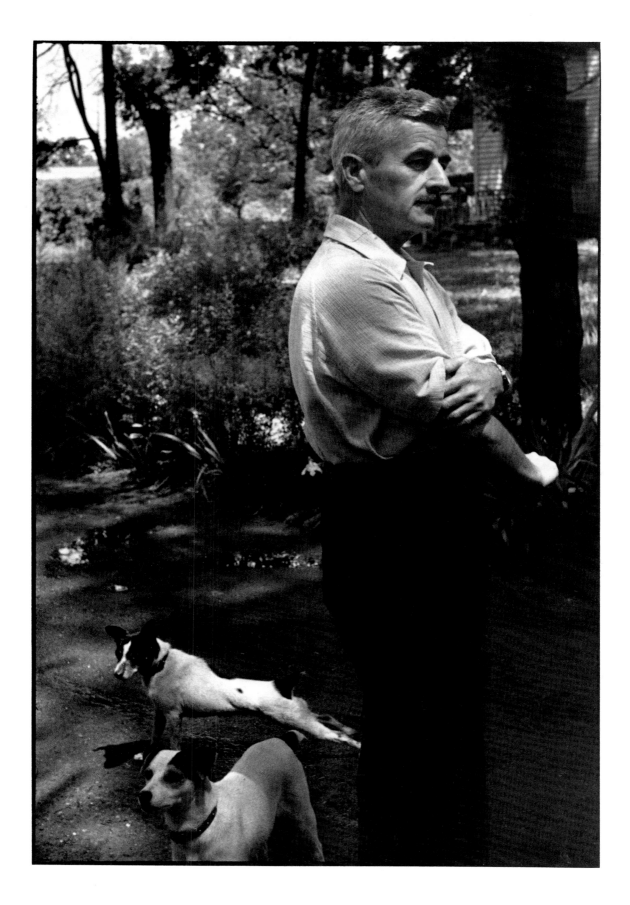

William Faulkner

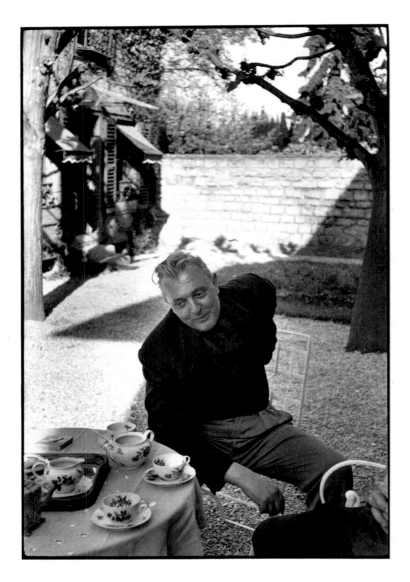

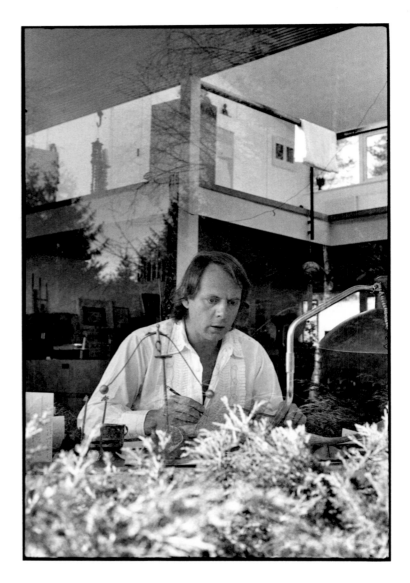

Jacques Tati Karlheinz Stockhausen

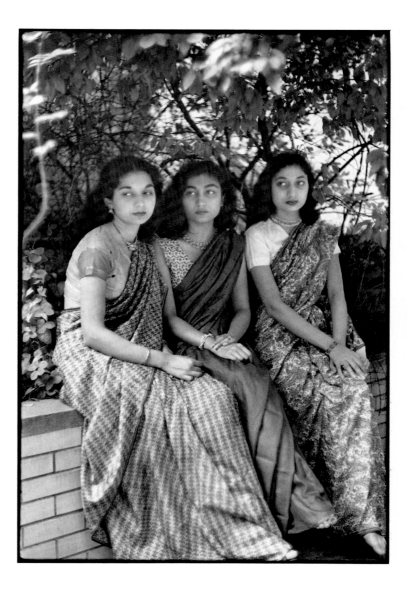

Tara Pandit, Krishna Roy, Rita Pandit

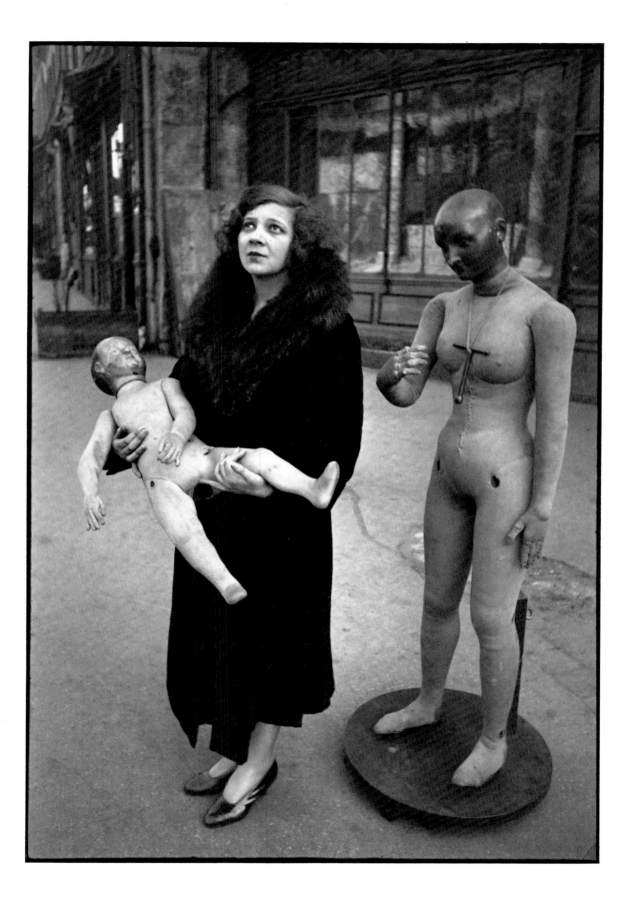

Léonor Fini

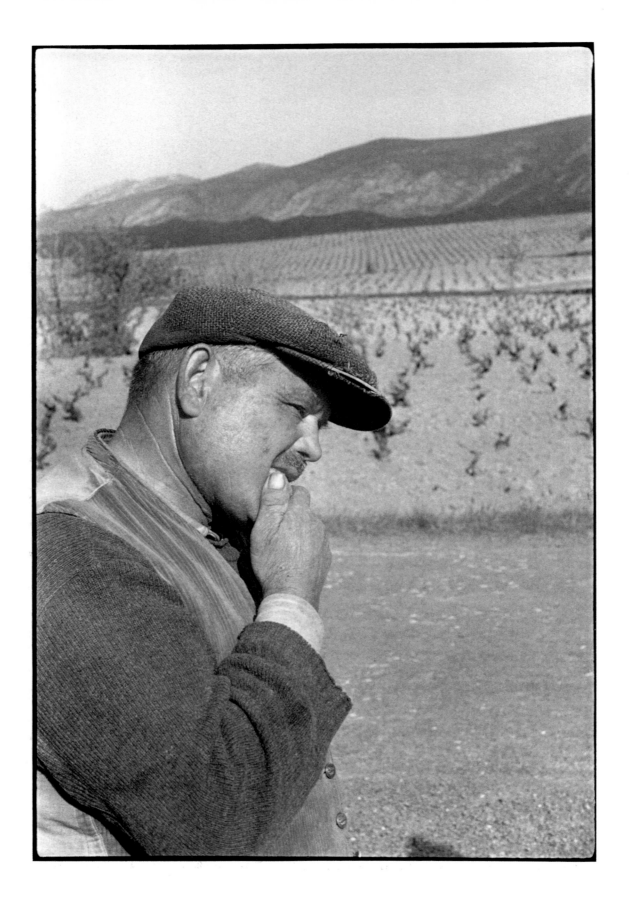

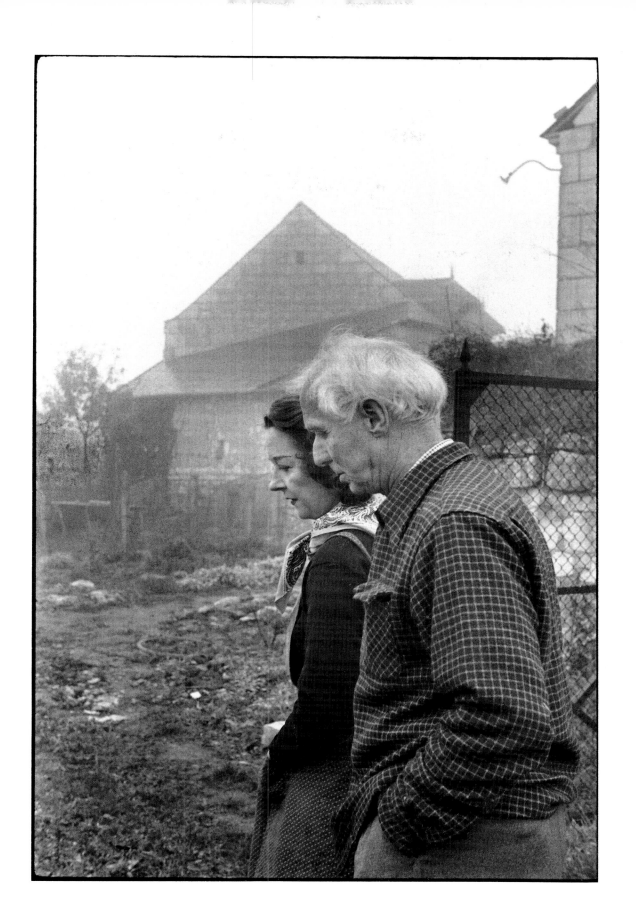

Max Ernst, Dorothea Tanning

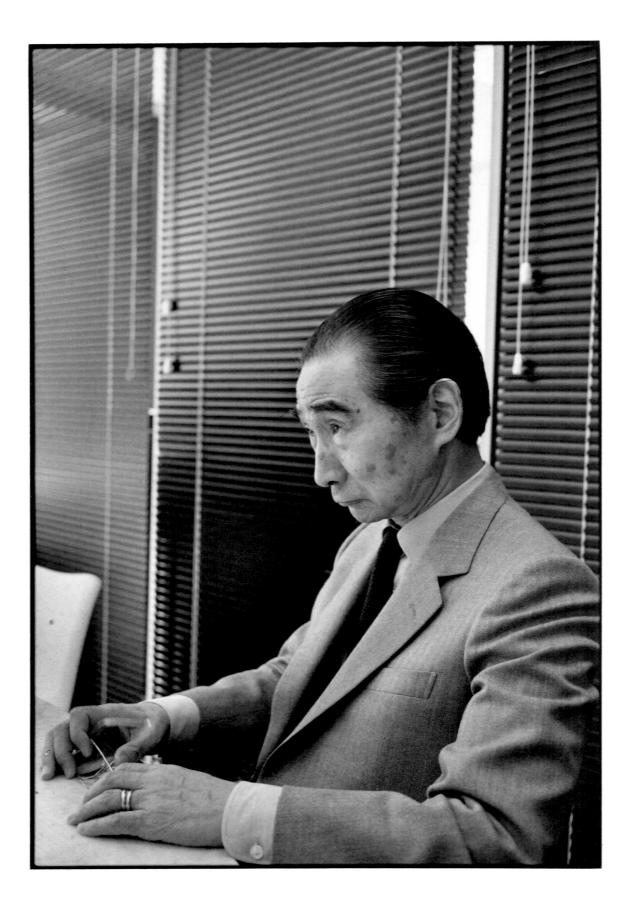

Kenzo Tange

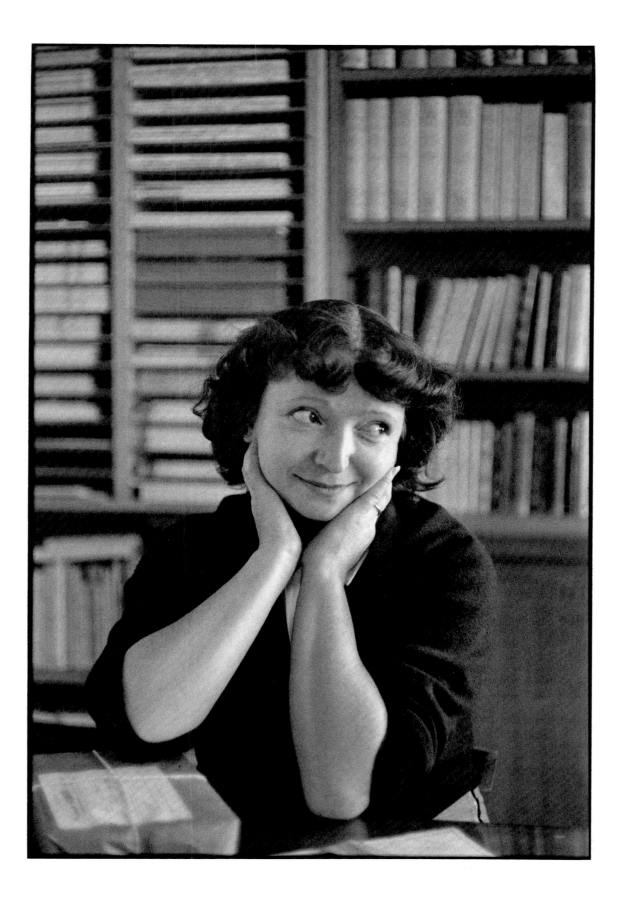

Suziel Bonnet

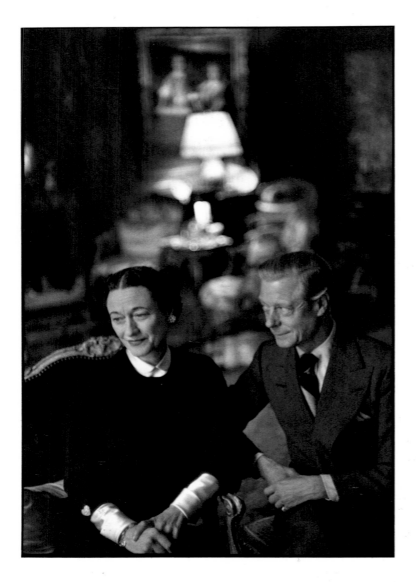

Duke of Windsor, Duchess of Windsor

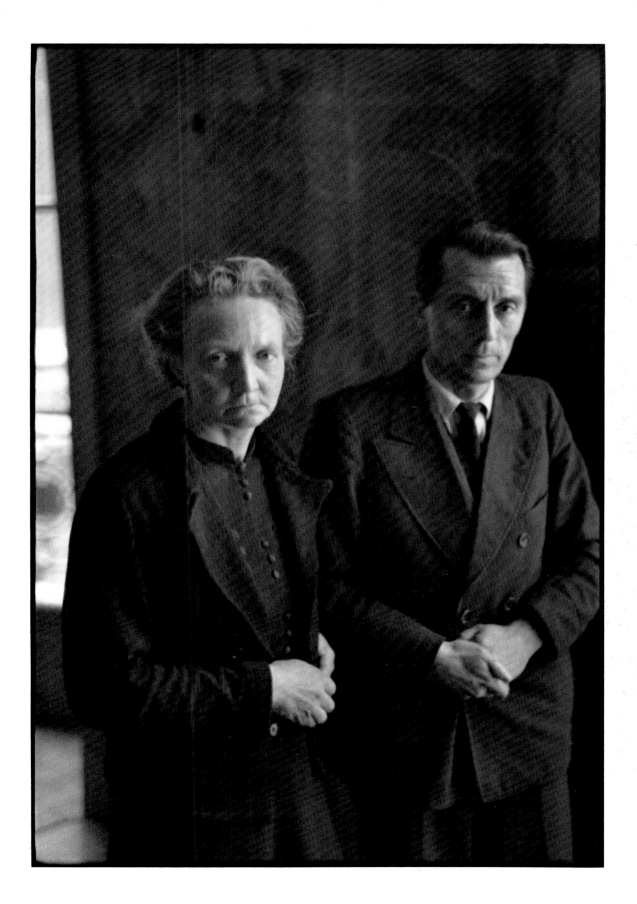

Irène Joliot-Curie, Frédéric Joliot-Curie

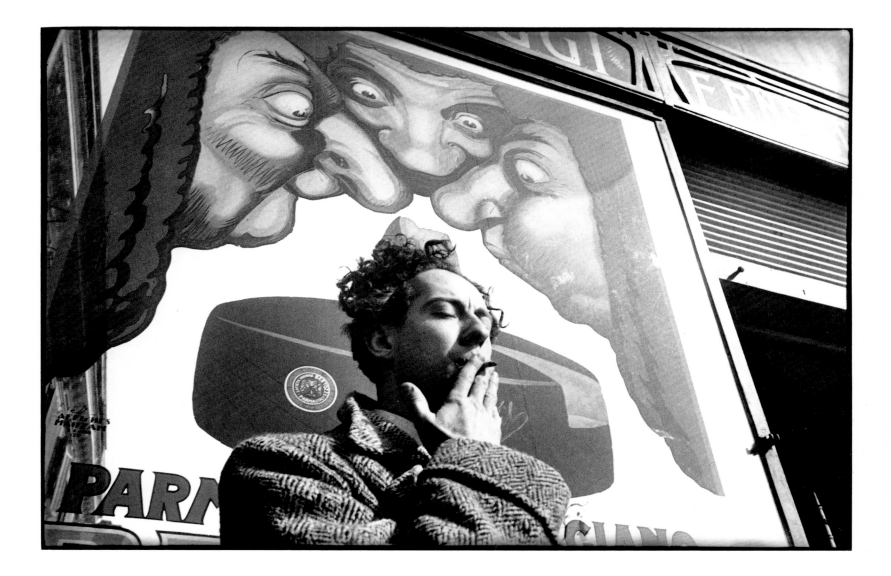

André Pieyre de Mandiargues

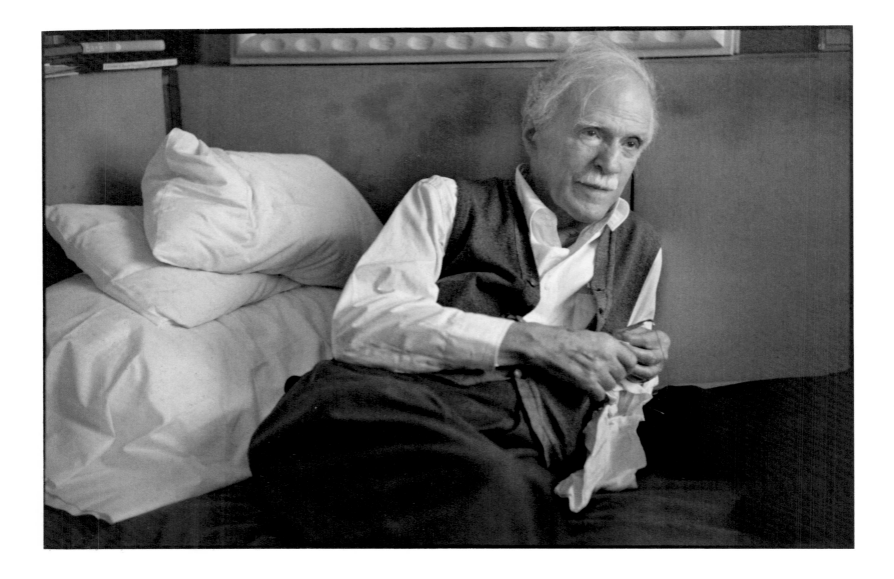

Alfred Stieglitz

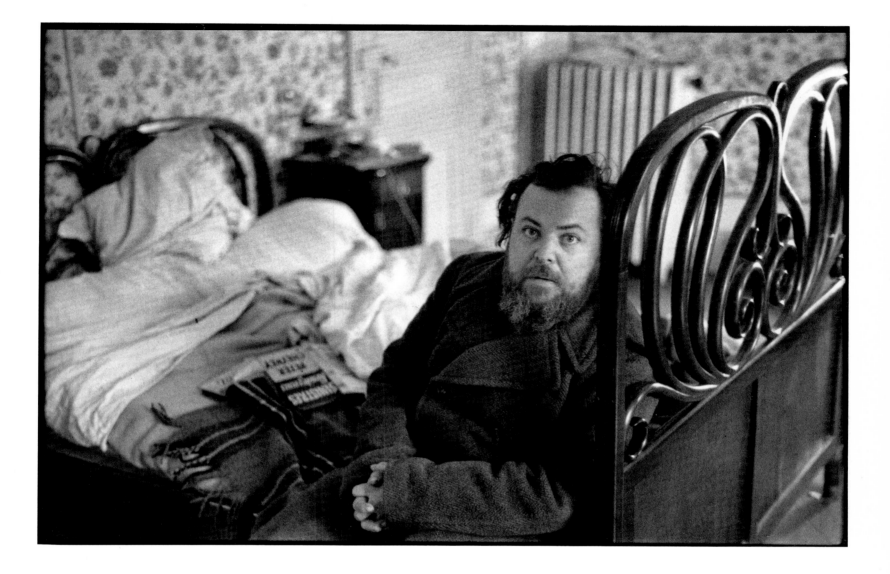

Christian Bérard

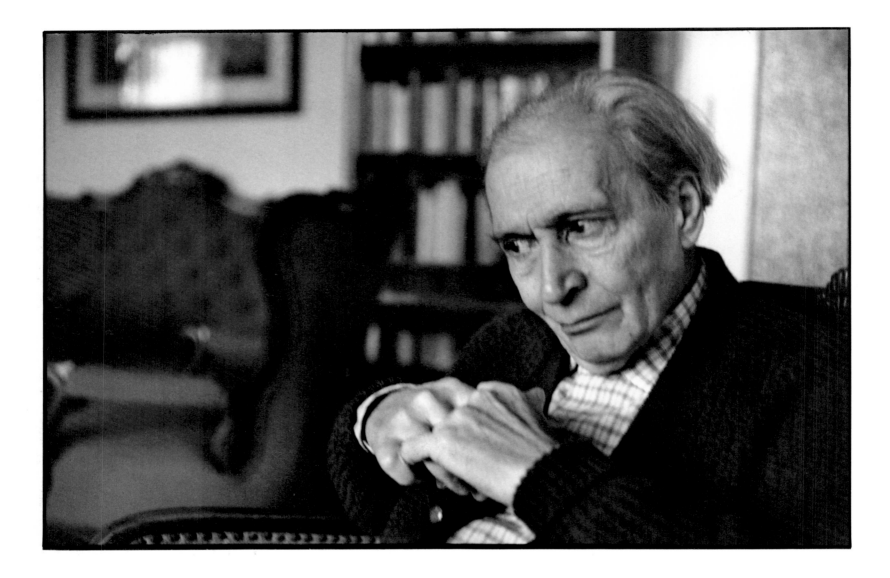

Georg Lukács

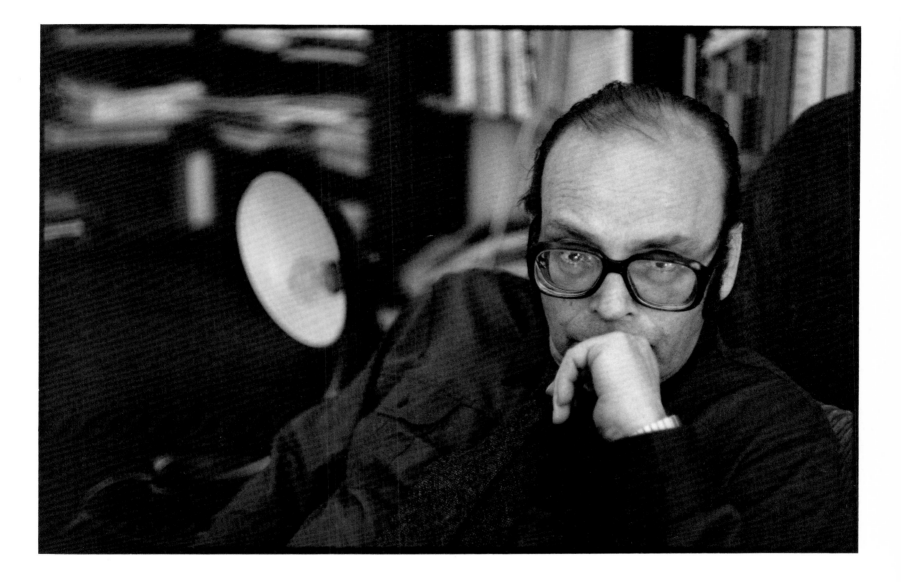

Georg Eisler

Alain Brustlein Robert Rauschenberg

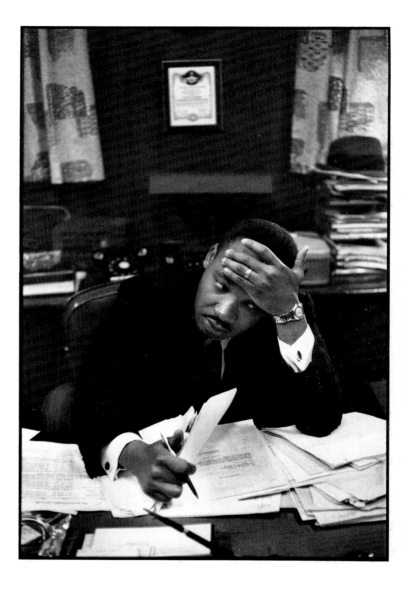

Martin Luther King

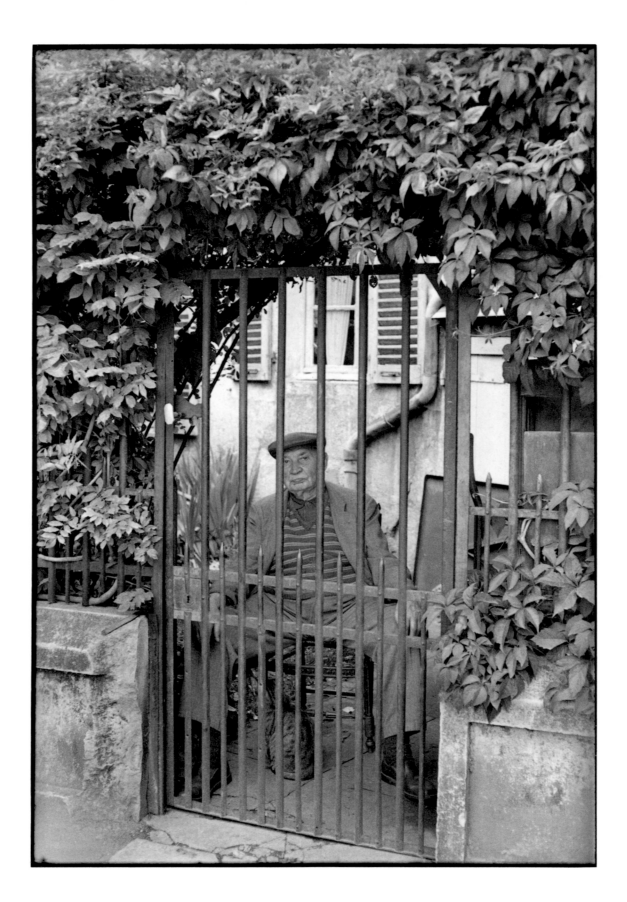

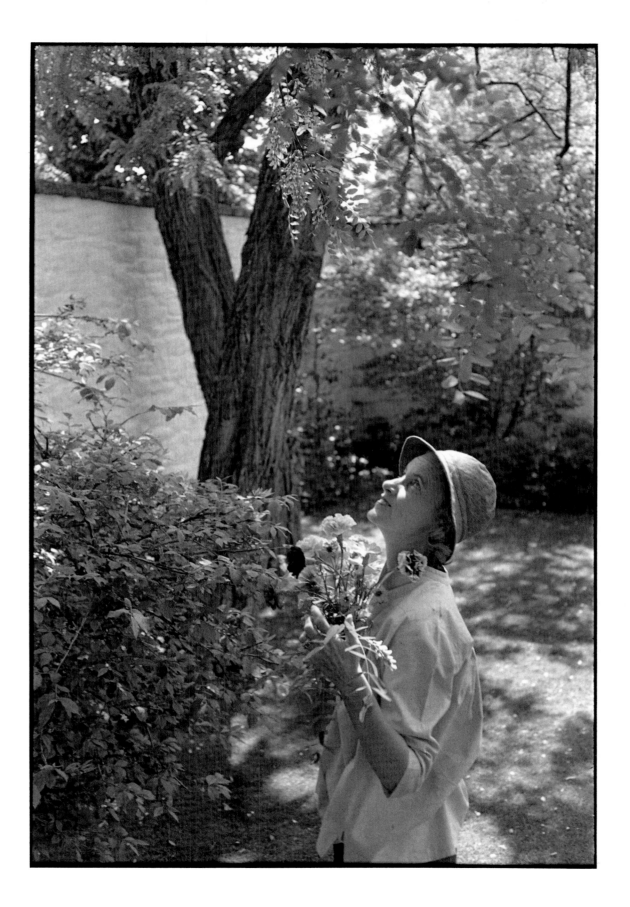

Mrs Paul Mellon

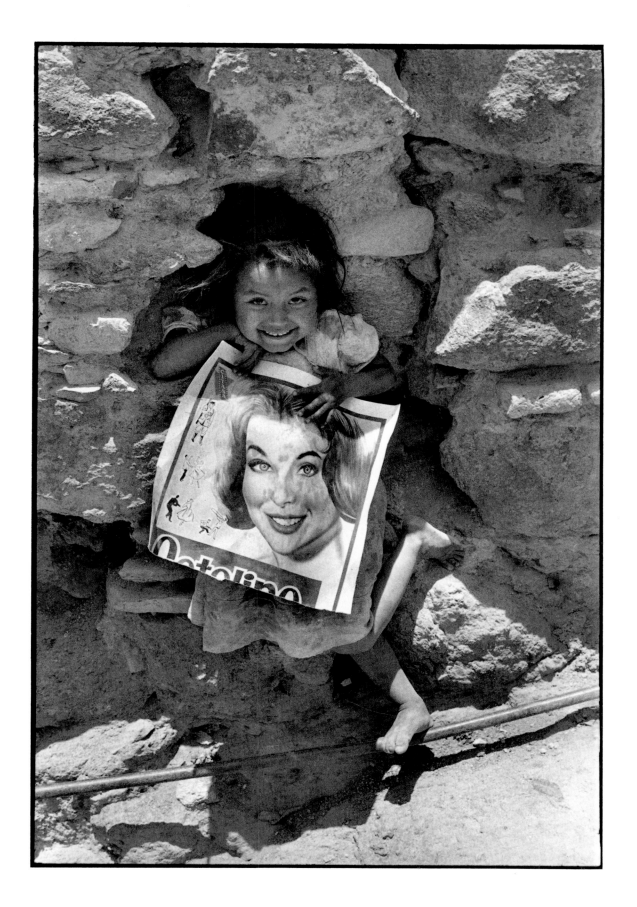

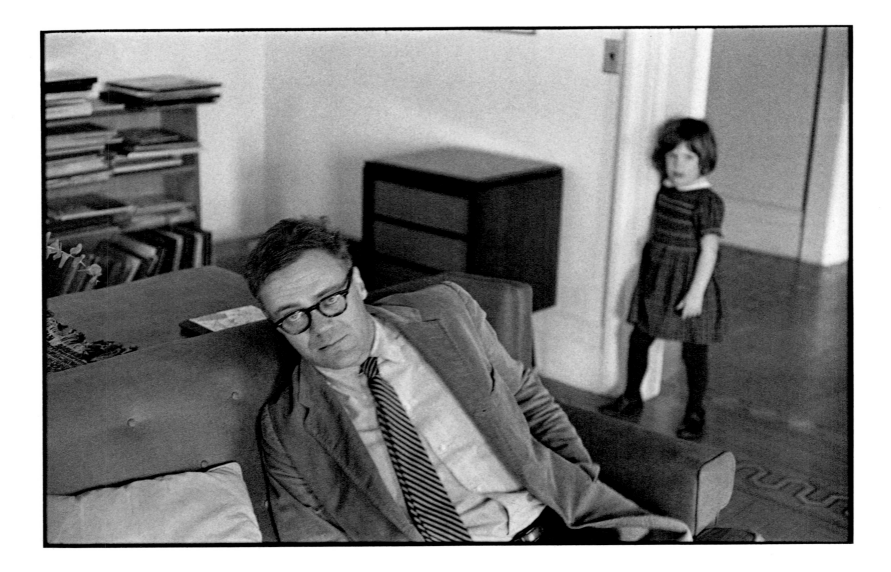

Robert Lowell

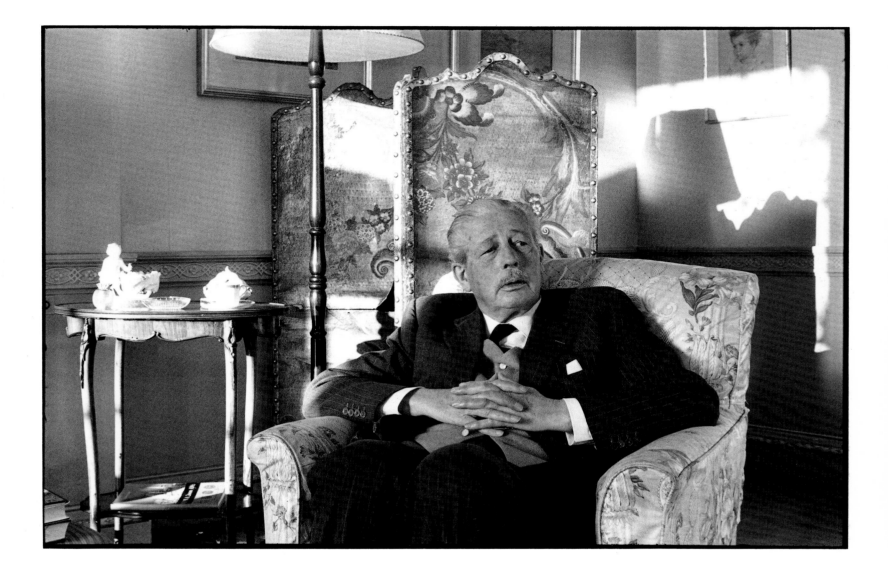

Harold Macmillan

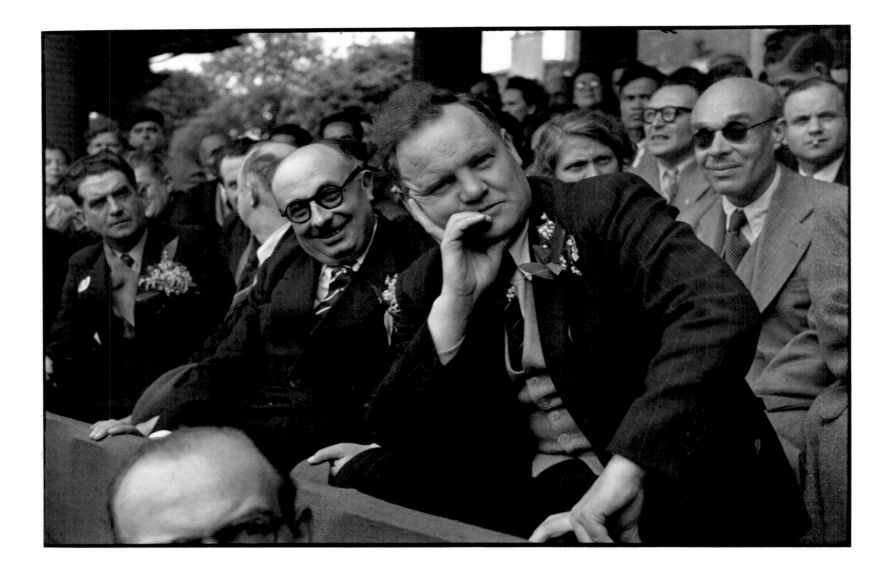

Jacques Duclos, Maurice Thorez

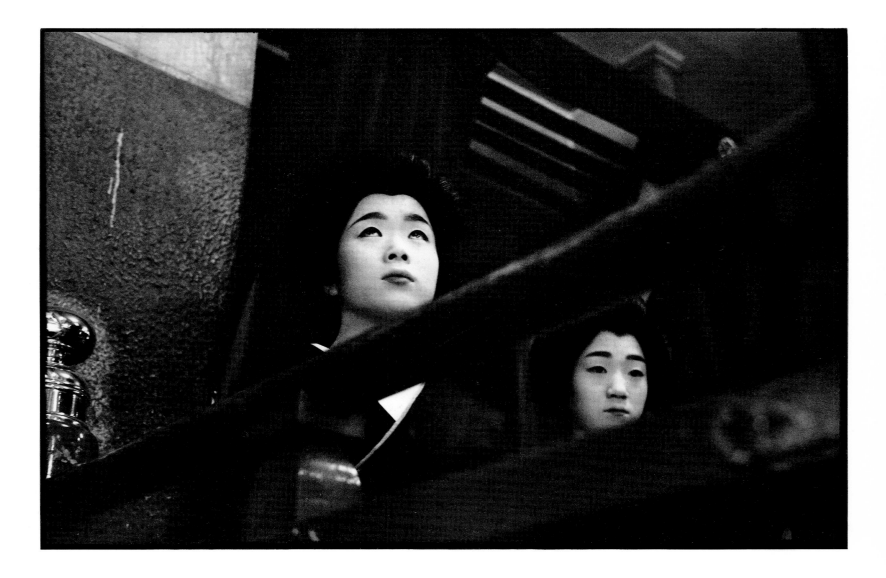

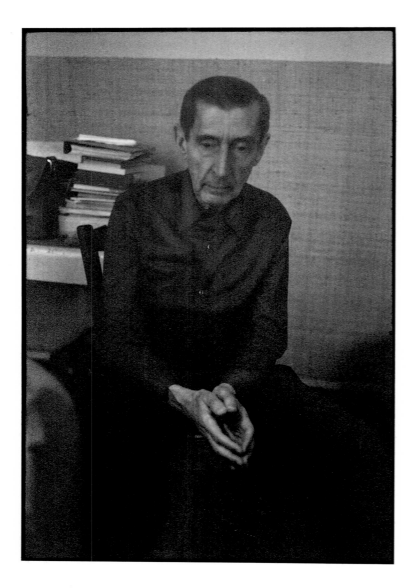

José Bergamin

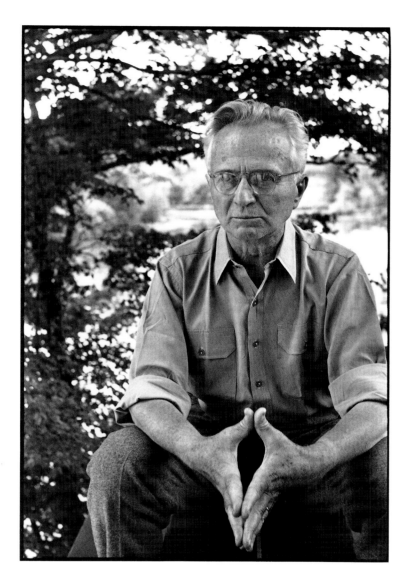

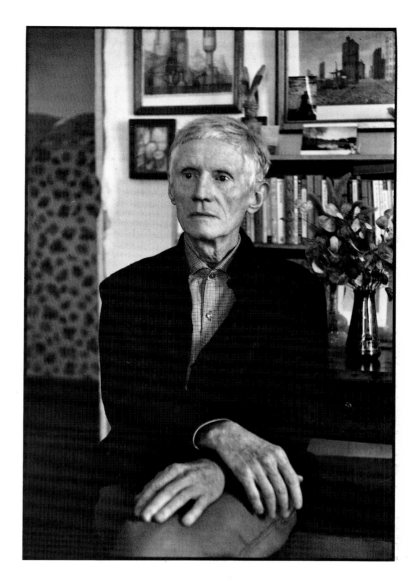

Edward Steichen Siegfried Klapper 193

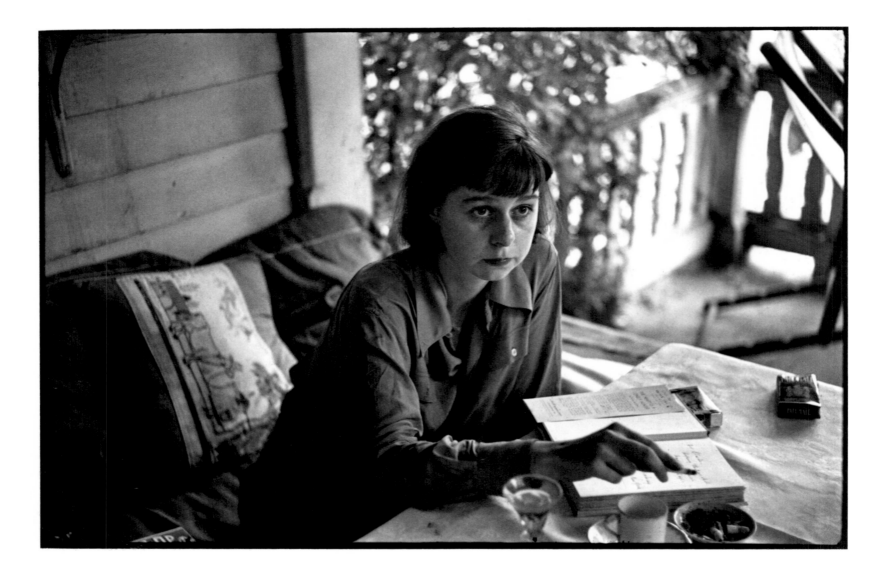

Carson McCullers

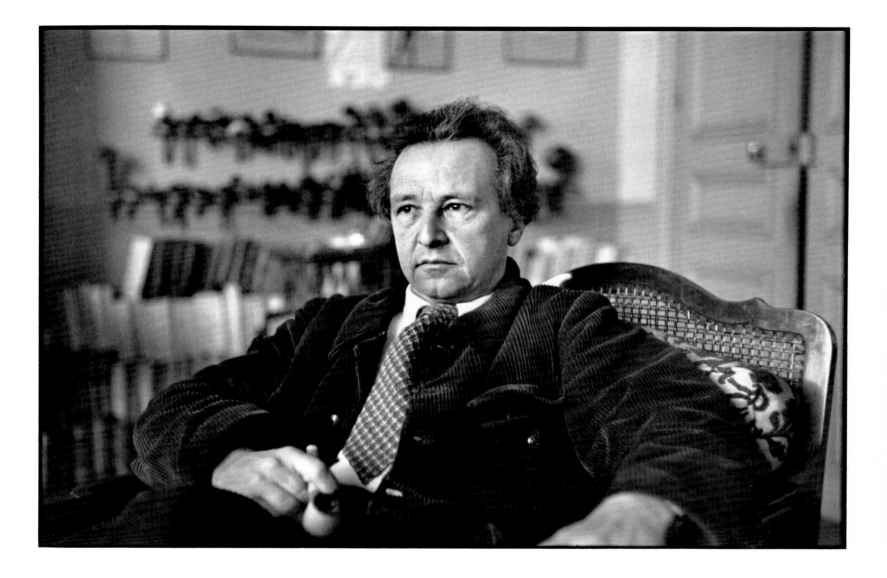

Arthur Honegger

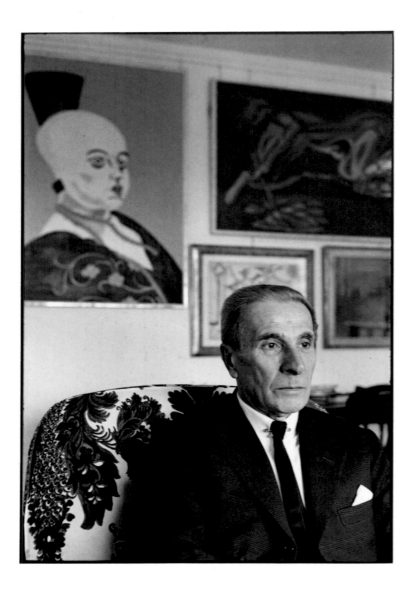

Dino Buzzati

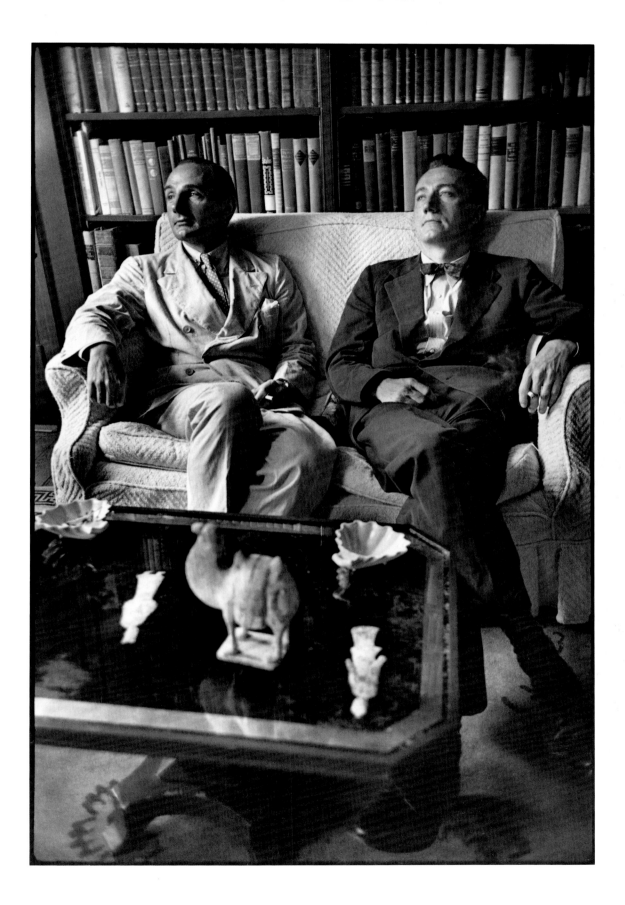

Joseph Alsop, Stewart Alsop

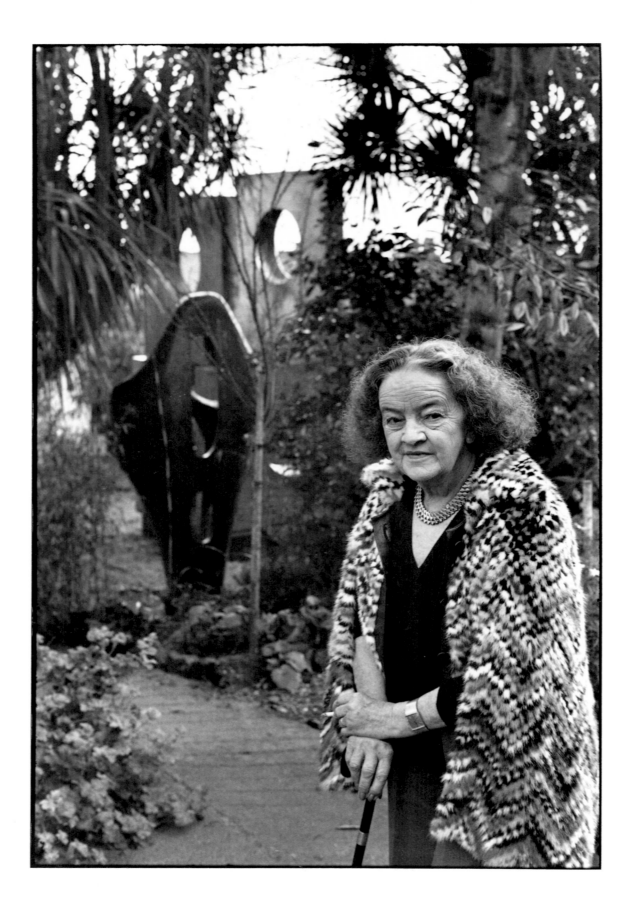

Barbara Hepworth

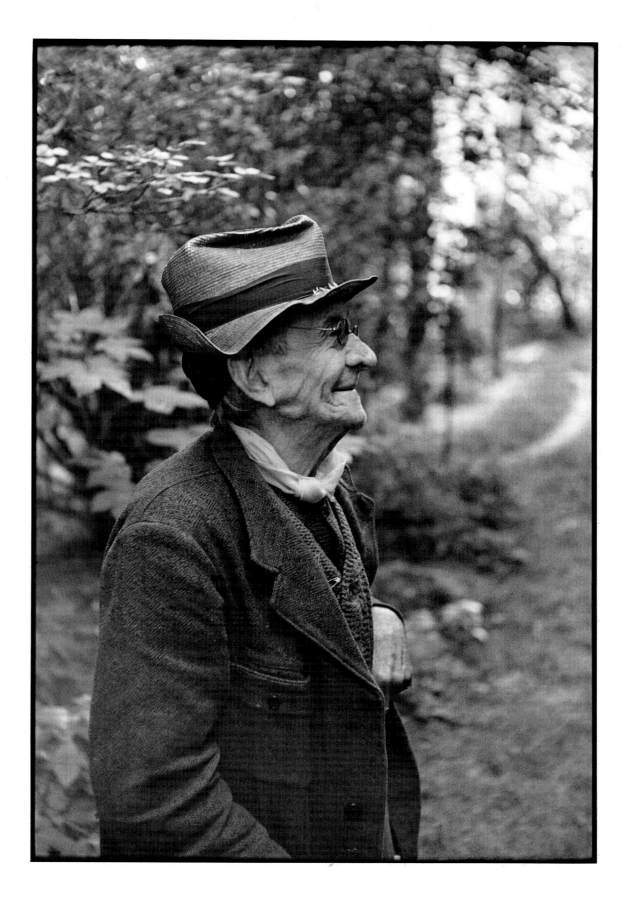

Paul Léautaud

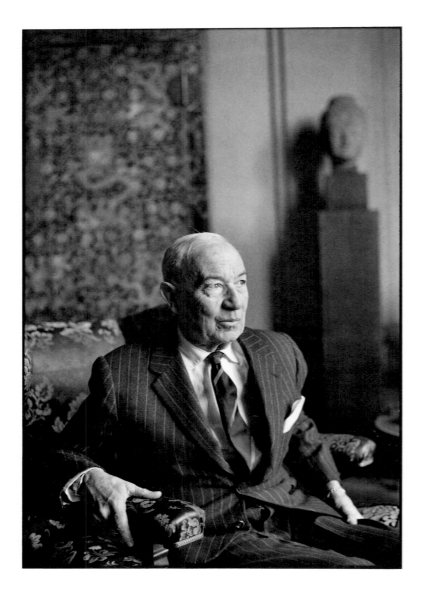

Paul Morand

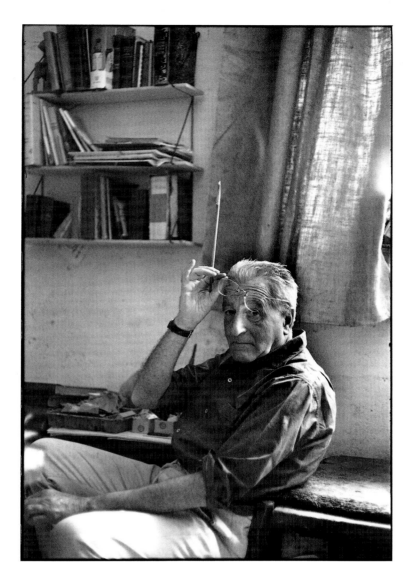 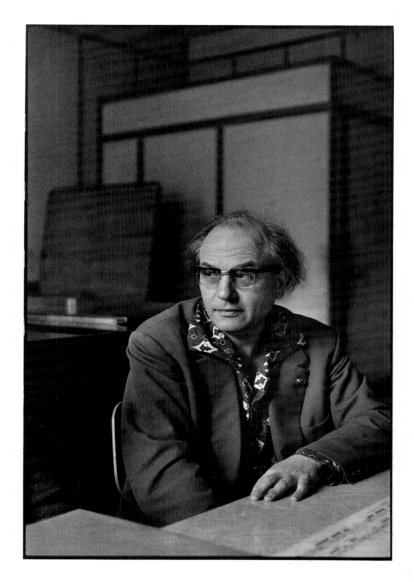

Willy Varlin Olivier Messiaen 201

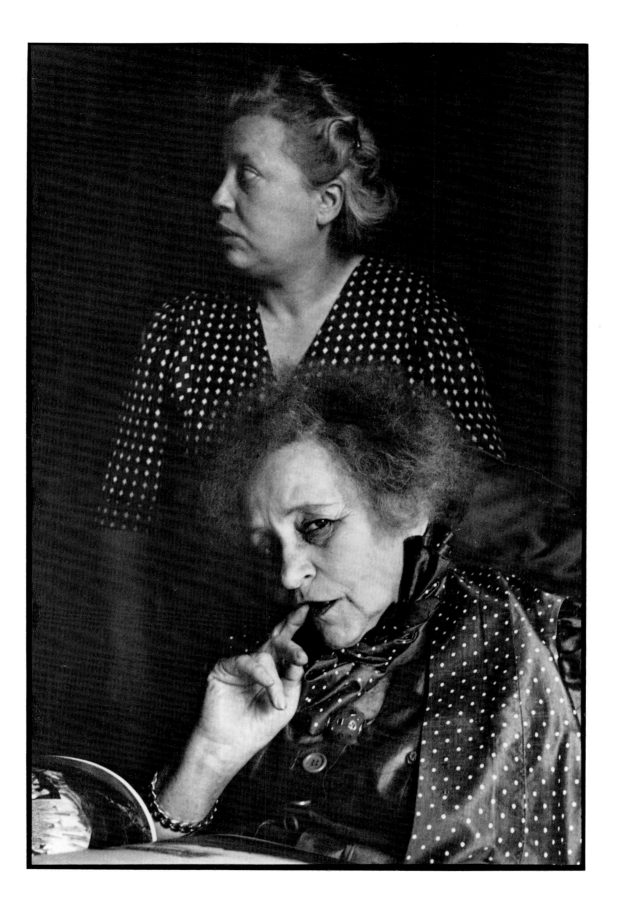

Colette, Pauline

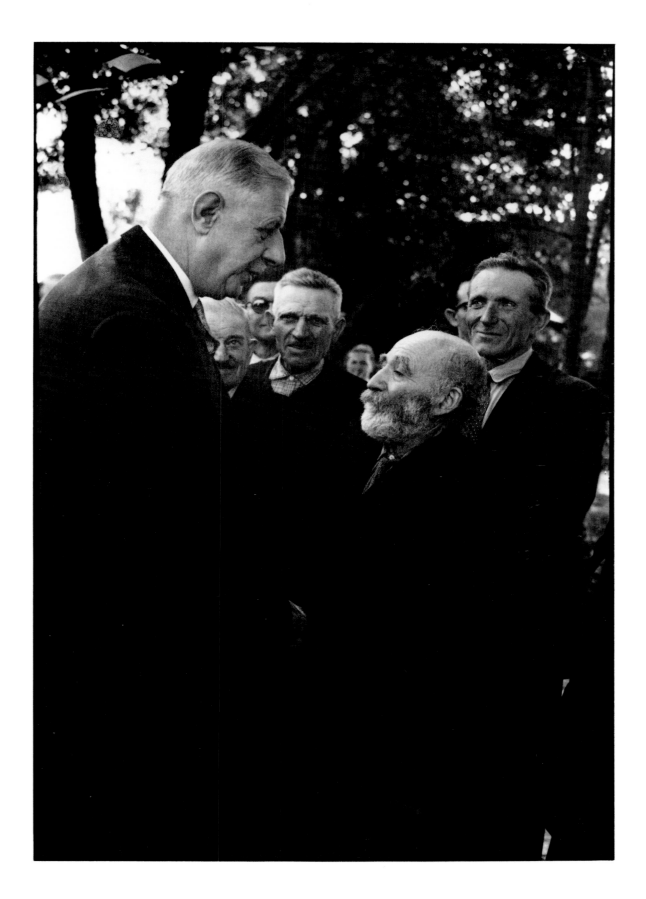

Charles de Gaulle

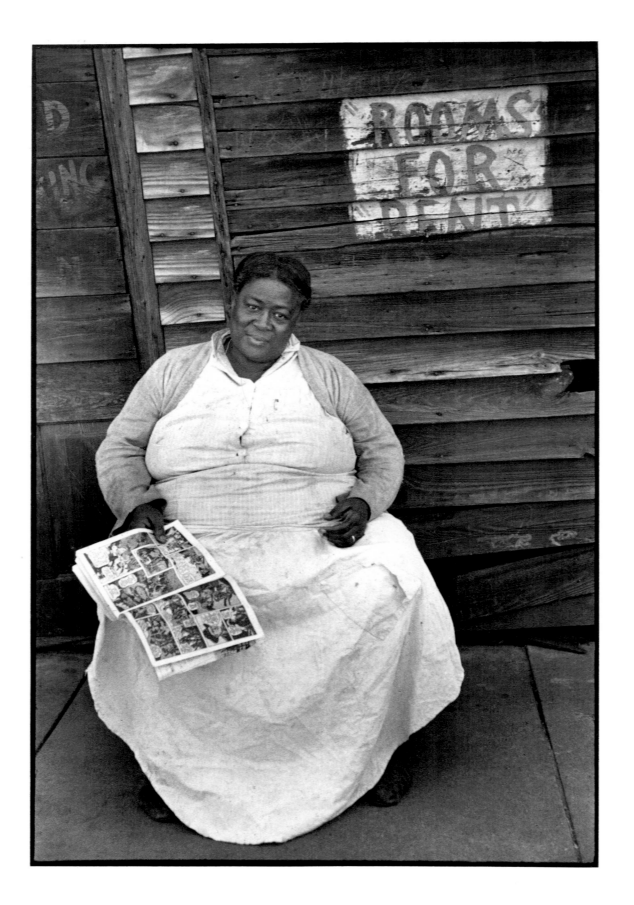

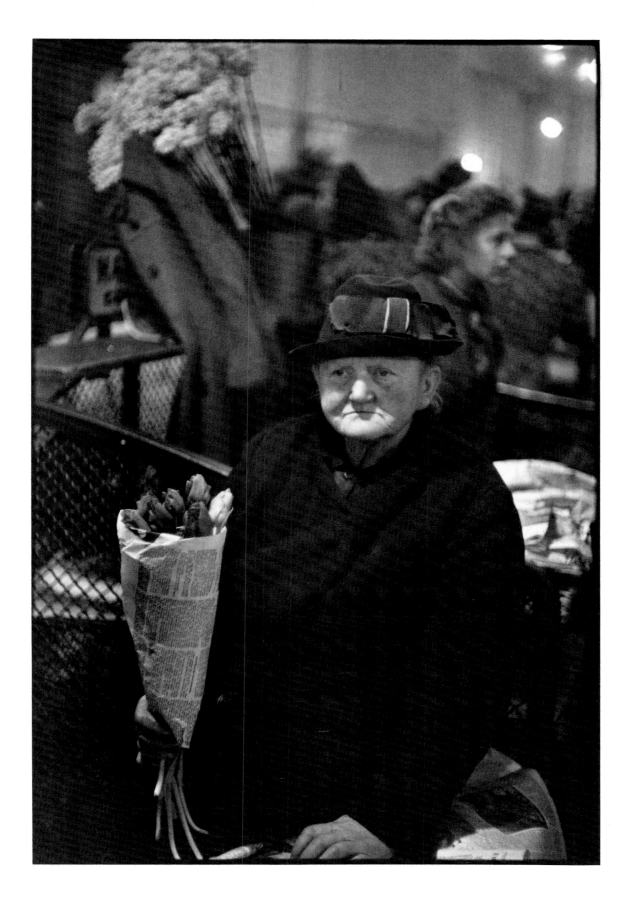

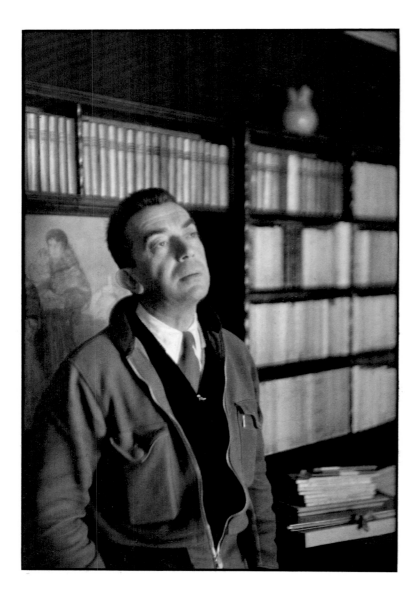

Marcel Aymé

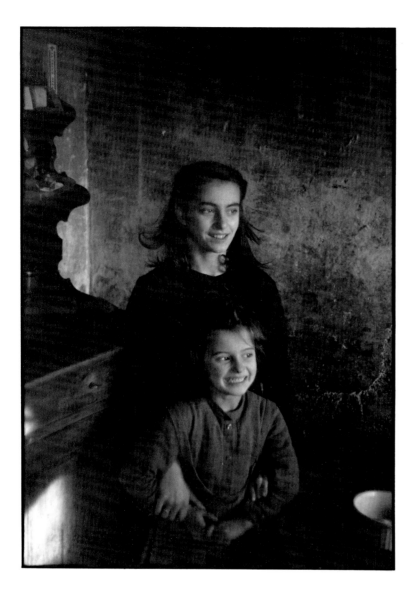

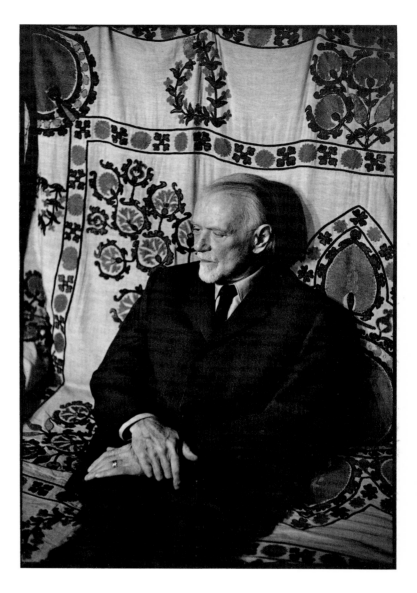

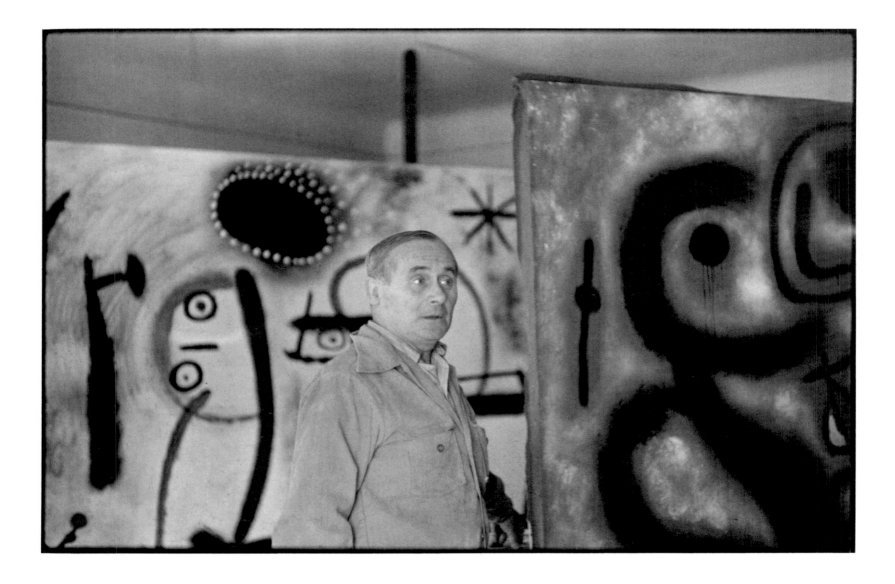

Joan Miró

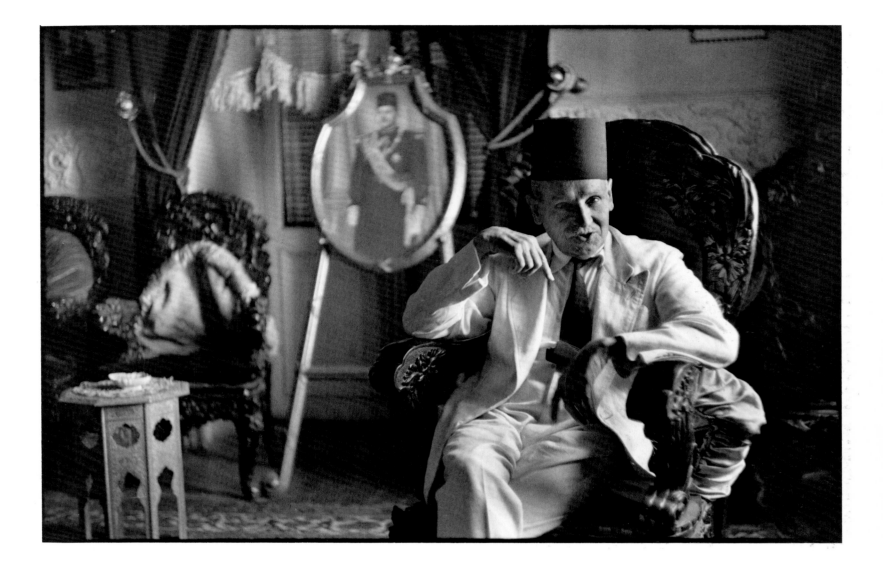

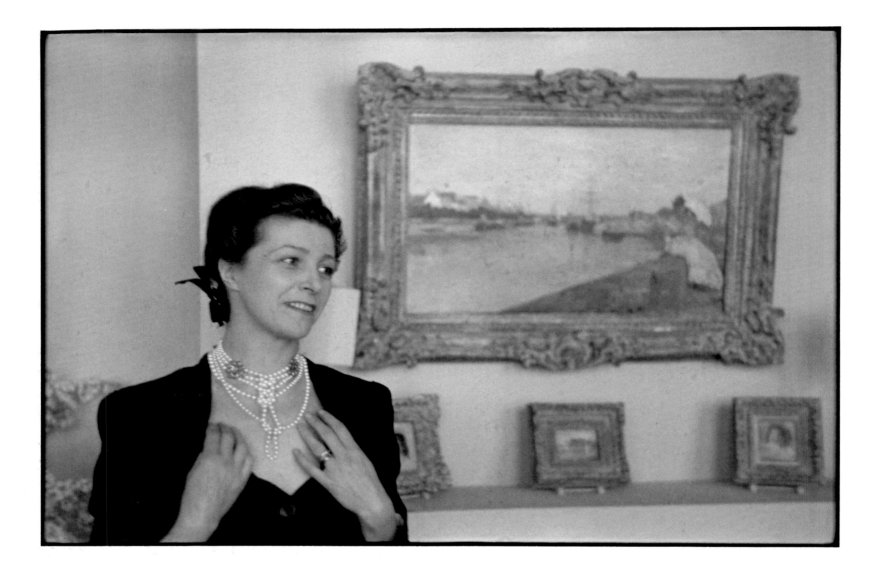

Louise de Vilmorin

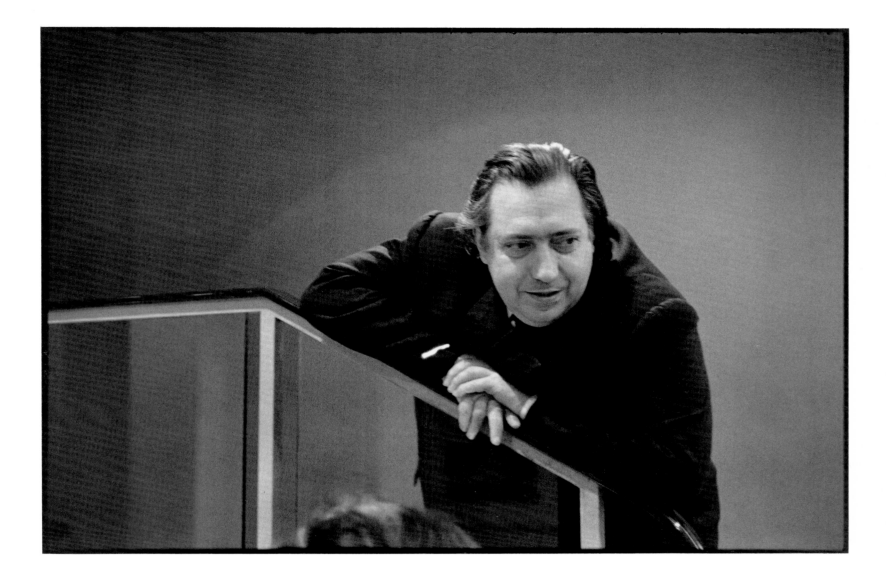

Henri Langlois

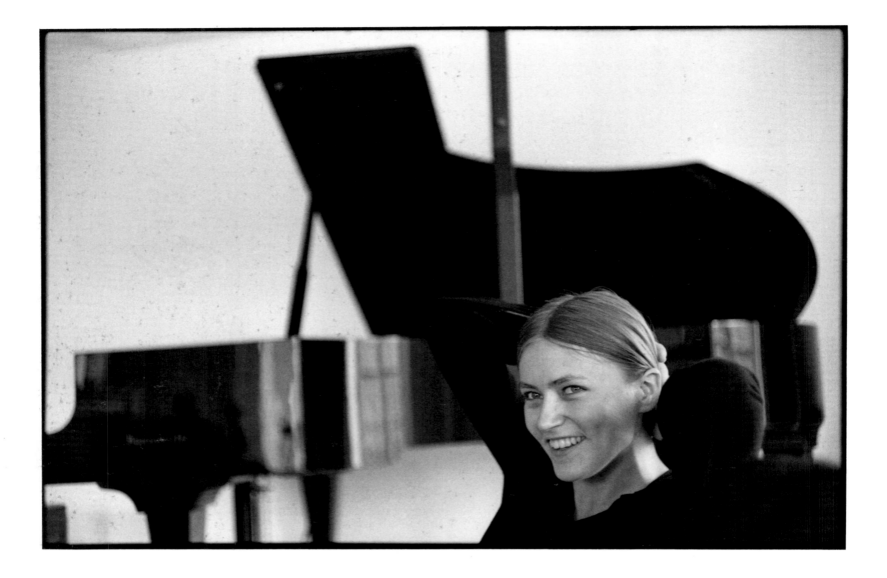

Hortense Cartier-Bresson

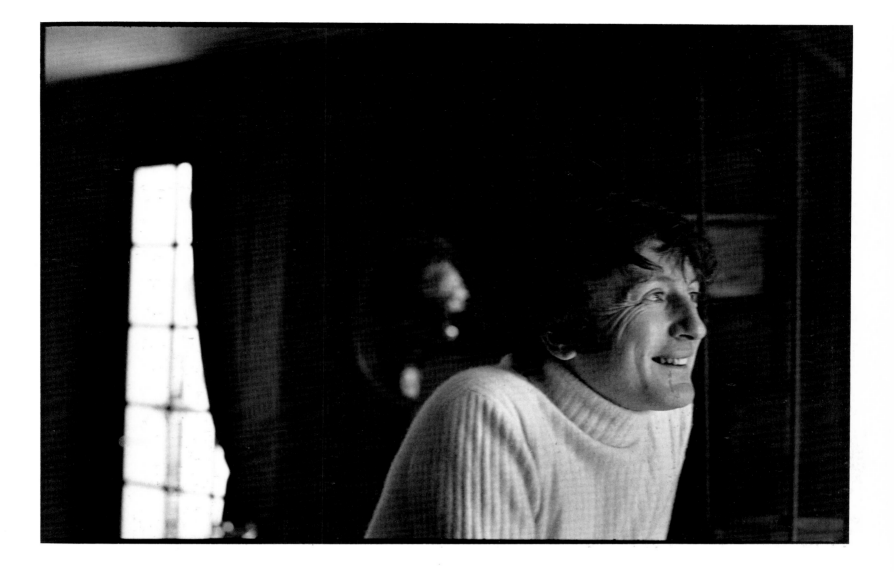

Claude Rich

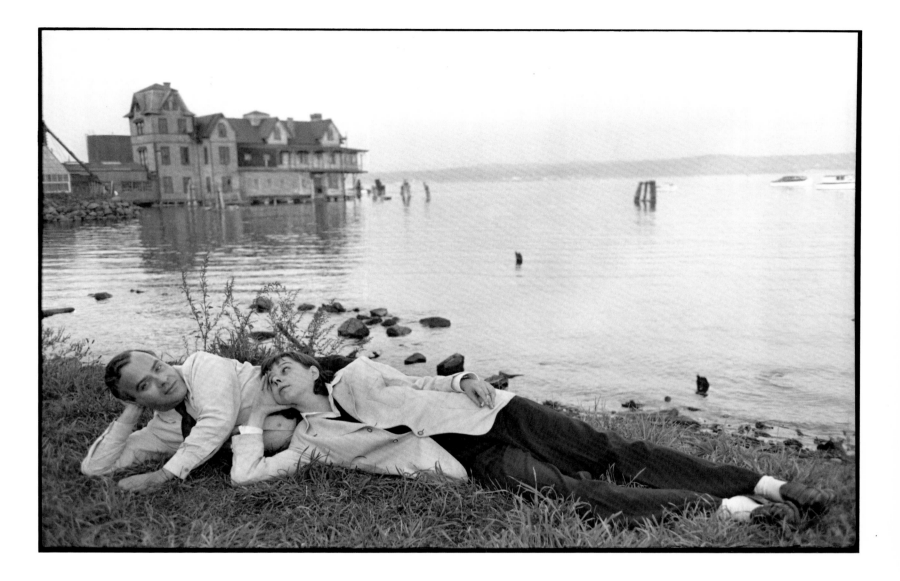

Carson McCullers, George Davis

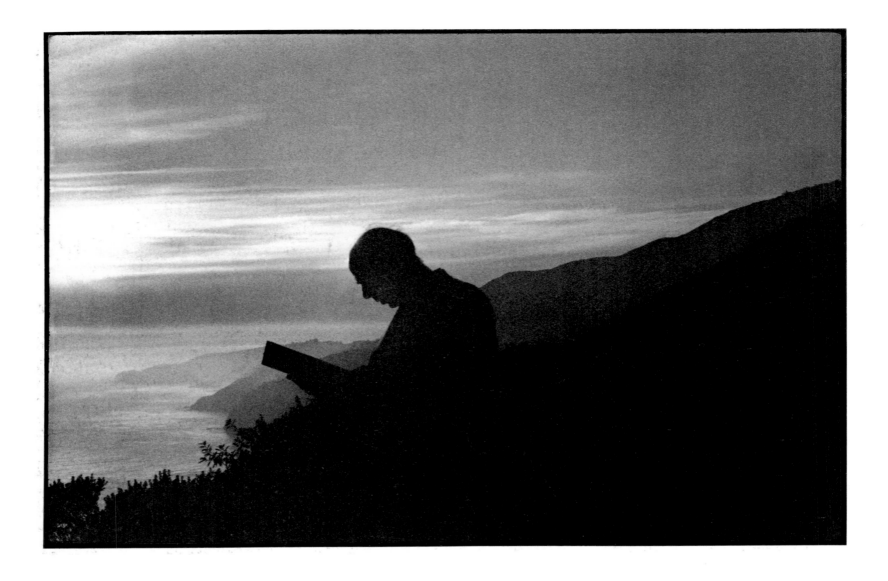

Henry Miller

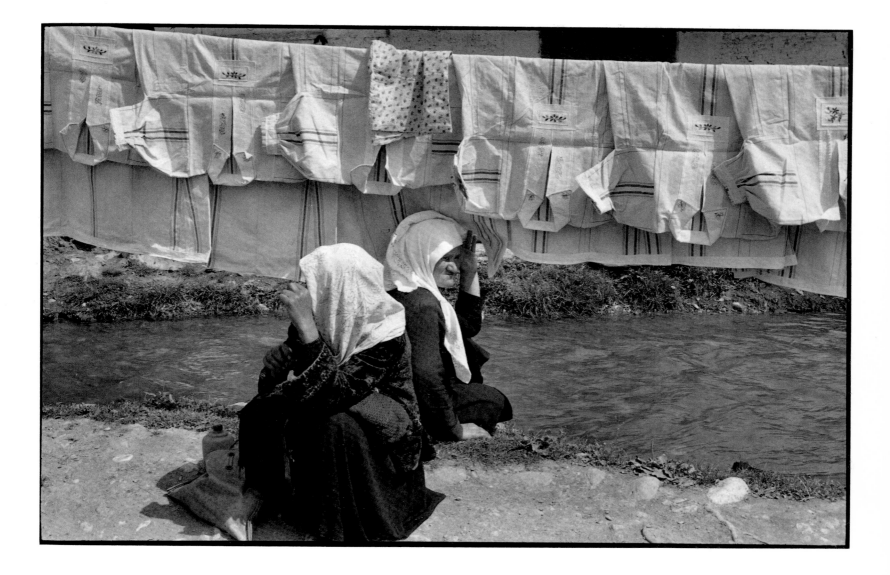

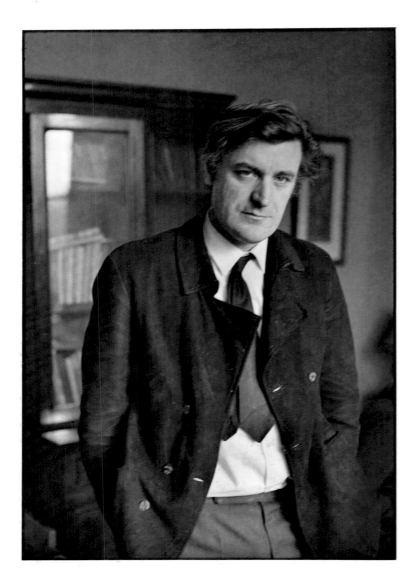

Ted Hughes

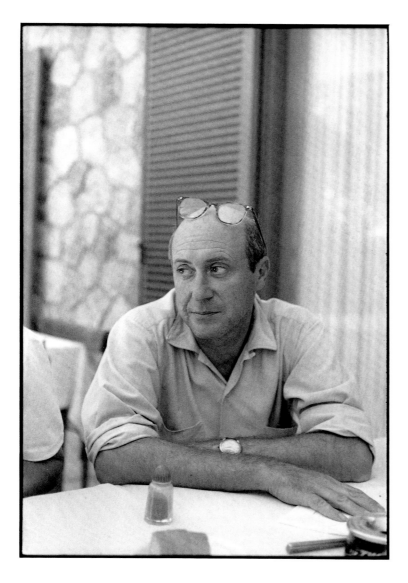

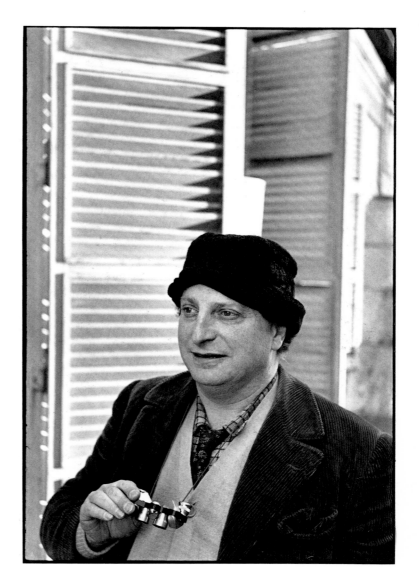

Yannis Tsaroukis

Carlo Levi

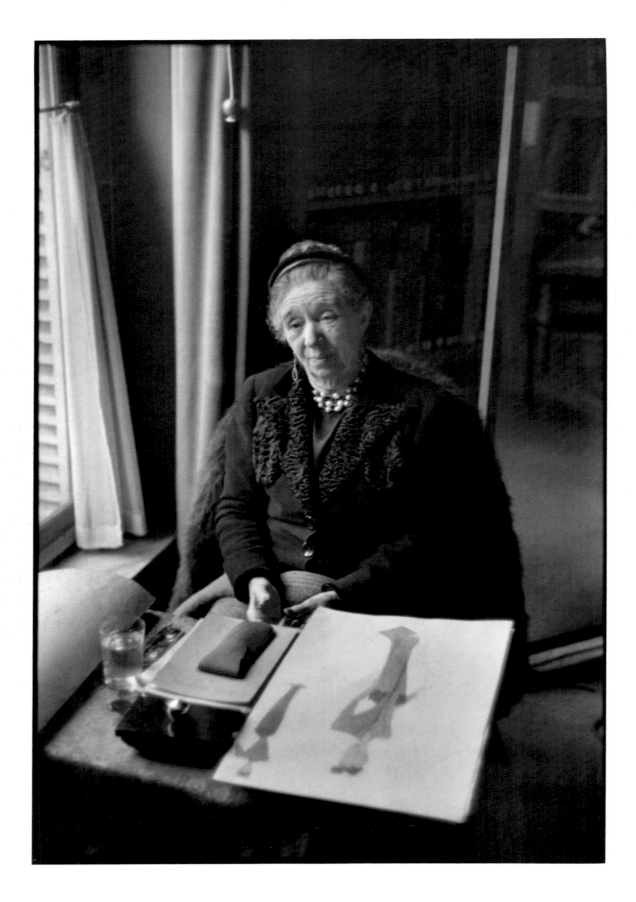

Jeanne Lanvin

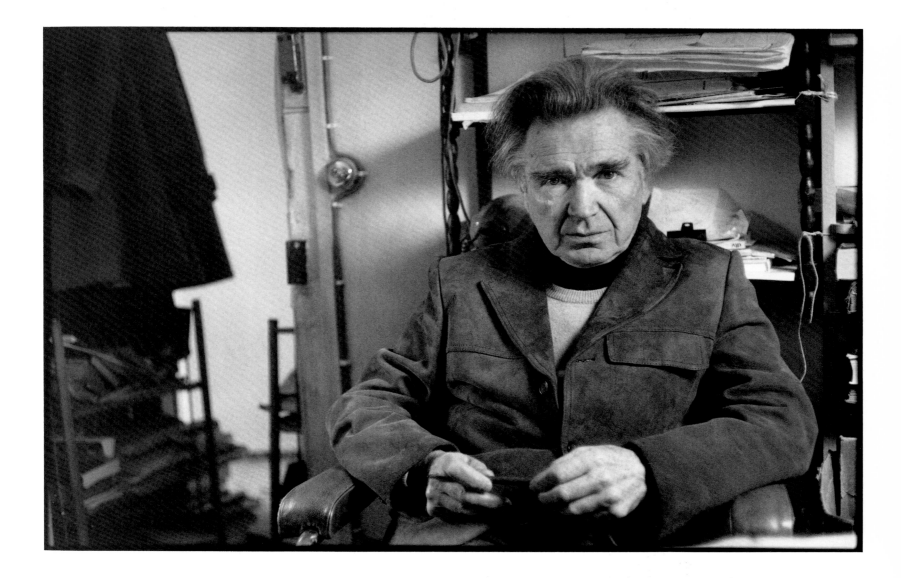

Cioran

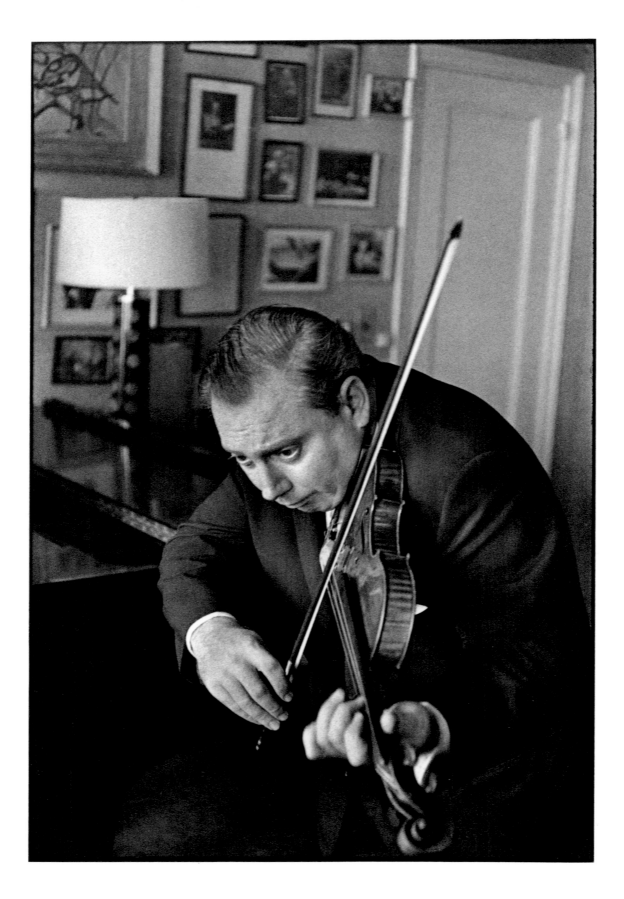

Isaac Stern

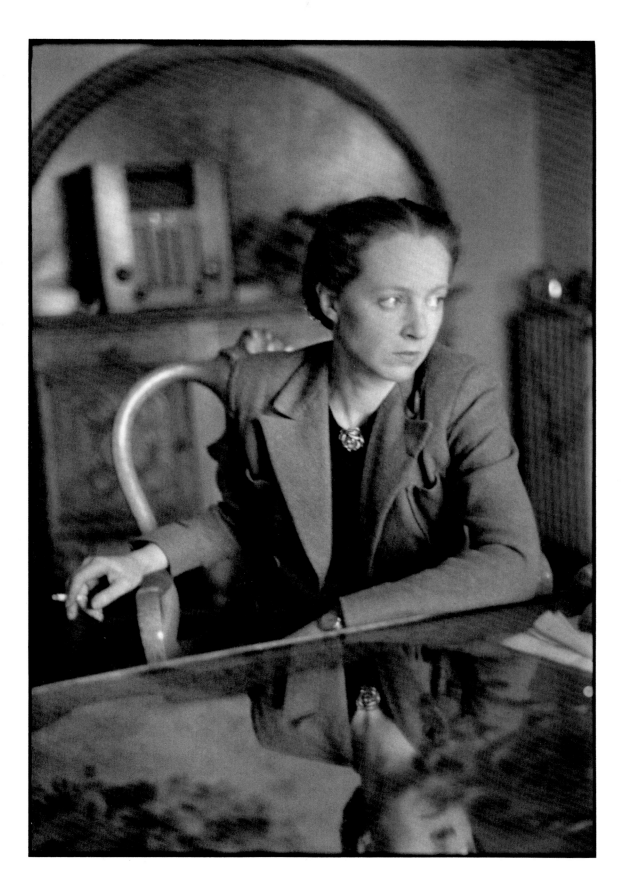

Marie-Claude Vogel-Vaillant-Couturier

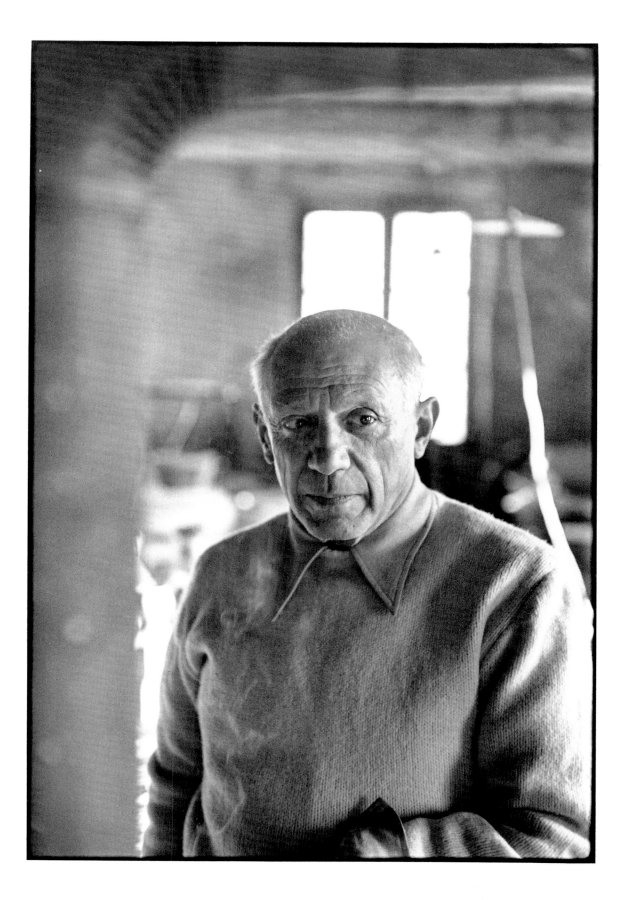

Pablo Picasso

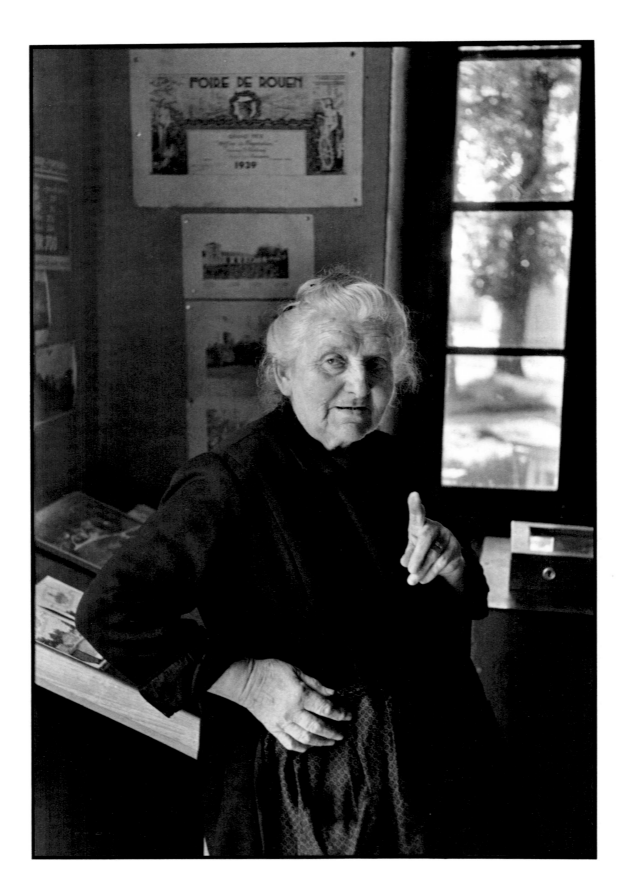

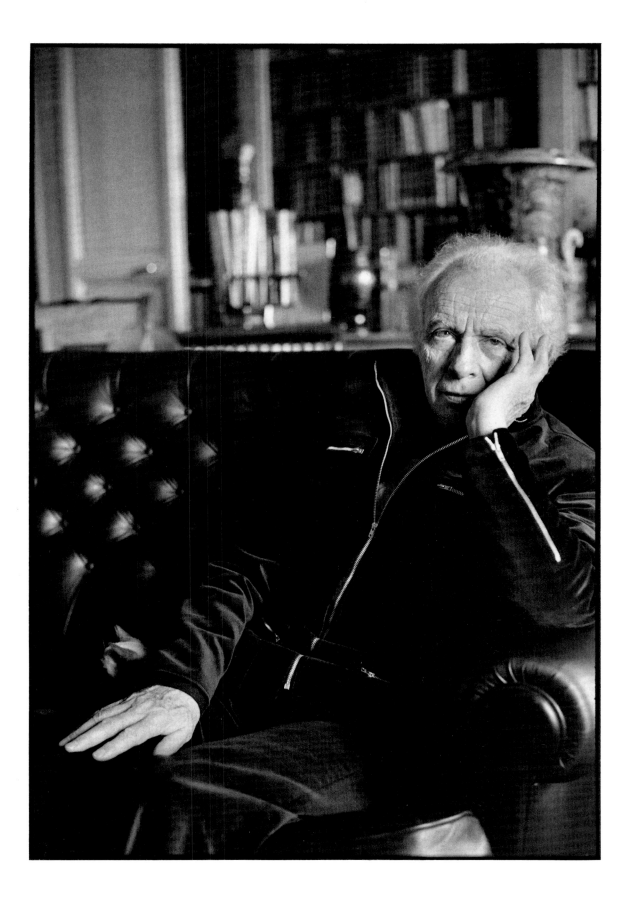

Louis Aragon

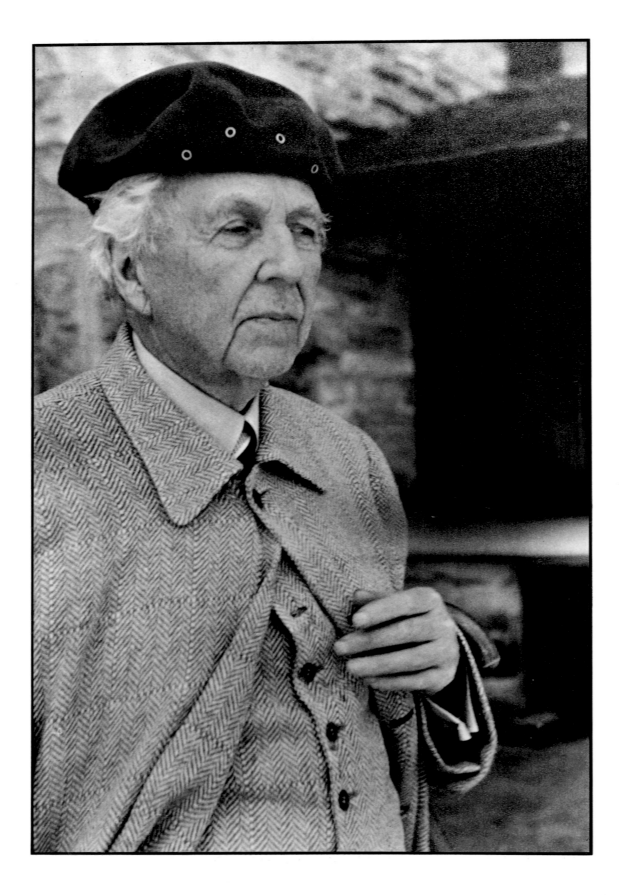

Frank Lloyd Wright

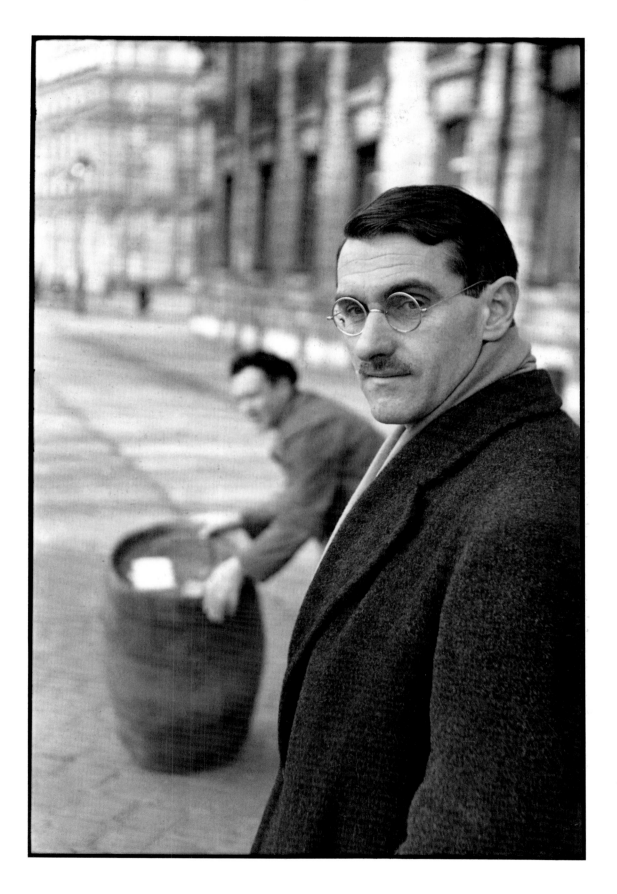

Jean Anouilh

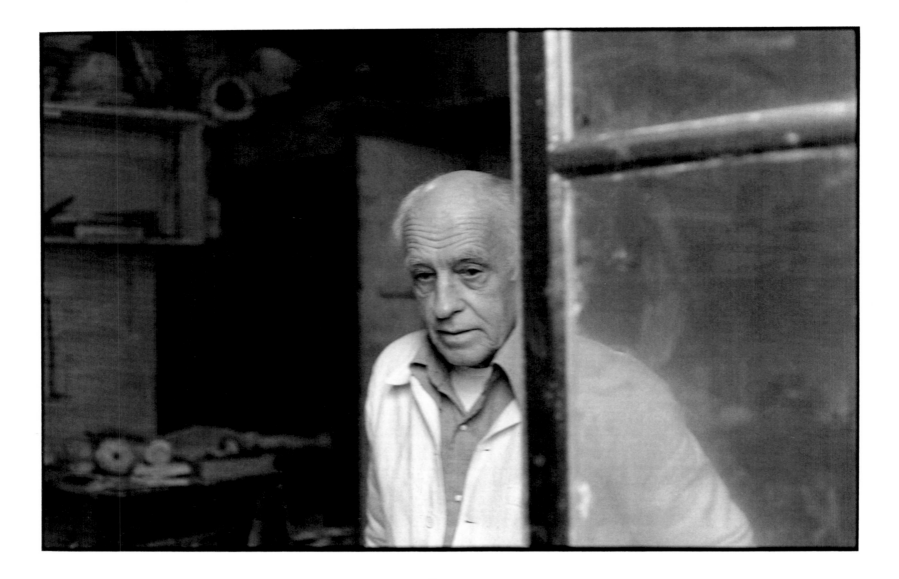

Diego Giacometti

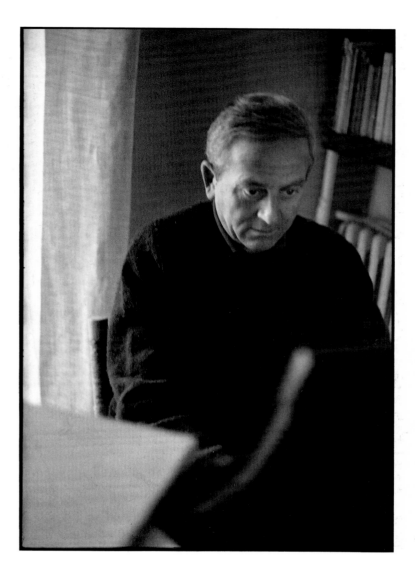

Maurice Ohana

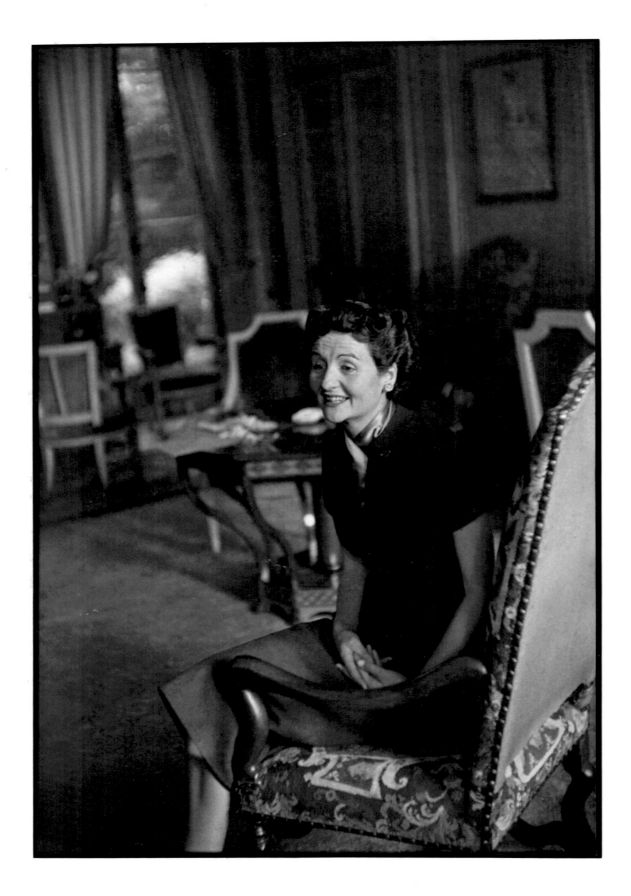

Nancy Mitford

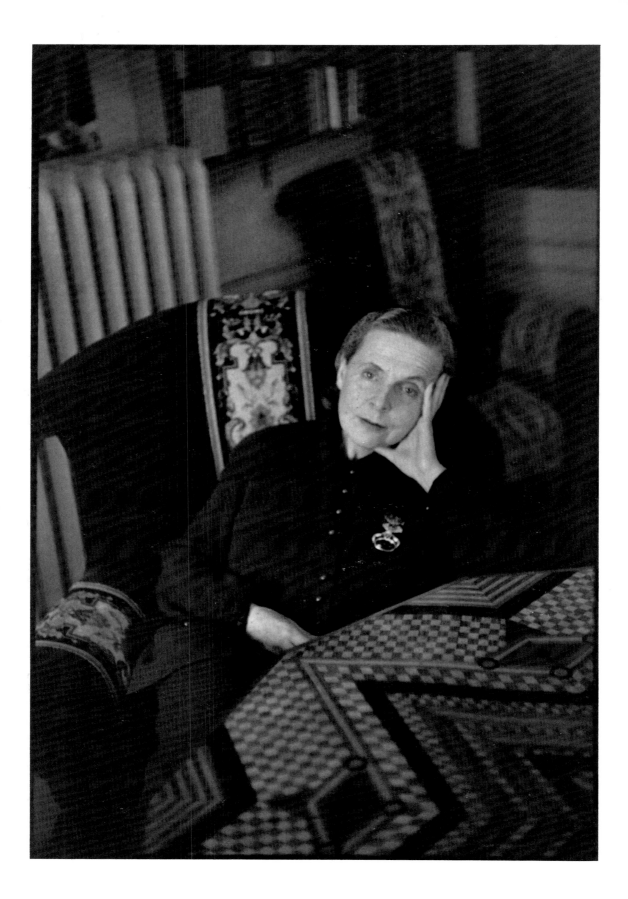

Elsa Triolet

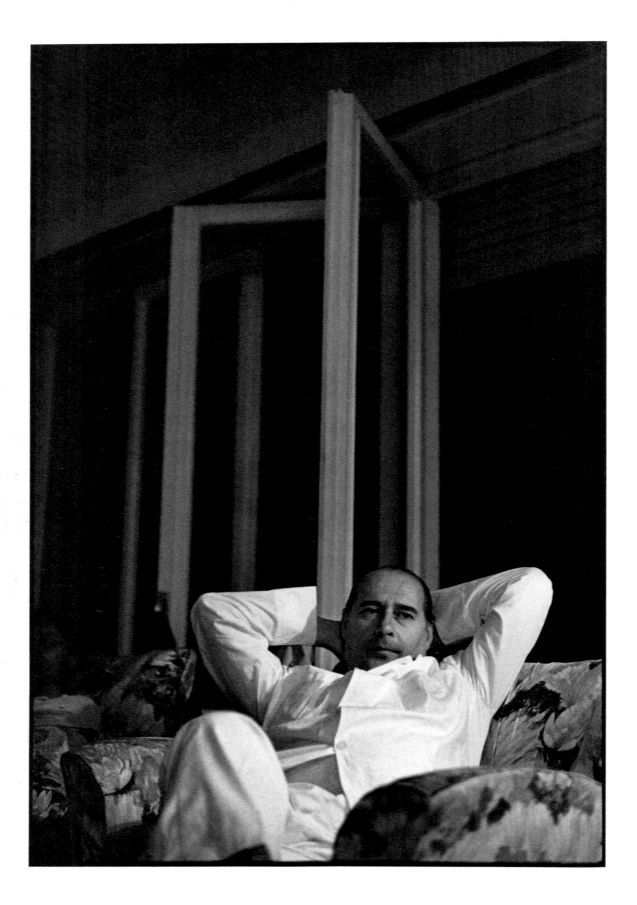

Roberto Rossellini

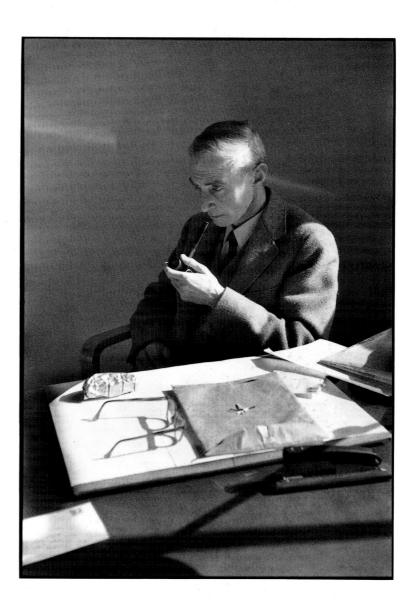

Robert Oppenheimer

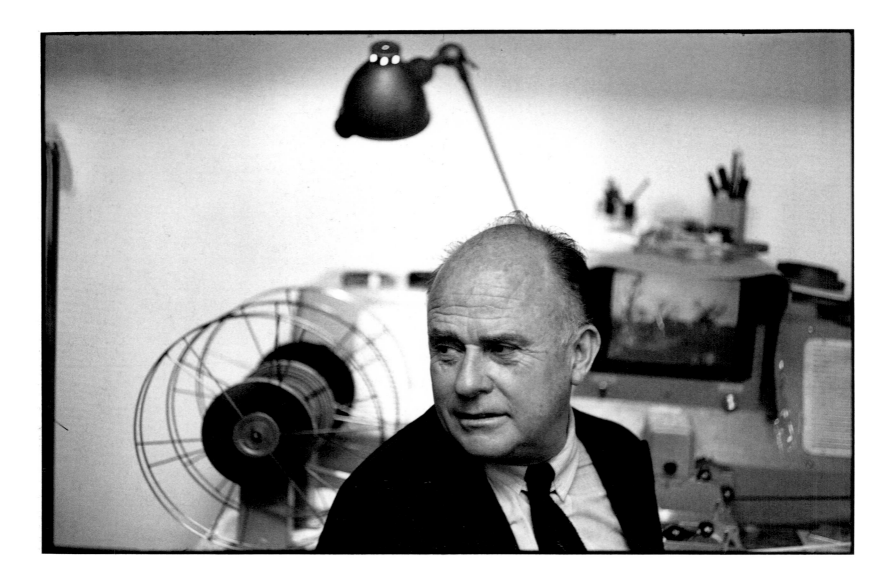

Jean Rouch

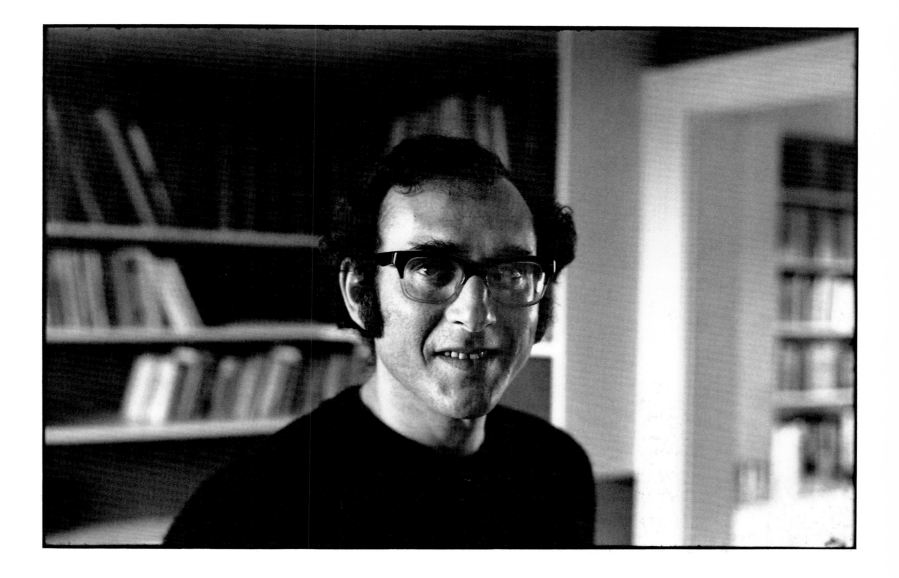

Harold Pinter

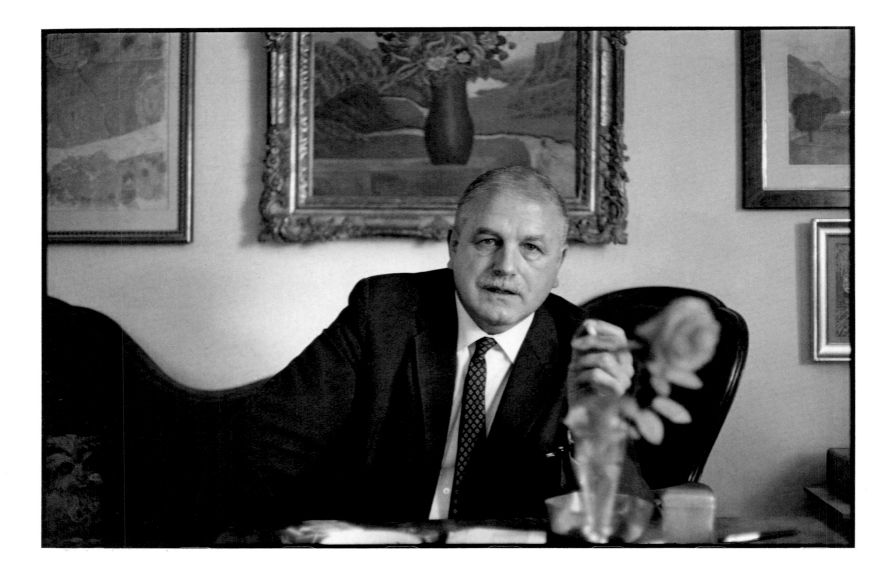

Manuel Gasser

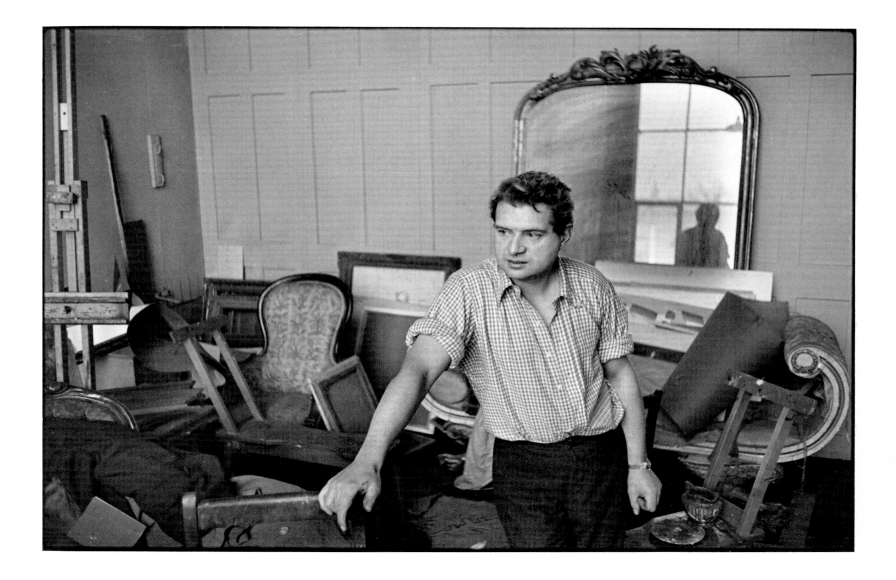

Francis Bacon

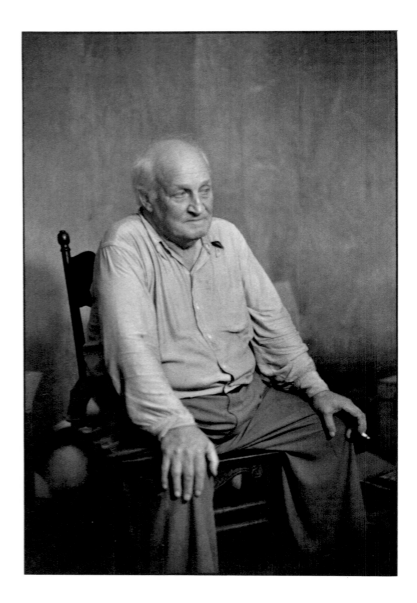

Robert Flaherty

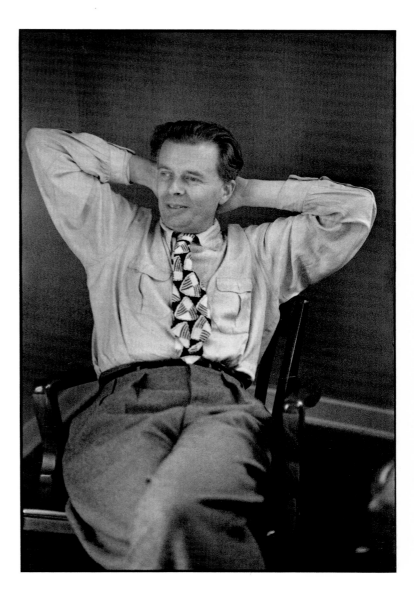

Aldous Huxley

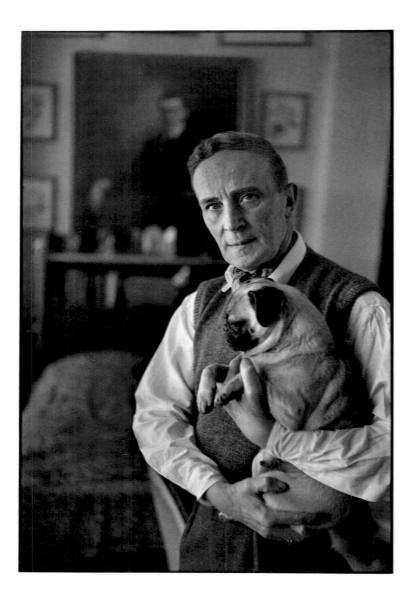

Prince Youssoupof

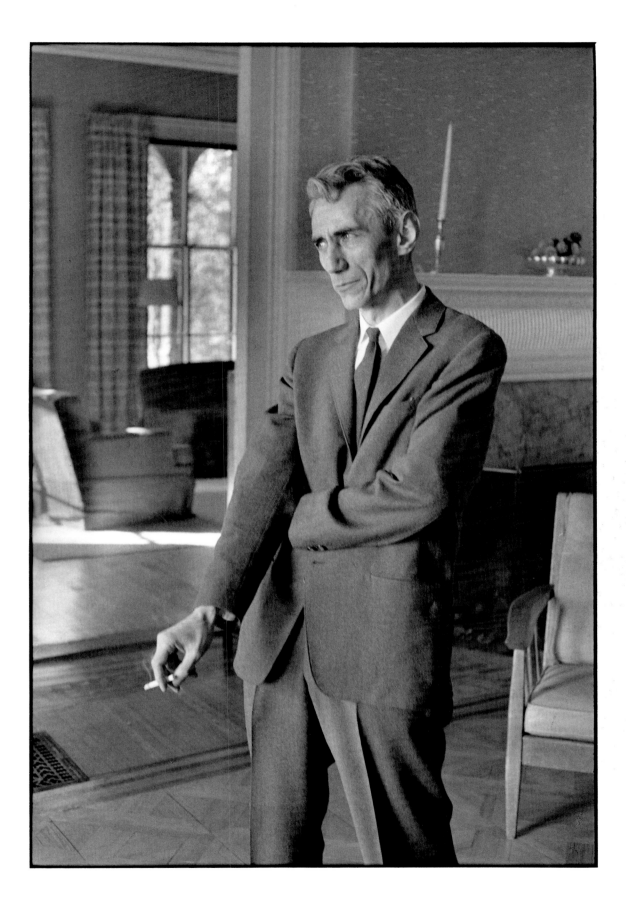

Claude Shannon

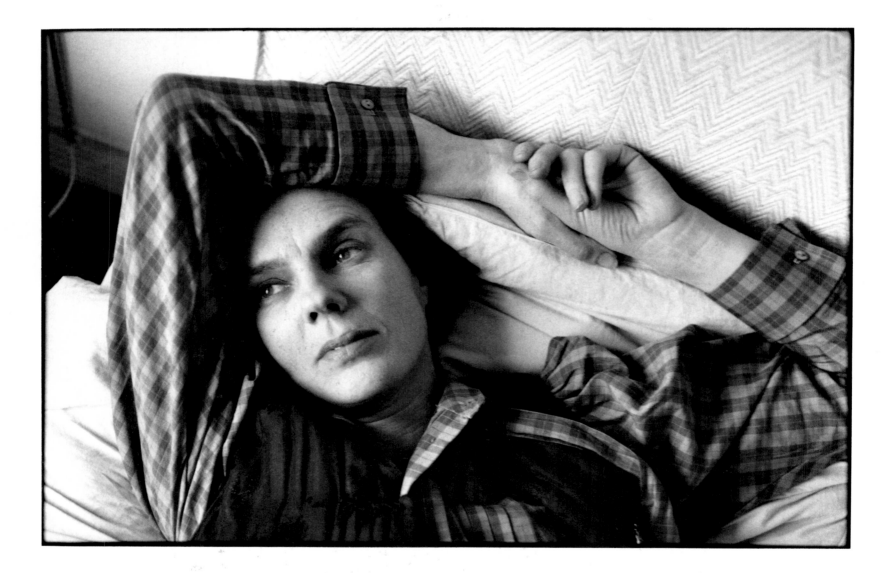

Martine Frank

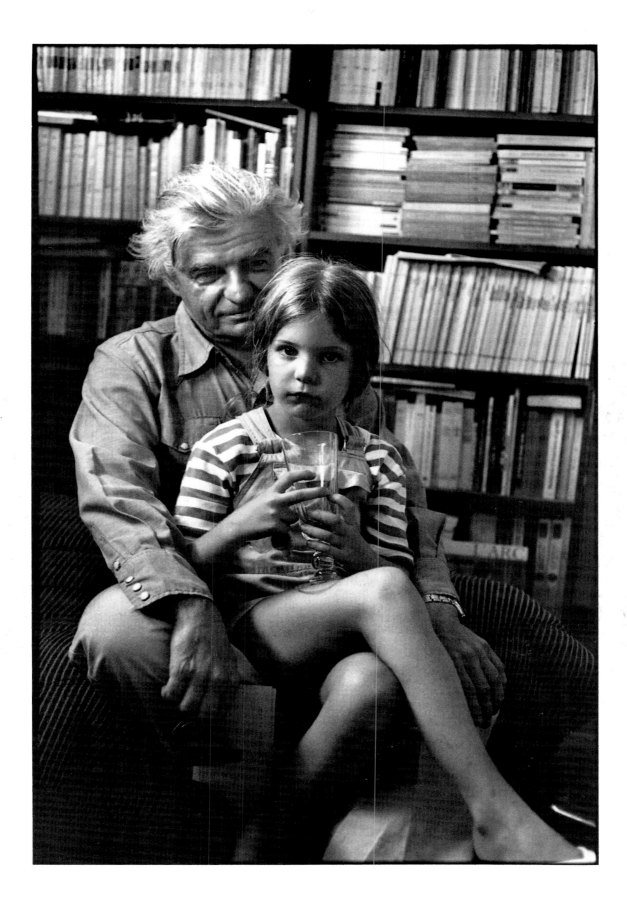

Yves Bonnefoy

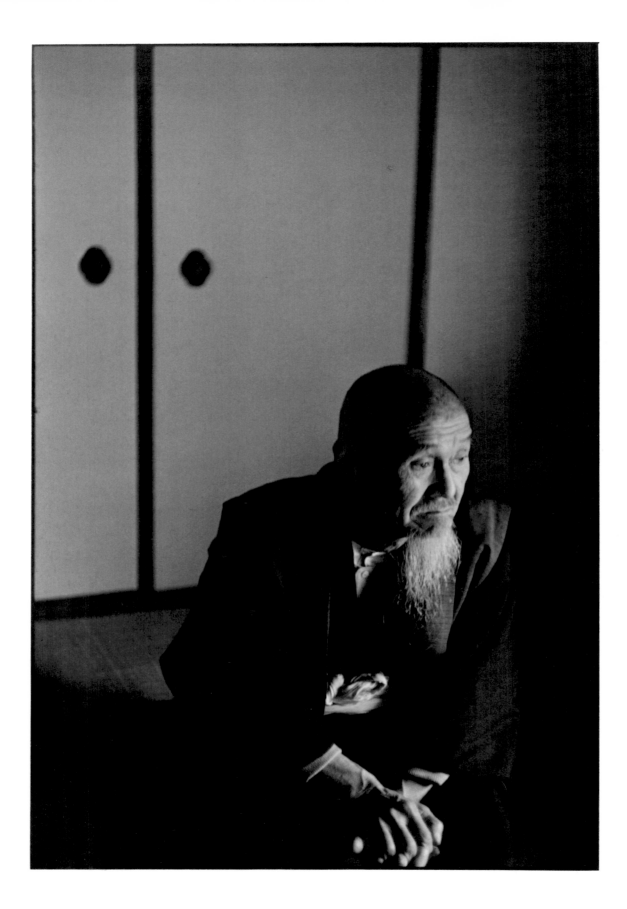

Koen Yamaguchi

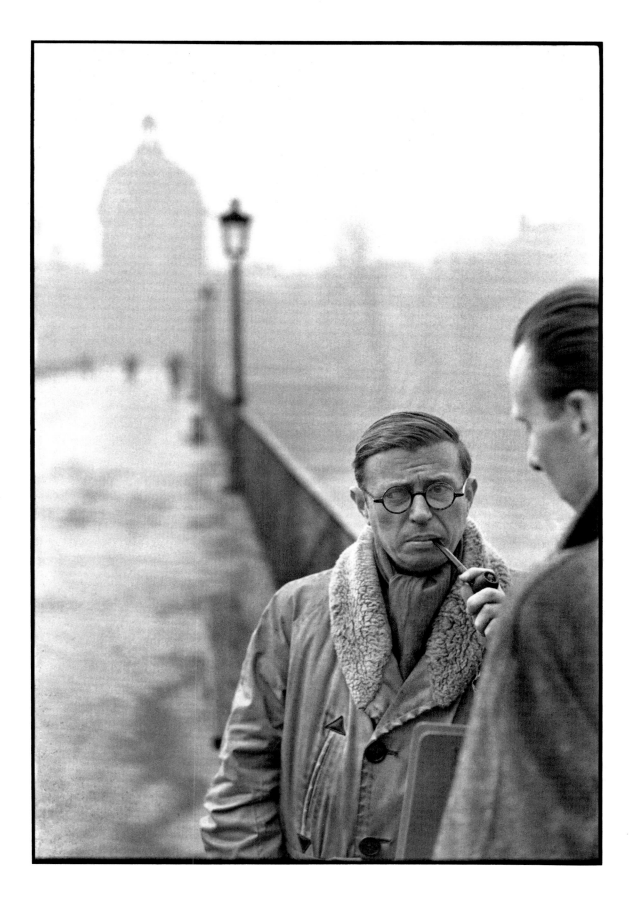

Jean-Paul Sartre, Jean Pouillon

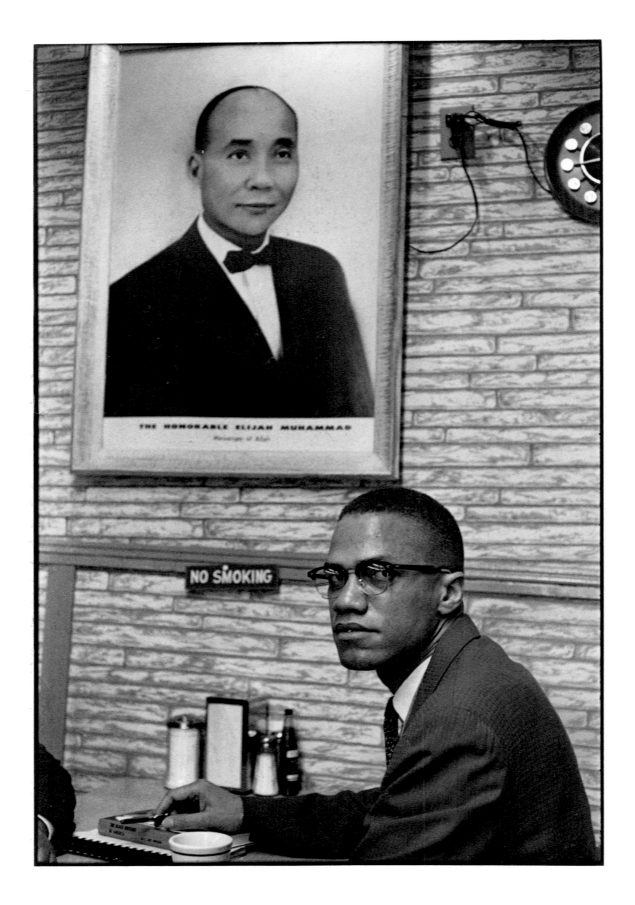

Malcolm X

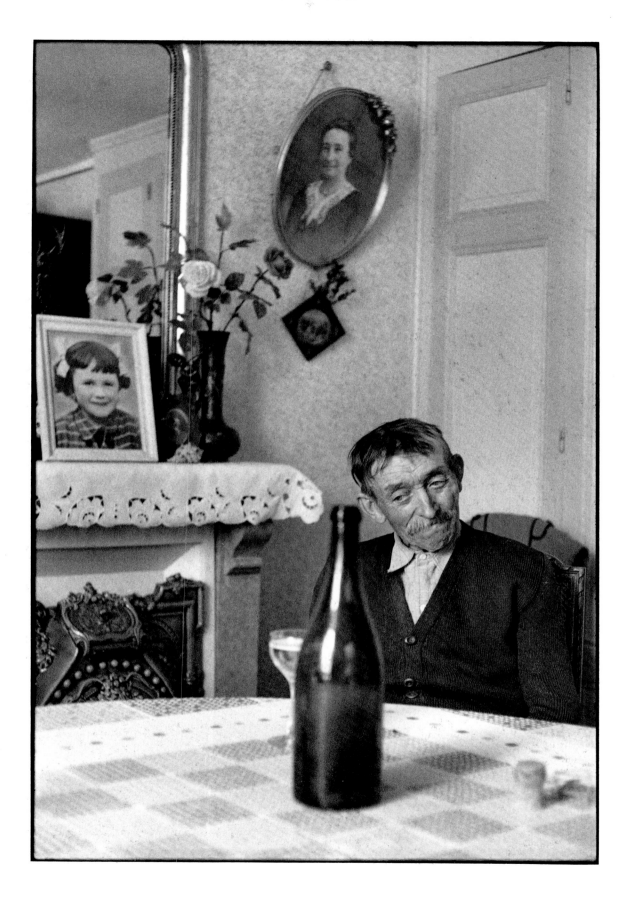

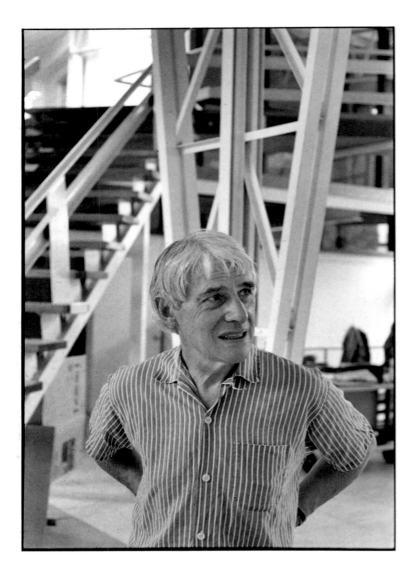

Willem de Kooning

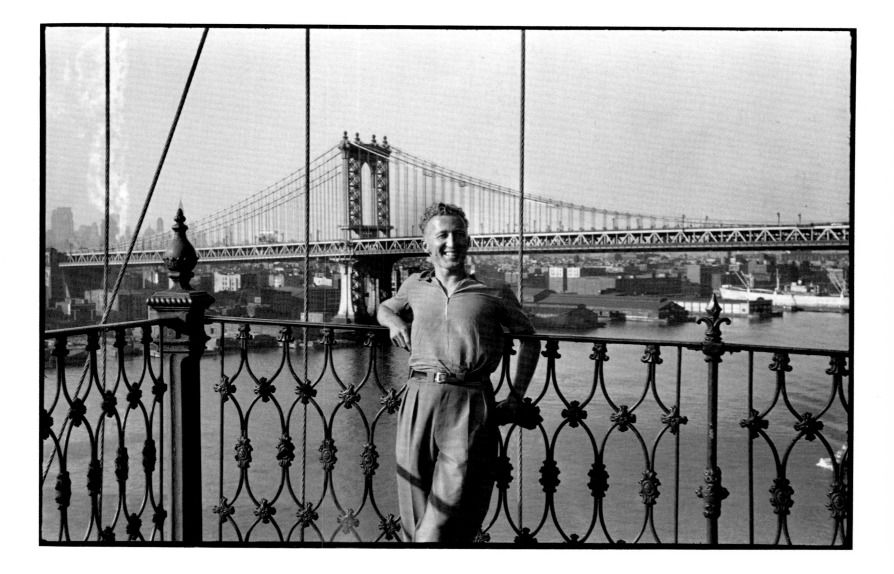

Claude Roy

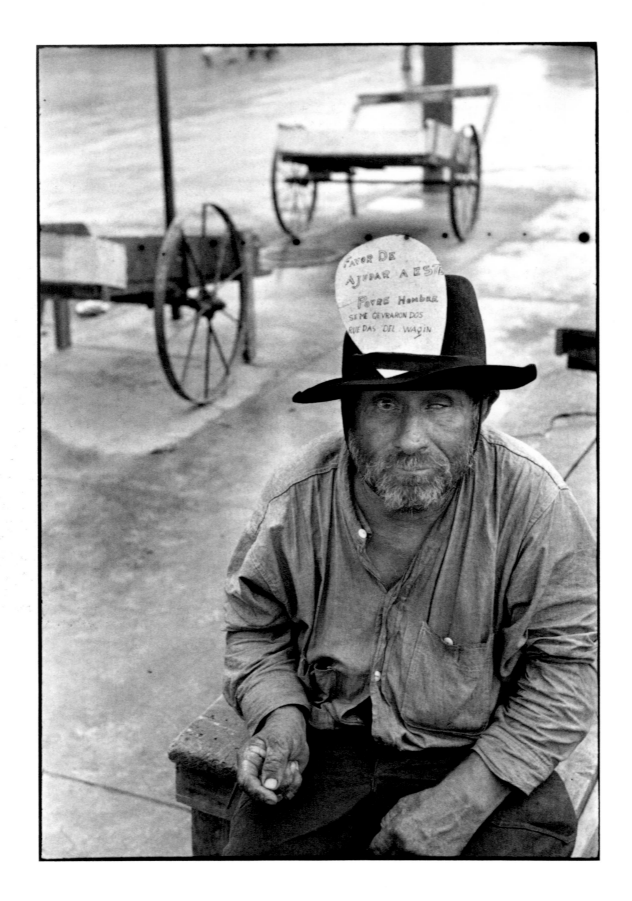

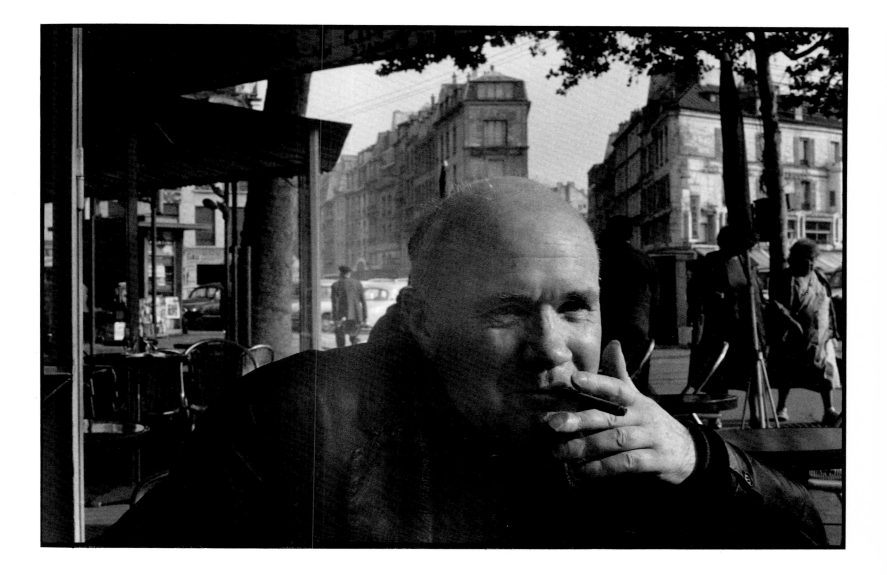

Jean Genet

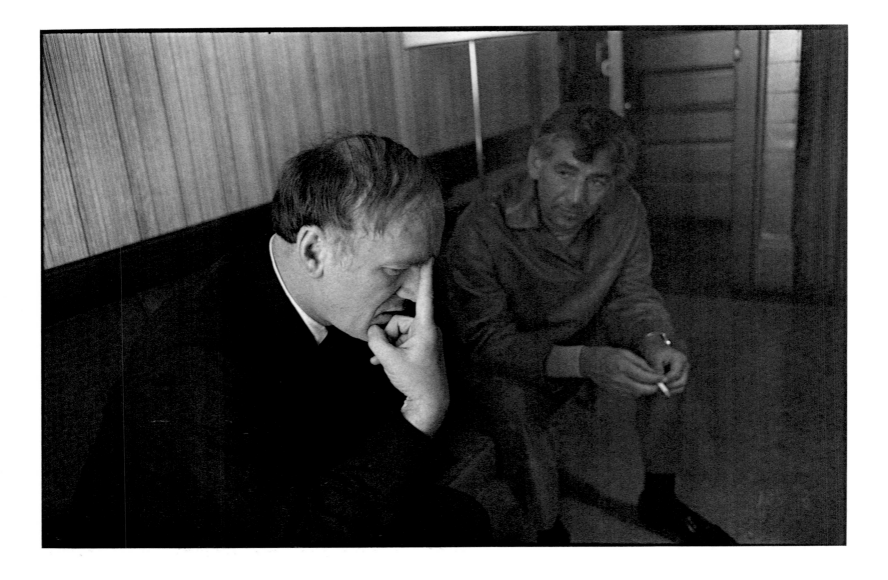

Sviatoslav Richter, Leonard Bernstein

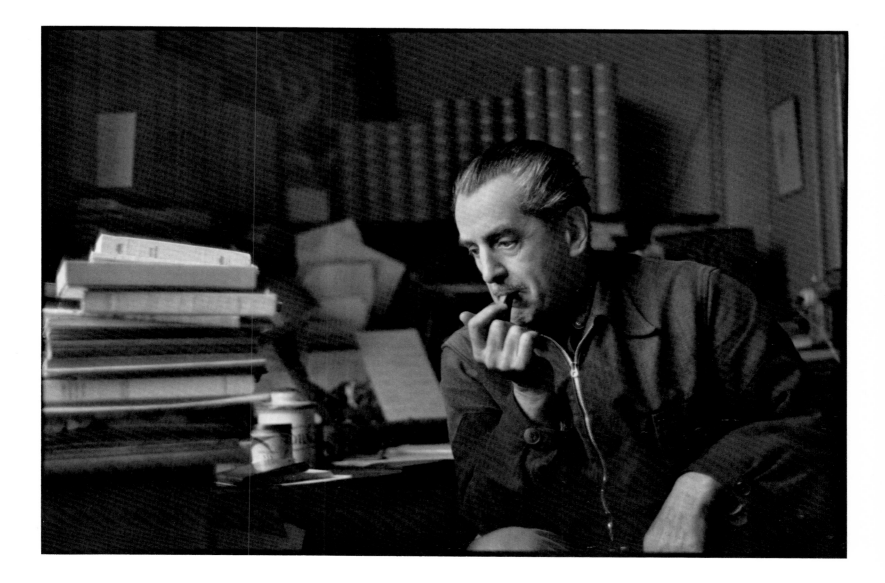

Jean Paulhan

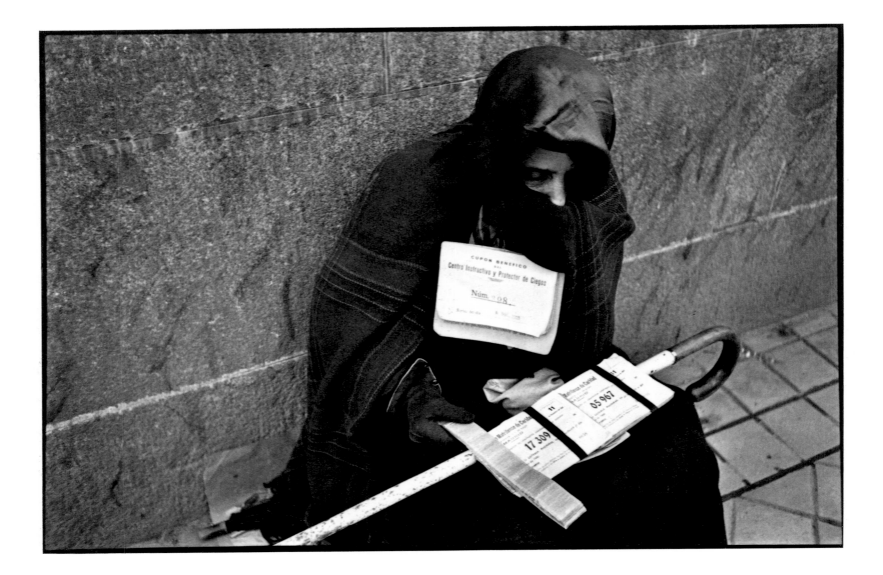

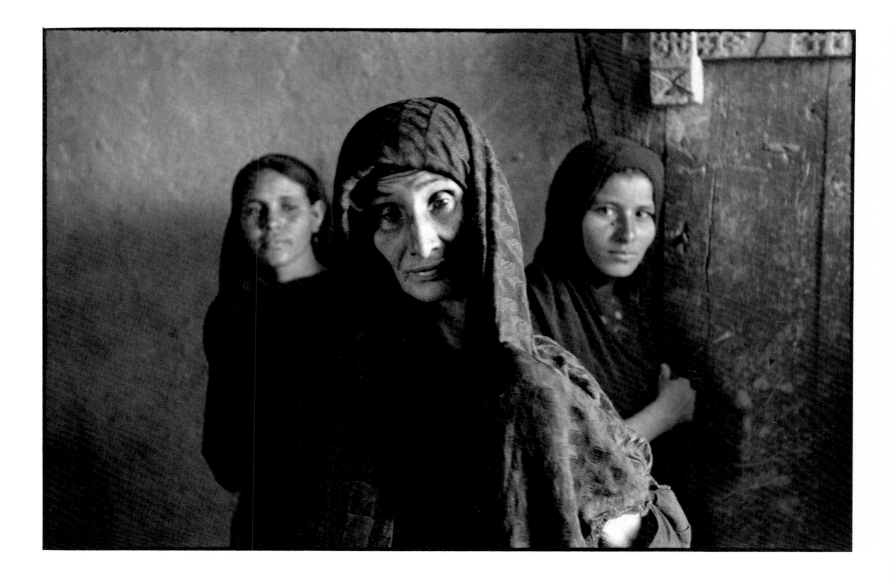

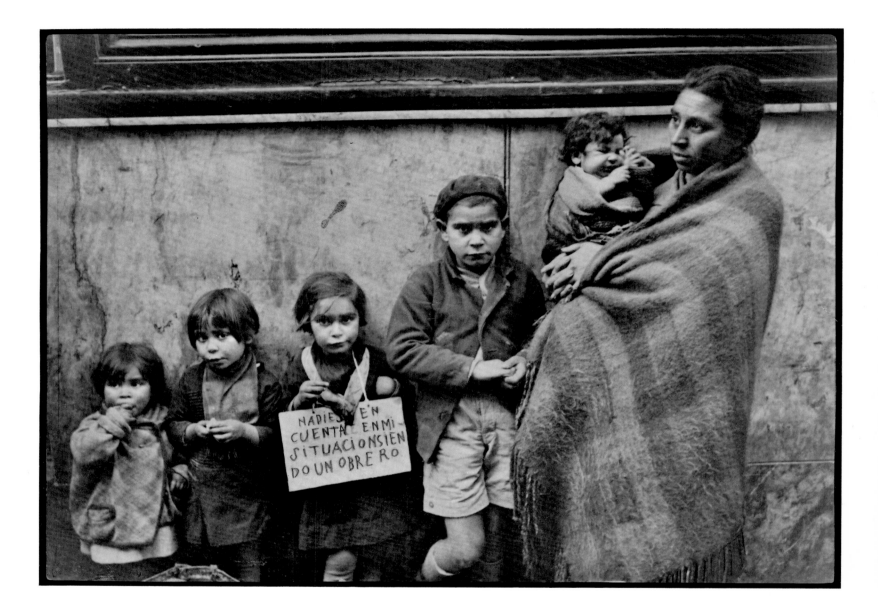

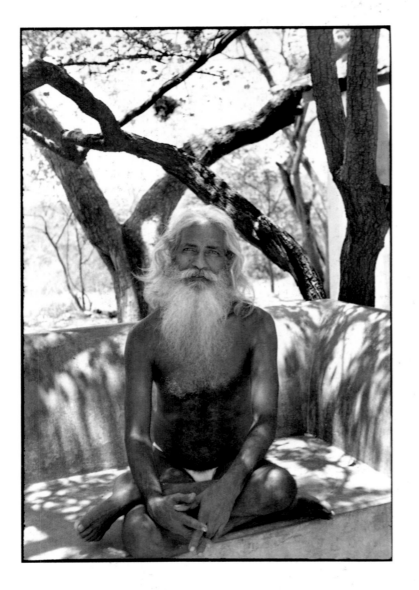

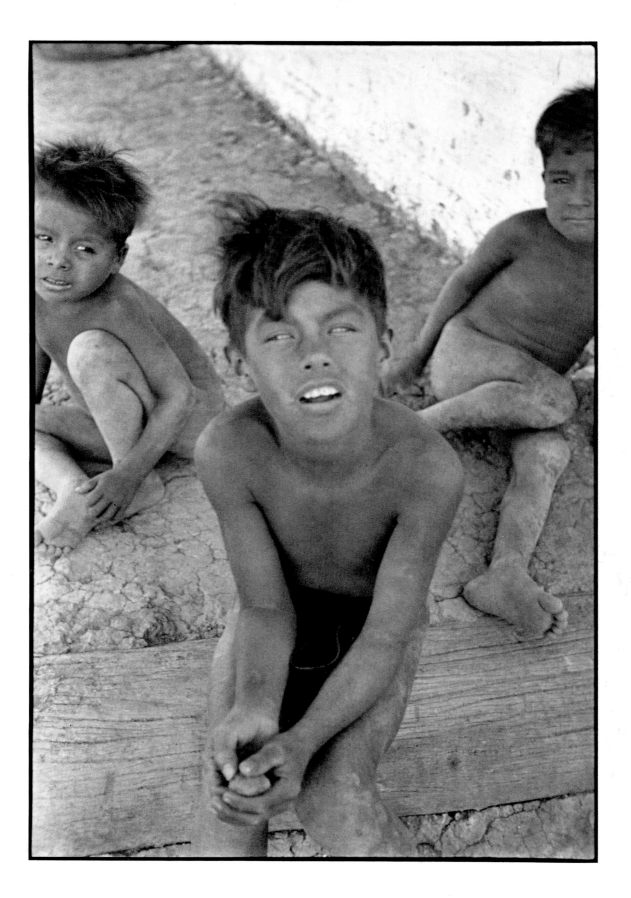

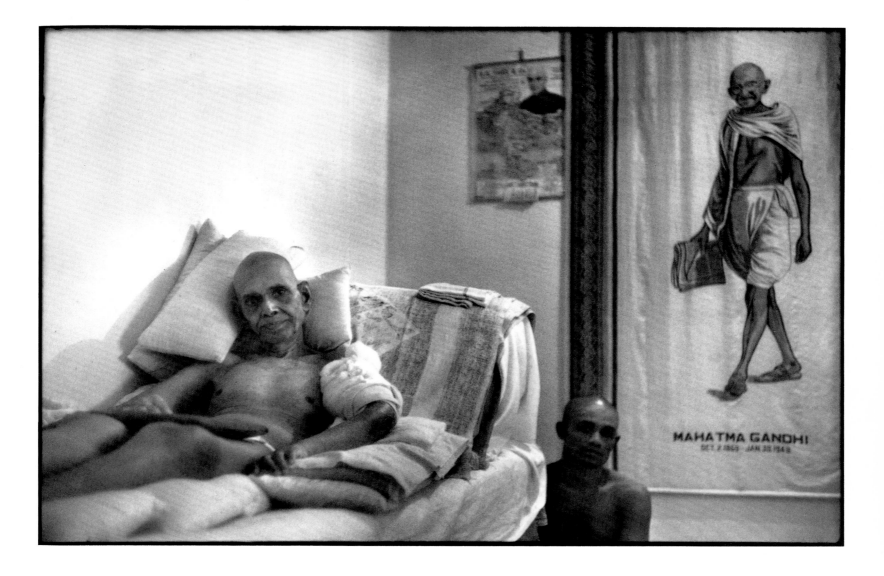

Sri Ramana Maharishi

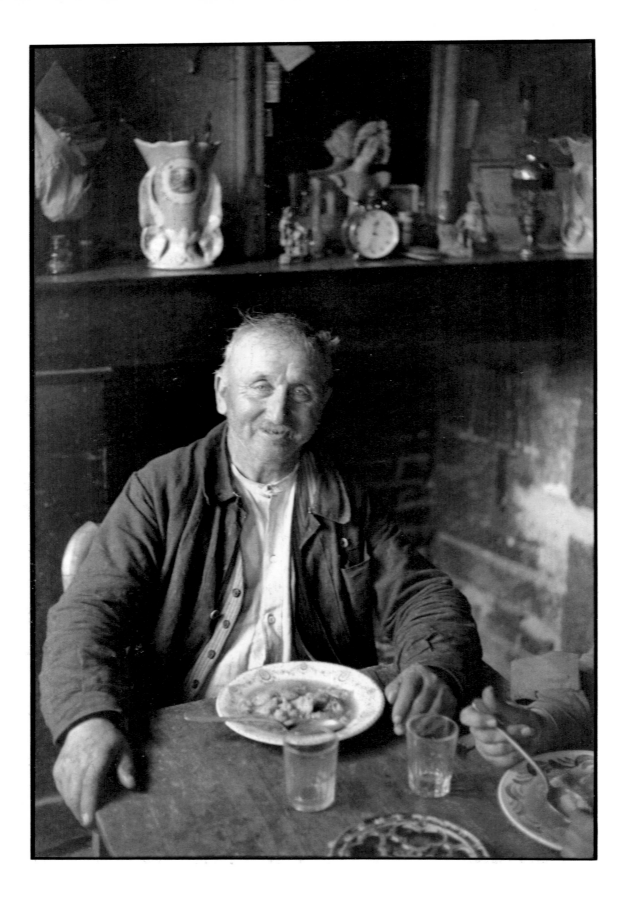

«Flo-Flo»

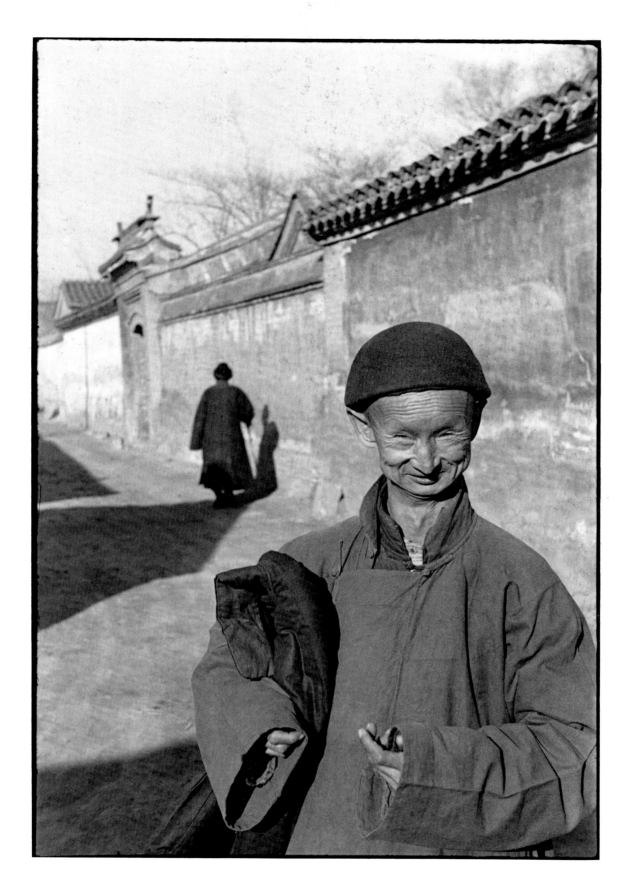

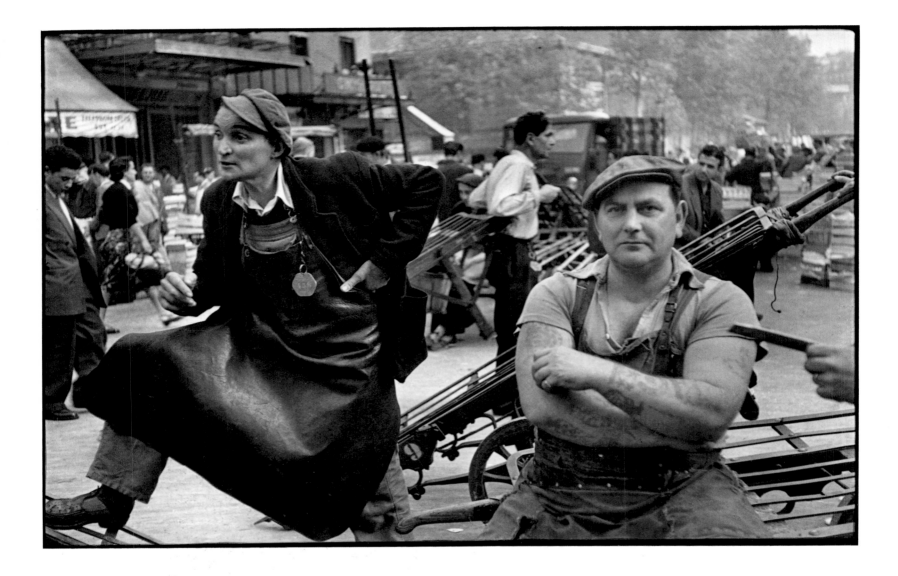

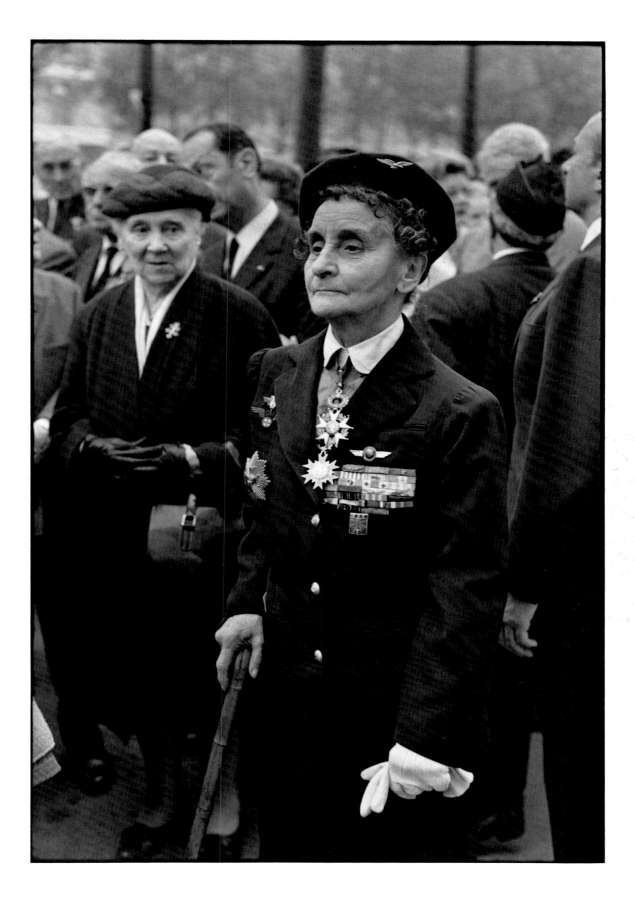

Jeanne Matthey

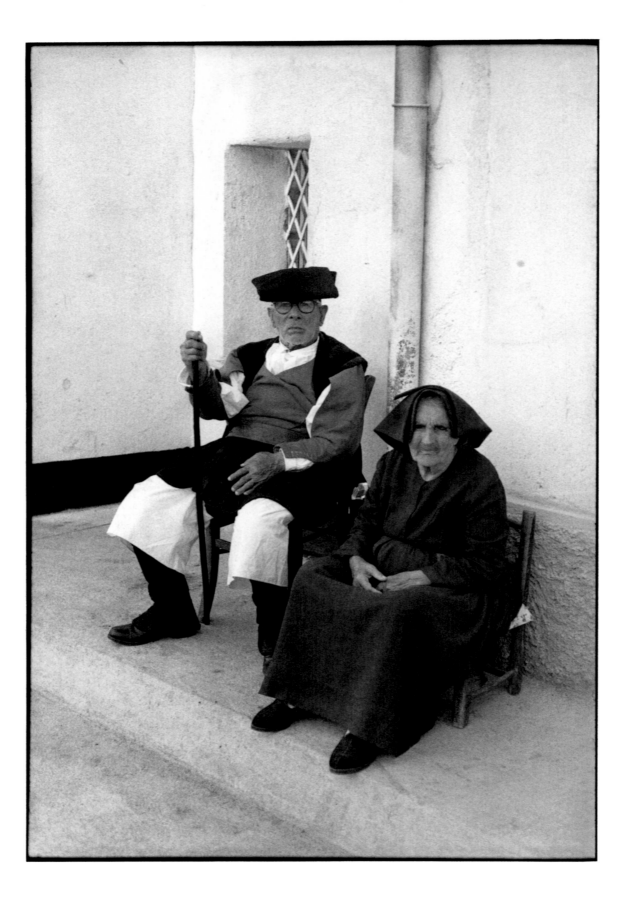

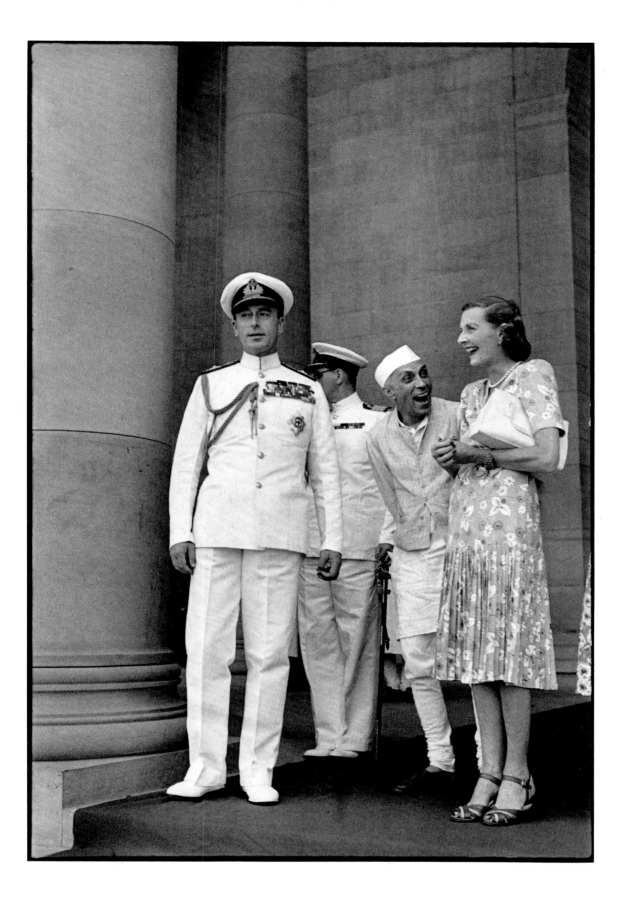

Lord Mountbatten, Lady Mountbatten, Jawaharlal Nehru

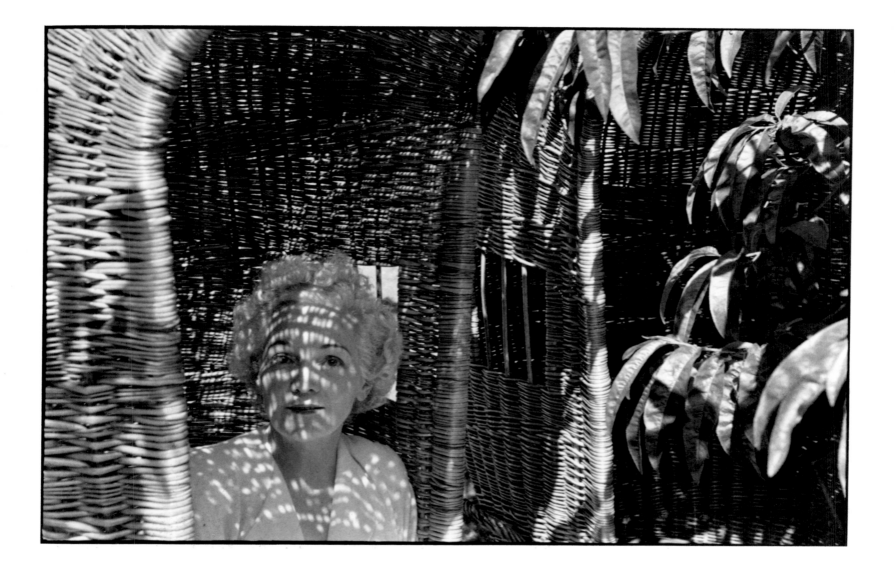

Katherine Anne Porter

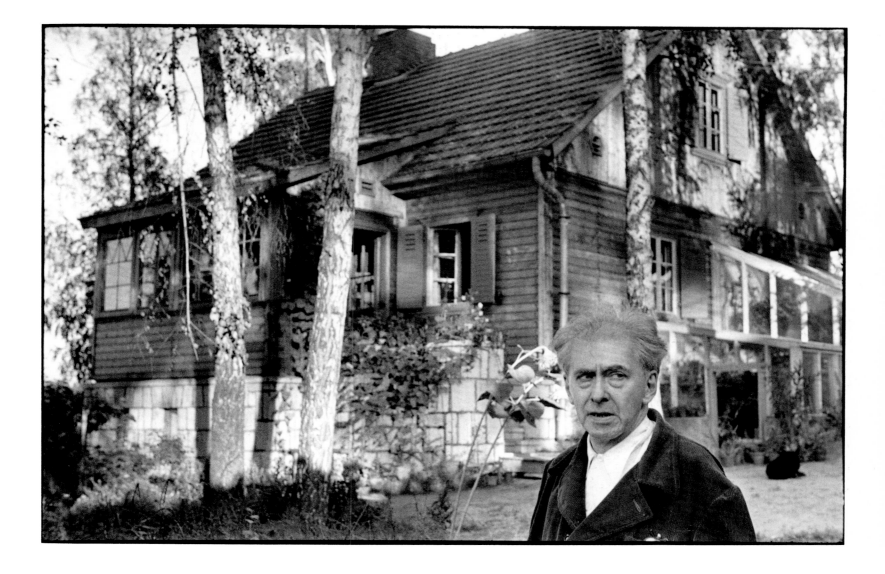

Ilia Ehrenbourg

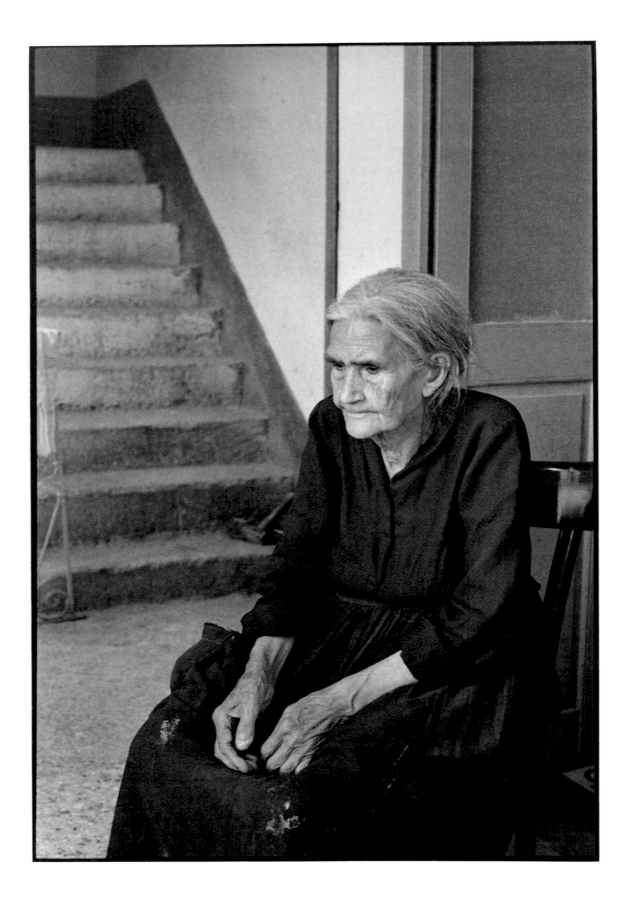

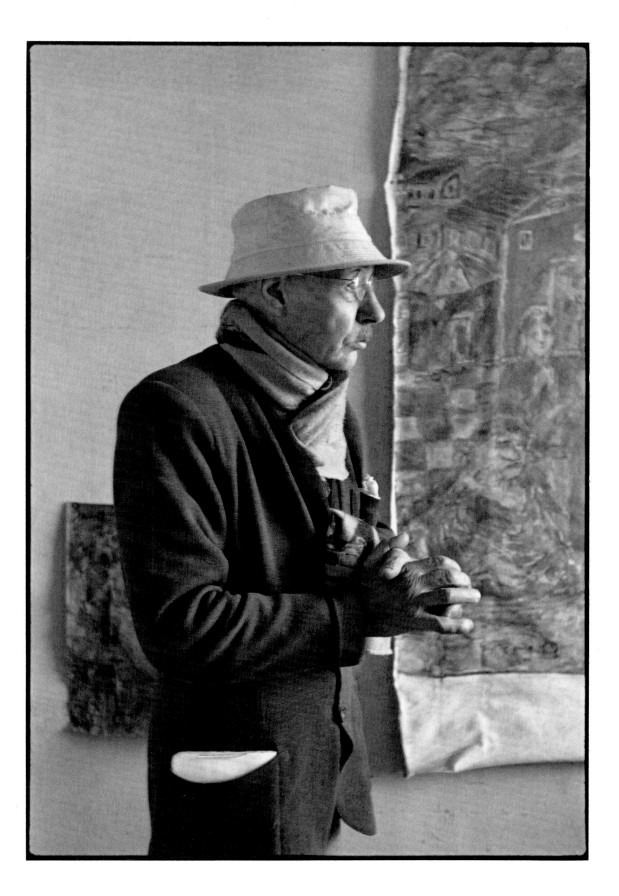

Pierre Bonnard

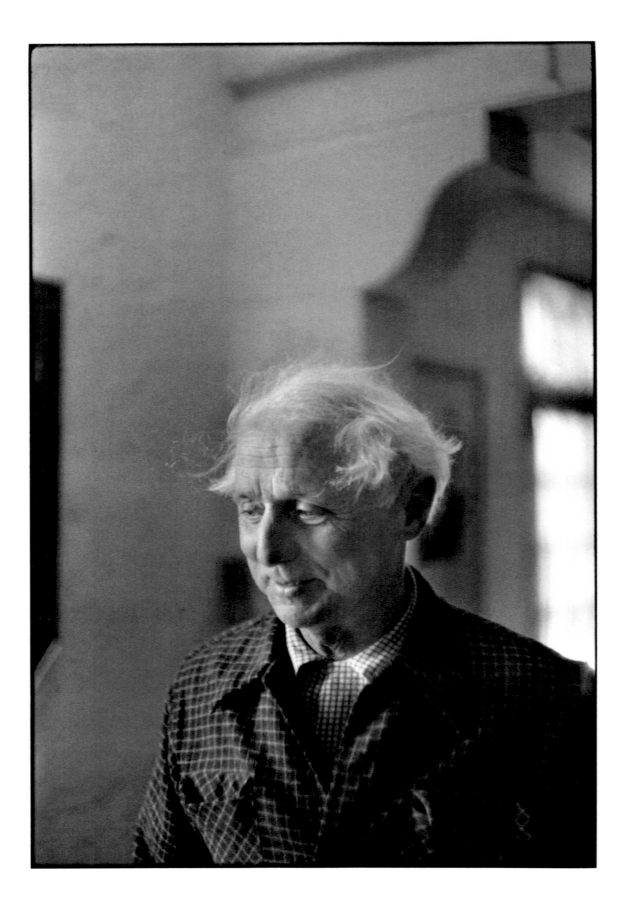

Max Ernst

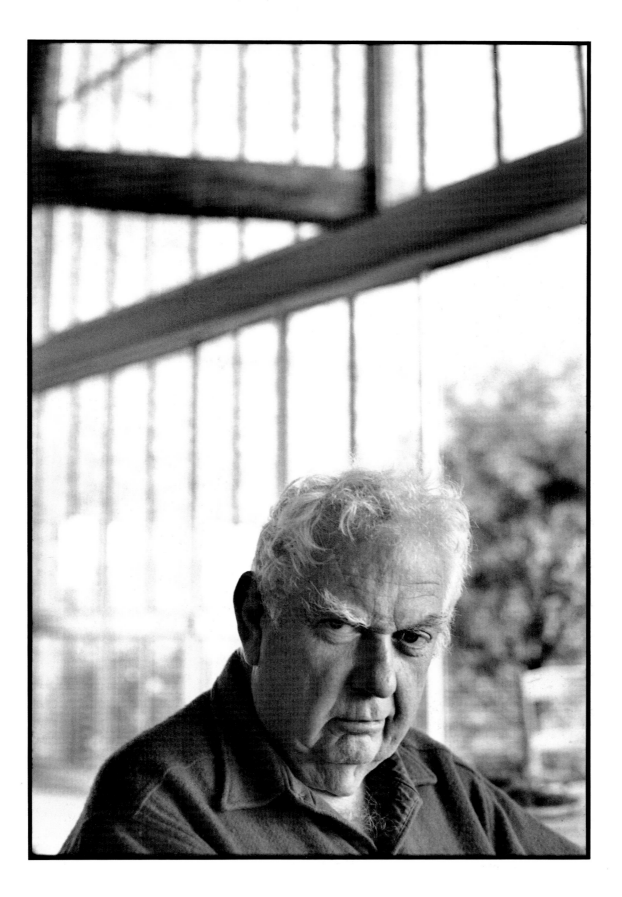

Alexander Calder

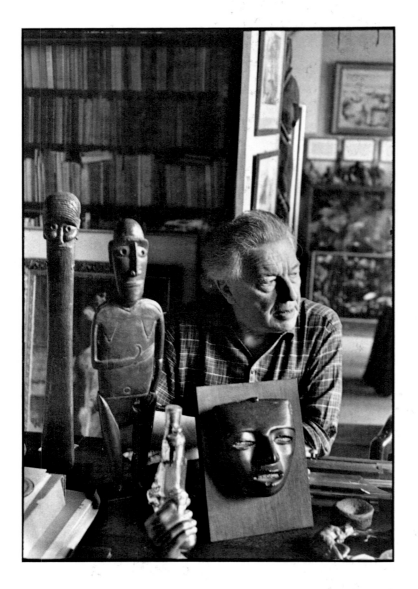

André Breton

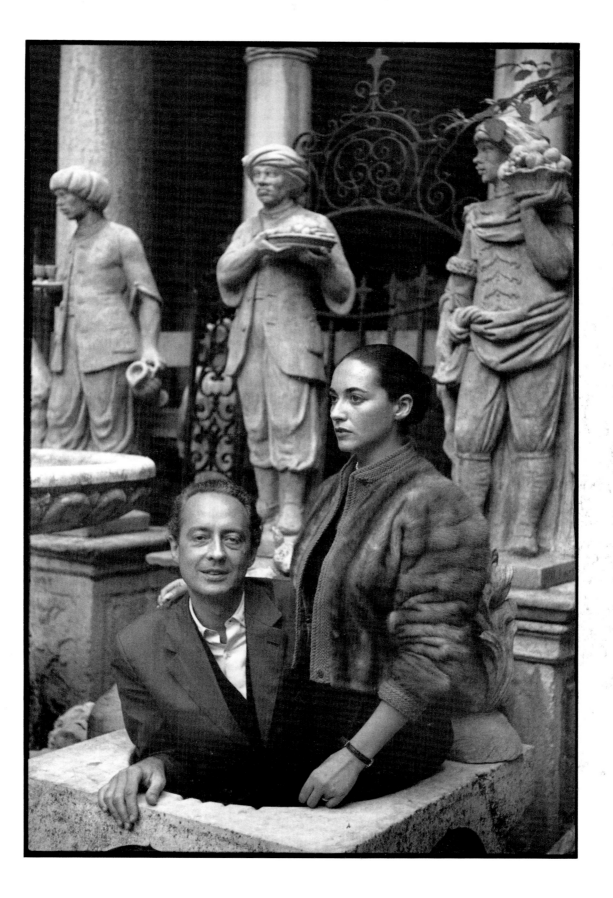

André Pieyre de Mandiargues, Bona

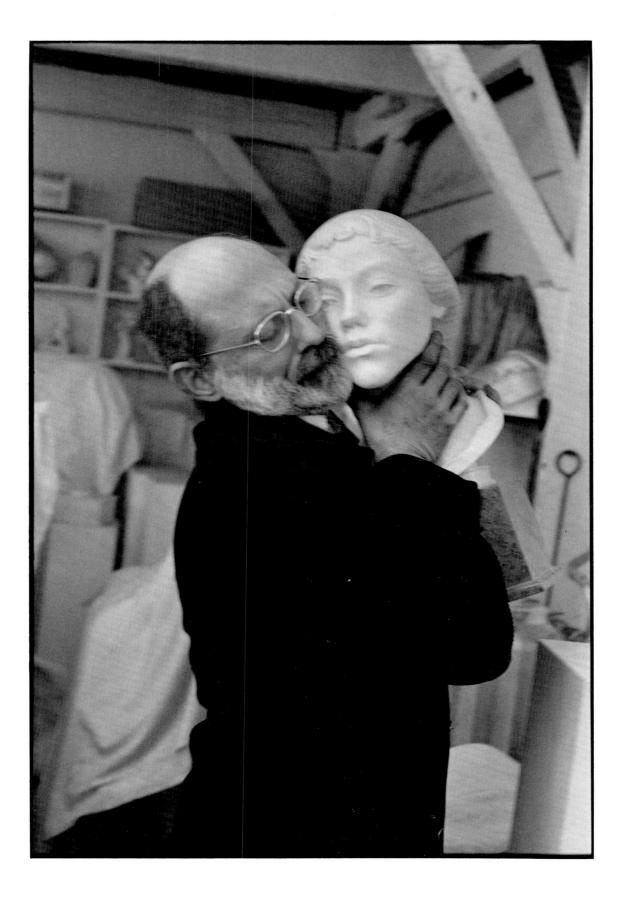

Joseph Erhardy

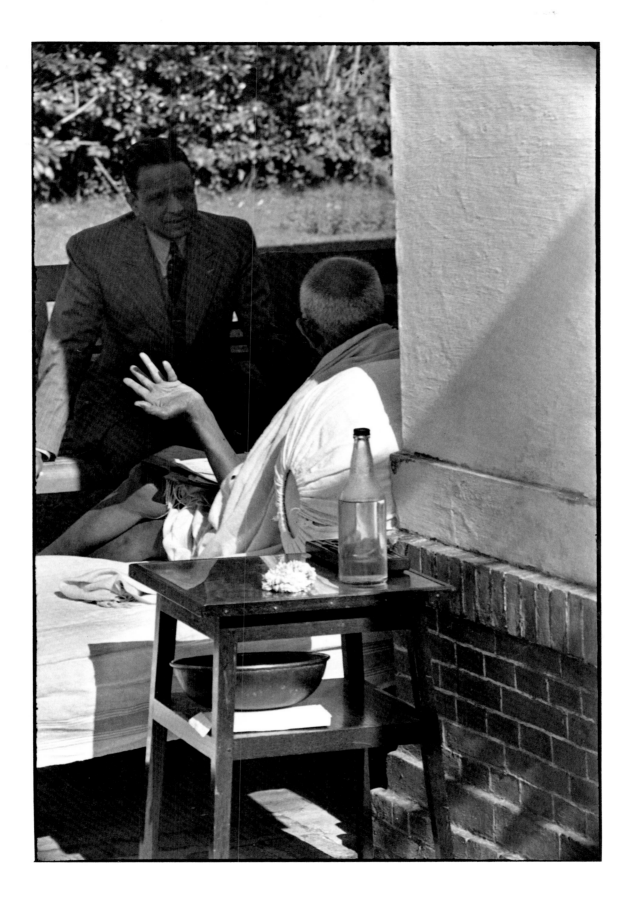

Gandhi

List of Illustrations

TECHNICAL INFORMATION AND CREDITS

Camera: Leica with 50 mm lens

All photographs from the archives of Magnum

Prints made at Pictorial Services by Georges Fèvre, Vojin
Mitrovic, Marc Hervé, Catherine Guilbaud

Layout by Jeanine Fricker and Claude Mézier
Text photoset by Foremost Typesetting, London
Reproduced and printed in offset lithography by
Jean Genoud, Lausanne
Bound by Mayer et Soutter, Lausanne